Politics, *Ink*

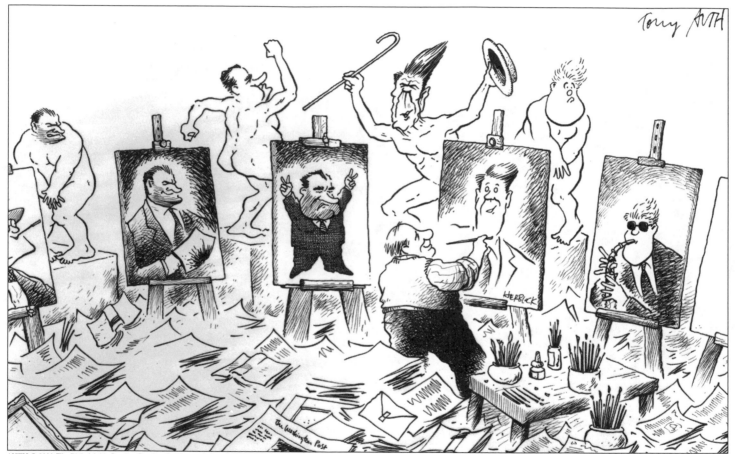

Politics, *Ink*

How America's Cartoonists Skewer Politicians, from King George III to George Dubya

EDWARD J. LORDAN

ROWMAN & LITTLEFIELD PUBLISHERS, INC.

Lanham • Boulder • New York • Toronto • Oxford

ROWMAN & LITTLEFIELD
PUBLISHERS, INC.

Published in the United States of America
by Rowman & Littlefield Publishers, Inc.
A wholly owned subsidary of The Rowman &
Littlefield Publishing Group, Inc.
4501 Forbes Boulevard, Suite 200, Lanham,
Maryland 20706
www.rowmanlittlefield.com

P.O. Box 317, Oxford OX2 9RU, UK

British Library Cataloguing in Publication
Information Available

Library of Congress Cataloging-in-
Publication Data

Lordan, Edward J.
 Politics, Ink : how America's cartoonists skewer
politicians, from King George III to George
Dubya / Edward J. Lordan.
 p. cm.
 Includes bibliographical references and index.
 ISBN 0-7425-3638-6 (pbk. : alk. paper)
1. United States—Politics and government—
Caricatures and cartoons. 2. Politicians—United
States—Caricatures and cartoons. 3. Political
cartoons—United States. 4. Editorial cartoons—
United States. 5. Cartoonists—United States—
History. 6. American wit and humor, Pictorial.
I. Title.
E183.L655 2006
320.973'02'07—dc22

 2004029565

Printed in the United States of America

♾™ The paper used in this publication meets
the minimum requirements of American
National Standard for Information Sciences—
Permanence of Paper for Printed Library
Materials, ANSI/NISO Z39.48-1992.

Satire, the saying goes, is about afflicting the comfortable and comforting the afflicted.

This book is dedicated to my parents: Robert E. Lordan, who taught me to treat the powerful with skepticism, and Marie Fischer Lordan, who taught me to treat the powerless with compassion.

CONTENTS

PREFACE

The cartoon is perhaps "the most powerful corrective tool, the form of censure employed most by the oppressed against their oppressors, by the weak against the strong . . . and even by moralists against the corrupt."[1]

JACINTO OCTAVIO PICON

WHAT EXACTLY *is* an editorial cartoon?

To many readers, it's a daily source of minor amusement, a welcome respite from the drudgery and woe reported in the other sections of the newspaper. To others, it's a critical tool in framing public opinion on the most important people and issues of our times. To the subject of the cartoon, it can seem to be a scathing, irresponsible form of attack, one that twists the subject's positions and holds them up to unjustified ridicule. To the cartoonists themselves, it can be the most wondrous form of expression, the ideal hybrid of art and commentary. Legendary cartoonist Herbert Block said, "the political cartoon is not a news story and it's not an oil portrait. It's essentially a means for poking fun, for puncturing pomposity."[2]

As long as there has been antiauthoritarianism, there have been editorial cartoons (see figure on page x). Since the earliest days of political commentary, editorial cartoonists have skewered the powerful and defended the powerless.

It takes more than antiauthoritarianism for editorial cartooning to flourish, however. Five different components must come together:

1. *A subject of ridicule.* This subject is almost always a powerful figure in society. The subject is usually political, but can also come from business, social, religious, or other institutions.
2. *Negative perceptions of the subject.* The subject is accused of some form of abuse, chicanery, inconsistency, immorality, or pomposity. Each of these perceptions makes excellent fodder for the editorial cartoon, some more than others. (Many cartoonists consider the best target for editorial cartoonist fodder to be hypocrisy.)
3. *A creative mind mixed with artistic talent.* It's not enough to demonstrate the foibles of the powerful—it is necessary for an editorial cartoonist to use humor to *capture* and

demonstrate the core of the issue in a memorable way.

4. *Medium for distribution.* Even the strongest message is useless unless it can be distributed. The editorial cartoonist needs a medium, not only to make a living, but to get out his or her message.

5. *An audience to appreciate the message.* The sole purpose of many other forms of cartoons is entertainment, but the goals of the editorial cartoon go beyond simple amusement. It educates, persuades, stimulates intellect and emotions. Therefore, the cartoonist requires an audience capable of decoding the cartoon's message. This decoding may require extensive knowledge of current events as well as at least a cursory familiarity with history or literature. The editorial cartoon requires a relatively sophisticated audience to be successful.

Some form of all five of these ingredients has been available since the American Revolution, but each has undergone a tremendous transformation

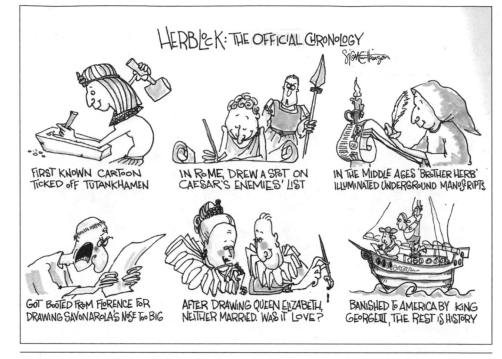

"Herbock: The Official Chronology" by Signe Wilkinson (*Philadelphia Daily News,* 2000)

during the life of the country. During some periods, such as the closing decades of the nineteenth century, all five elements came together in an amazing convergence, resulting in political cartoons powerful enough to have fundamentally altered the news process, American perceptions, even the politics of the nation. During other periods, such as the decade following World War II, the evolution of these ingredients worked in the opposite direction, severely reducing the impact of editorial cartoons.

This book traces the history of editorial cartoons by looking at each of

these five elements. It examines the American political cartoon from the earliest artistry of Benjamin Franklin to the talking caricatures of political figures that populate the Internet today.

The book is divided into two sections. Part I, the first five chapters, is a chronological review of the development of the editorial cartoon in America. These chapters highlight the artists, events, and technological and social developments that explain the evolution of this form of expression. Part II, chapters 6 through 9, focuses on the editorial cartoon in the modern world. It includes an examination of the process of cartooning as well as the people who draw and read the cartoons, along with predictions about the future of editorial cartoons in America. Part II also includes a chapter called "In Their Own Words," which consists of quotations from leaders in the industry about their profession.

A word of warning: most political cartoons are local and time sensitive, so the further the reader is from the time and place of the cartoon's creation, the more challenging it is to grasp its subtleties. Cultural context is often important when trying to appreciate subjects or images used by cartoonists from generations ago. Imagine, for example, if a reader two hundred years from now were to view a 2004 cartoon in which Homer Simpson poked fun at Bill Clinton's libido. Whenever possible, I have tried to explain the social or political environment for these cartoons so that, I hope, you can appreciate their value in the context in which they were created.

A lot of people made this book possible. I have had the honor of talking with a number of American editorial cartoonists who gave me their time and thoughts about their profession, and these contacts have only increased my appreciation of their talents and the contribution they make to public discourse. The profession is filled with vibrant, charitable people who not only agreed to interviews, but also connected me with additional sources and encouraged me to complete the project. These cartoonists include Signe Wilkinson, Mark Fiore, Draper Hill, Bruce Plante, Wayne Stroot, and V. Cullum Rogers. The staffs at the Francis Harvey Green Library at West Chester University of Pennsylvania and the Library of Congress in Washington, DC, responded quickly and professionally to each of my many requests. Many family members, Chollets and Lordans, encouraged me by expressing interest in this project. Jim O'Donnell rescued me during computer failures and Darlene McAnally helped by creating extra time for me to do research. My wife, Mary Chollet Lordan, listened patiently to my many conversations with myself during the two and a half years spent researching and writing. My patient and diligent editors at Rowman & Littlefield, Brenda Hadenfeldt, Erica Fast, Jehanne Schweitzer, and Bevin McLaughlin, spent countless hours guiding me through the laborious production process. Finally, my thanks to two major influences on my appreciation of humor: the Mountain Trip guys and my sons, Daniel and Brendan, who fill my life with laughter.

PART I

The History of American Political Cartoons

From the earliest political artwork of Benjamin Franklin in 1747 to the cartoon tributes to terrorism victims in September of 2001, political cartoons have always expressed the deepest feelings of the American people. Sometimes these cartoons make us laugh, sometimes they make us cry, but the best ones always make us think.

Part I of this book traces the history of the editorial cartoon in America. It is a history of large issues—literacy rates, technological innovation, immigration—that have significantly influenced the cartoon's development. At the same time, it is a history of individuals— artists, politicians, and media leaders who helped shape this unique form of political expression.

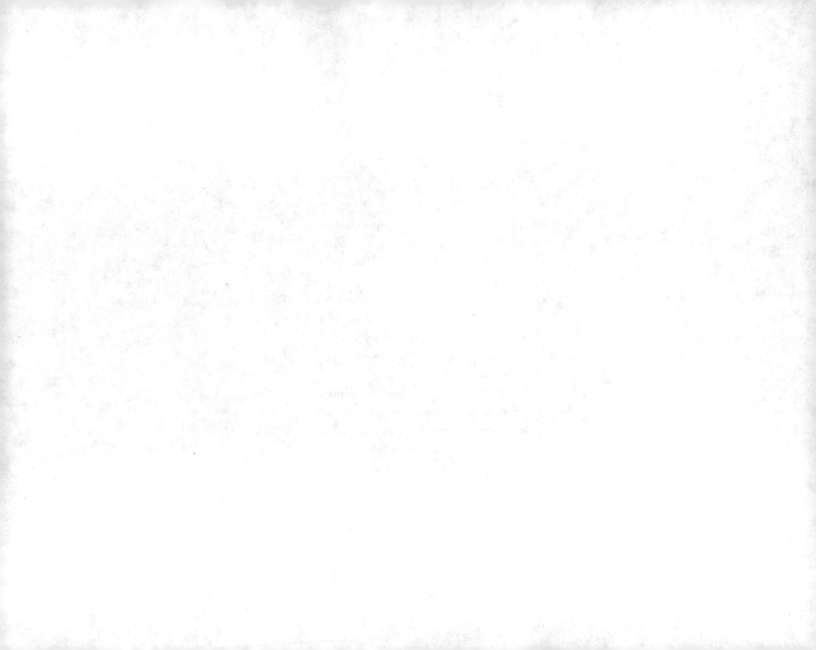

ONE

Cartoons and the Birth of the Nation

1740 to 1785

The cartoonist, however negligible his artistry, is more likely to impress in . . . a campaign of hatred than even the mob orator and the columnist.[1]

E. H. GOMBRICH

Cartooning is not merely a passive reflection of the public spirit, but rather contributes to building that public spirit in powerful ways. It is where the political imagination is created.[2]

MICHEL VOVELLE

THE BIRTH OF political satire in America has its roots in the death of an even more powerful institution in England: the concept of the "infallible king." Prior to George III's ascendancy to the throne in 1760, the common assumption in a monarchy was that the king (if not the actual person who held the crown) was incapable of wrong. Unfortunately for George III, a spirit of rebellion was emerging on both sides of the ocean, and he would become its primary target. By the time American colonists started using political cartoons to protest against the English crown, they had amassed a wealth of antiauthoritarian examples to use as models—most of them from England itself.

The political cartoon began in America because of the confluence of three disparate factors in the mid-eighteenth century: the rapid increase in the colonial population, the establishment of print media in the colonies, and a series of tumultuous political developments in Europe and the colonies. These factors helped launch the earliest colonial political cartoonists, men like Benjamin Franklin and Paul Revere, and, in the process, helped inspire the American Revolution.

Colonial Growth: Population and Literacy

The audience for printed materials in the American colonies grew significantly in the mid-1700s (see table 1.1), with the colonial population more than doubling between 1740 and 1770. The most explosive growth occurred in the colonies' largest cities, such as Boston, New York, and Philadelphia, which was convenient for the distribution of printed materials.

It was not only the size of the colonial population that grew, but the literacy rate as well. While literacy was not the sole determinant of access to news during the colonial period—it was common practice in many taverns and other public places for literate people to read newspapers aloud to those who had gathered—there is no question

Table 1.1

Population Growth in the American Colonies

Year	Estimated Population
1740	905,600
1750	1,170,800
1760	1,593,600
1770	2,148,100

SOURCE: Learning Network, InfoPlease, "Colonial Population Estimates," 2005, at www.infoplease.com/ipa/A0004979.html.

that literacy affected the sale of printed material. As William Gilmore-Lehne notes, the majority of colonists were capable of reading by the middle of the century:

Among the regions and for European Americans, literacy was highest in New England, and uniformly high: reaching an average of about 75% for males and 65% for females by 1750. Moreover, female reading levels reached higher levels than among women who remained in England. In the Mid-Atlantic literacy levels varied widely, though at the high end, they nearly matched New England levels for males. Literacy progressed much more slowly throughout the South, with male levels hovering around 50%–60%, and female levels no more than 40% except among the elite During the Revolutionary Era and Early Republic, basic literacy—the rudiments of active cultural participation—for settlers from European countries rose sharply in New England to very high though not universal levels.[3]

The Growth of the Print Media

Historian Charles Press notes a pattern in the distribution of political caricature in democratic societies. Specifics such as space and time have varied, but generally the political caricature has first been carried through general print systems (cards, posters, etc.), then through magazines, and eventually through newspapers.[4] This was as true in the American colonies as it had been in England. As the colonial population and appetite for news grew, print shops in the largest cities sprang up to meet the demand. These shops printed and distributed the latest news through broadsides, pamphlets, and newspapers.

Broadsides were useful for their simplicity, portability, and saturation coverage. Their content ranged from the simple—the announcement of an event such as a sale, speech, or ship arrival—to the complex—a full-page editorial about a key issue of the day. Broadsides were relatively inexpensive to produce and distribute, so that a printer could assemble information, print it, and get it out to a large area rapidly, and a reader could easily carry a number of broadsides simultaneously.

Pamphlets were more complex and expensive. Ranging from eight to nearly a hundred pages, pamphlets were used to distribute more lengthy, and frequently more serious, content than broadsides. Religious tracts and church proceedings, lengthy government proclamations, complex and nuanced political positions, scientific findings, and histories were all transmitted through this medium.

Newspapers grew in number and influence throughout the colonies in the middle of the 1700s (see table 1.2), with a fourfold increase between the 1740s and 1770s. The most dramatic

growth, in the middle of the 1760s and the early 1770s, was both a response to unpopular decisions by the British government, such as the Stamp Act of 1765, and a reaction to the explosive growth in commerce and populations in the major seaboard cities during this period.

It was important not only *how many* colonial newspapers there were, but also *who controlled* their production and the *primary purpose* of each publication. Colonial newspapers began exclusively as instruments of the government, as Gilmore-Lehne points out:

In each British North American colony, the first printing office was established by the Governor and legislative apparatus. Its chief purpose was to publish materials supporting the government's official public communications arena. Aside from these specialized ventures, most subsequent print centers commenced printing and publishing with a weekly newspaper. This had become a regular practice by the mid-1760s, earlier in colonies with the longest tradition of printing.[5]

Table 1.2

Growth of Newspapers in the American Colonies

Decade	Number of Newspapers	Number of Communities with Newspapers
1740s	19	7
1750s	28	13
1760s	45	18
1770s	89	35

SOURCE: Adapted from William J. Gilmore-Lehne, "Communications History: United States, 1585–1880; Visual Essays and Images for Teaching/Research in History and American Studies," at www.stockton.edu/~gilmorew/0amnhist/comuhis1-4.htm.

Over time, however, printers began to view the newspaper as an additional source of income and not simply as an official organ of the state. Three-fourths of the master printers in the colonies from 1700 to 1765 attempted to print newspapers. Unfortunately for those printers, the venture didn't necessarily ensure financial stability. Painstakingly detailed work, presses that produced a maximum of 250 impressions an hour, and a general lack of resources, including paper and ink, made newspaper production difficult.[6] Press runs were limited—at most three hundred copies of a newspaper in the first half of the century, up to as many as eight hundred copies by 1765.

The laborious printing process also made it difficult for printers to include anything other than text in broadsides, pamphlets, and newspapers. Artwork of any kind was rare in a newspaper, and most caricatures and cartoons of the time were etched into copperplate, a time-consuming process. Printers had made significant progress since earlier in the century, when carved wood-blocks were required to reproduce drawings, but the engraving methods used in the colonial period were still crude and time intensive.

Since the combination of graphic and text was so complex, the earliest political cartoons often stood on their own. The modern political cartoon is usually one element of a large, information-packed editorial page. This creates limitations, and opportunities, for the editorial cartoonist. The modern political cartoon can explain or comment on the news that surrounds it. By

contrast, a cartoon from an eighteenth-century broadsheet was often unadorned and context free. Combine this challenge with crude and cumbersome production methods, and it is easy to see why cartoons were few and far between.

With their close connection to the government, it made good economic sense for print shops to avoid printing controversial, subversive, or antiauthoritarian messages. In the first half of the century, most colonial papers shied away from editorial comment. When they weren't printing the official position of the government, they printed straight news, a great deal of it commercial, including dispatches from ships entering local ports. This practice helped the papers avoid alienating any potential readers or, later, advertisers. Printers assumed a more political orientation in the 1750s and 1760s, however. As the political situation in the colonies became more volatile, the content of newspapers began to take on a decidedly partisan tone. As colonists began to feel more threatened, first from the west, by the French and Indian conflicts, then from the east, by increasing taxation and regulation on the part of England, papers began to promote specific political perspectives, either protesting or defending the British crown.

King George: An Easy Target

While an emerging press served an increasing and increasingly literate colonial population, two key elements were still needed for political cartooning to take root: a target for ridicule and a sense of injustice. By the mid-1700s, colonists had both, the latter in abundance.

The target for their wrath was the English government, conveniently personified by that government's figurehead, George III. If many colonialists were hardscrabble risk takers who thrived on hard work in harsh elements, the king of England was their opposite: his rule, which began in 1760, was the result of birthright, not his own efforts, and he had a well-deserved reputation as a manipulative leader who surrounded himself with a hand-

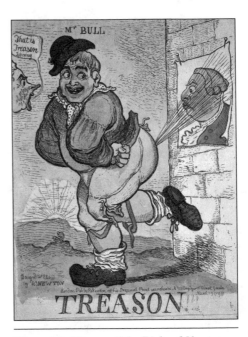

Figure 1.1: "Treason!" by Richard Newton (March 19, 1798)

picked collection of sycophants. Furthermore, as his reign progressed, his mind regressed: as early as 1765 George began showing signs of porphyria, a mental illness that eventually led to madness. As the king's mental illness worsened, his behavior and language became increasingly bizarre, again providing material for humorists

at home and in the increasingly rebellious colonies. If his imperiousness and eccentricity weren't enough fodder for political cartoonists, King George was also obstinate and somewhat less than brilliant, qualities that made him even easier to lampoon.

Figure 1.1 captures the attitude of one ribald cartoonist, Richard Newton, toward the king. The cartoon employs two important characteristics of political cartooning: the use of icons (John Bull, symbolic of England) and the threat of political retribution for lampooning powerful public figures. Figure 1.2 shows a slightly more sophisticated but equally insulting view of the king. Here he is portrayed as an ineffective and overly emotional leader, weeping in the doorway while his dukes and lords argue politics at a table before him.

As for the sense of injustice, the conclusion of the Seven Years War between France and England in 1763 resulted in two decisions by the English government that permanently alienated many American colonists. First, George III forbade colonists to occupy

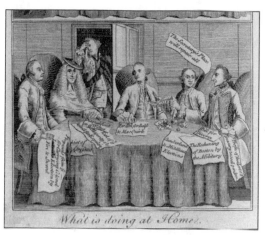

Figure 1.2: "What may be done Abroad. What is doing at home." (Lower half of the cartoon is shown.) Artist unknown. Designed and engraved for the *Political Register* (April 16, 1769)

the Ohio Valley, land for which colonial and English soldiers had fought side by side. Second, the British parliament voted to pay for the costs of the war through a series of increasingly onerous taxes on colonial activity: the Stamp Act in 1765, on paper, legal documents, newspapers, even playing cards; the Townshend Act in 1767, on sugar, glass, paint, and molasses; finally, the Tea Act of 1773, on a staple in every colonial household.

Colonists were so incensed by the actions of the crown that when they formally listed their grievances, in their Declaration of Independence in

1776, the majority of the document was a catalog of George III's worst transgressions. Some grievances were economic: "Cutting off our trade with all parts of the world." Others addressed basic freedoms: "Depriving us in many cases, of the benefits of trial by jury." And some were simply complaints about too much government: "He has erected a multitude of new offices, and sent hither swarms of officers to harass our people, and eat out their substance." All added up to a general sense of oppression and exploitation that covered all aspects of life in the New World. Colonial outrage was com-

pounded by the king's reaction to these complaints: George III was intolerant of dissent, particularly from upstart colonists.

Cartoonists Come of Age: Franklin, Friends, and Foes

In a sophisticated society such as London in the mid-1700s, an artist might be able to find work full-time creating caricatures. In the two-man print shops of the American colonies, however, no man could make a living off of caricature only. Therefore, cartooning in the American colonies evolved decades after it had been established in England.

Printers wore many hats: editor, artist, salesman, typesetter, and so on. The colonist most comfortable with the multiple roles of the printer/newspaperman was Benjamin Franklin (who could add postmaster, librarian, insurance agent, and scientist to his list of occupations as well). Franklin had been apprenticed to his brother, James, printing the *Boston Gazette* in his hometown and, later, worked with An-drew Bradford and the *American Weekly Mercury* in Philadelphia. His familiarity with both of the colonies' principal cities, as well as his involvement in the major literary and political circles of the time, gave him a unique perspective on colonial issues.

It comes as no surprise, then, that the first political cartoon in America and the first political cartoon printed in an American newspaper were both created by Benjamin Franklin.

His first cartoon, "Non Votis," or "The Waggoneer and Hercules," appeared in his pamphlet *Plain Truth* in 1747. In the woodcut, Hercules declines requests for help from a wagoneer whose wagon is stuck in mud. The English translation of the Latin inscription accompanying the cartoon reads, "Not by offerings nor by womanish prayers is the help of gods obtained." A more modern interpretation of the message could be "God helps those who help themselves"—Franklin was urging his audience, the Pennsylvania Quakers, to put aside their religious beliefs and take up arms against Indians.

In his autobiography, Franklin writes:

> I determined to try what might be done by a voluntary Association of the People. To promote this I first wrote & published a pamphlet, intitled *Plain Truth*, in which I stated our defenceless Situation in strong Lights, with the Necessity of Union & Discipline for our Defence, and promis'd to propose in a few Days an Association to be generally signed for that purpose. The Pamphlet had a sudden & surprising Effect.[7]

Franklin's call to arms is not against British troops; in fact, at this time, and for many years after, Franklin and most of his colleagues considered themselves citizens of England as well as citizens of the colonies. Here, the appeal is to unify against French and Indian forces. It would be more than a decade before Franklin, and those who shared his view of the world, would begin to perceive the British crown as the real nemesis in America. Regardless of the enemy, however, a strong theme was evident in Franklin's work: a call

Barbs in Britain's Backyard—English Cartoonists Also Protested George III—and His Enemies

As if King George III and his contemporaries didn't have enough trouble in their futile attempt to quell colonial rebellion, they had plenty of detractors back home as well. Three cartoonists—James Gillray, James Sayers, and Thomas Rowlandson—made careers out of lampooning British aristocracy.

James Gillray was apprenticed to a letter engraver but had been formally trained at the Royal Academy of the Arts. His early work was more social than political, but he eventually evolved from social critic to government gadfly. His *George the Button-Maker* and *Farmer George* series, both focusing on the king, were particularly popular. Gillray frequently depicted the king as a dupe and a fool, unaware that his opponents—and confidantes—were stealing his authority. Ironically, Gillray's later life paralleled that of his favorite target: he spent his final years battling insanity.

The king made an inviting target, but he wasn't the only figure in the British government to be satirized. Cartoonists Thomas Rowlandson and James Sayers focused on Charles James Fox, a leading minister and no friend of George III, helping turn popular opinion against Fox's coalition and strengthen the king's political position.

Rowlandson, like Gillray, studied art at the Royal Academy, before opening a portrait shop. His work evolved from portraiture to journal art to book illustration to lithography. Over the course of his career, his political stances and gambling habits led him to legal troubles. Sayers, on the other hand, lived well off the earnings of his etchings. His motivation was far more political than economic: he was a strong supporter of Fox's opponents.

Historian David Johnson notes that the mid- to late 1700s were flush times for political cartoons in England:

Despite their cost (sixpence uncoloured and from one to two shillings for a hand-coloured print) there was a significant increase in output during these years. An average year in the 1770s might produce fifty political prints, but there were 120 in 1782, and some 450 published within the twelve months of the Fox-North coalition, the King's attempt to remove it and the general election of 1784. Most of these were anti-coalition, and increasingly, anti-Fox. A print run of between 500 and 1,500 was normal, and where two identical plates were used 3,000 was possible. Displayed in the print shops of London and Westminster where a daily visit was part of the social routine for men of fashion, they also provided a free gallery "for the gaping multitude." Increasingly, too, they reached country towns and foreign markets, while they could be purchased from hawkers, or even by mail order. Often there were pirated versions, cheap reprints and reduced copies. In addition to appearing in collections and exhibitions, prints were commonly displayed in men's rooms—smoking and billiard rooms, barbers, inns and brothels.[a]

These cartoonists not only influenced popular opinion about the political issues and personalities of their times, they also fundamentally altered the way political cartoons were drawn. As Johnson notes, they "were instrumental in developing a new style of caricature which turned away from emblematic and wordy representation to a real, if exaggerated, depiction of persons and events. Largely without labels and verbal keys, they were witty and pungent commentaries."[b] The work of these English artists would impact that of their American counterparts for decades: not only would colonial revolutionaries mimic the drawing and design of the famous English caricaturists, but, in many ways, they would borrow their humor as well. ∎

for unity among the colonies to promote their interests, and a call to arms to protect those interests.

Franklin's first newspaper cartoon appeared in the May 9, 1754, edition of his *Pennsylvania Gazette*. The cartoon, called "Join, or Die," (figure 1.3) also attempted to persuade his fellow colonists to band together in defense

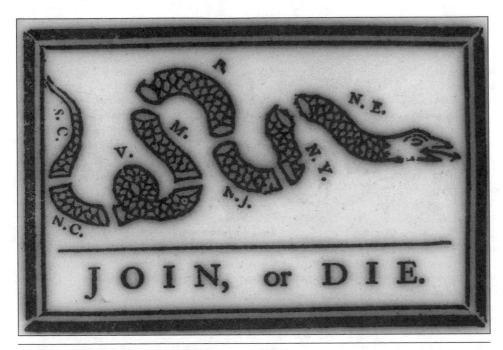

Figure 1.3: "Join, or Die" by Benjamin Franklin (1754)

against French and Indian forces. In the article, Franklin describes the hundreds of Indians and French soldiers pillaging and destroying villages in the western part of the colony, along with the murdering and scalping of families in Virginia.

Franklin selected a symbol that would be easily understood by his audience and would also reflect the drama and imminent danger he envisioned. He chose the image of a snake hacked into eight sections, based on the superstition that a severed snake can reconnect itself. The image is far cleaner and more professional than Franklin's "The Waggoneer and Hercules" cartoon: over time, Franklin had improved as a cartoonist.

Within a month of publication in Franklin's paper his cartoon had been reproduced in every significant newspaper on the continent. To some degree, the widespread use of the cartoon helped Franklin spread his message. But the image was also co-opted for other purposes—a frustrating practice that cartoonists would be forced to live with for decades to follow. Printers would borrow Franklin's image to urge unity in response to a range of real and perceived attacks: Indian incursions, the Stamp Act, British oppression. Twenty years later, Boston publisher Paul Revere would go so far as to incorporate the "Join, or Die" snake image into the masthead of Isaiah Thomas's triweekly *Massachusetts Spy* (figure 1.6); for nine months, the publisher coupled the snake with a dragon representing Great Britain.

By 1774 Franklin was employing another cartoon, "Magna Britannia; Her Colonies Reduced" (figure 1.7) to embody his political perspective. Historians differ as to whether Franklin actually drew the image, but there is no question that he distributed it widely

The Snake Sheds Its Symbolic Skin

If you were selecting an icon to represent the best qualities of your country, would your first choice be a snake? (Keep in mind that Benjamin Franklin had other unusual ideas—he also lobbied to make the turkey the national bird.)

In the "Join, or Die" cartoon, the snake image worked because it was based on a mythology common to the era: the mistaken assumption that a severed snake could be brought back to life if reassembled. But snakes came with heavy baggage: for thousands of years they had been associated with sinister activity and treachery, and were often used as the archetype of evil.

The negative implications were not lost on Franklin's opponents. Stephen Hess and Sandy Northrup note that:

> Having the American revolutionaries depict their cause as a dissected snake was thought a good joke by one pro-British editor, James Rivington, who published this verse in his New York Gazetteer:
>
> > Ye sons of Sedition, how comes it to pass
> > That America's typed by a snake-in-the-grass?[a]

The snake image was useful because it was both recognizable and versatile — cartoonists could employ it in a variety of situations. Anti-British editors in the American colonies co-opted the severed snake image eleven years later, to protest the Stamp Act, and in 1776, to urge colonial unity—not against the French and Indians, but against the British.

The snake image even traveled across the Atlantic Ocean: in 1782, English illustrator James Gillray, poking fun at English rule, used Franklin's colonial snake to create a vastly different impression (figure 1.4). Franklin's image was a desperate, severed reptile clinging to its life, but Gillray chose to draw the colonial snake as a powerful, deadly serpent coiling around the British troops of Cornwallis and Burgoyne.

That same year, Gillray portrayed the American snake with other animal images (Spain as a spaniel, France as a fighting cock, and Holland as a pug dog) in a fight against the British lion (figure 1.5). "I will have America and

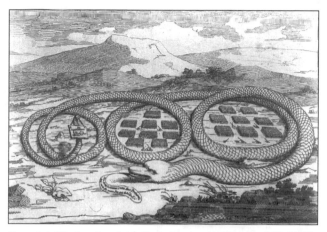

Figure 1.4: "The American Rattle Snake," by James Gillray (April 12, 1782)

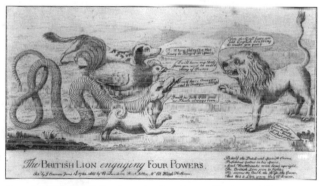

Figure 1.5: "The British Lion Engaging Four Powers," by James Gillray (June 13, 1782)

be independent," says the snake. "You shall all have an old English drubbing to make you quick," responds the lion. Gillray's first image proved to be prescient, his second overly optimistic. ∎

in his travels. The cartoon employed
another severed figure to demonstrate a
land in crisis; but instead of represent-
ing the colonies with a snake, this car-
toon used a pitiable image of Britannia
with her limbs, labeled as the colonies,
severed from the main body. The figure
of Britannia is far more detailed and
poignant than the earlier snake image.
The background includes British ships
with brooms instead of masts, symbol-
izing that they are for sale, and the
foreground includes a withered oak
tree, a symbol of England. The motto
within the cartoon, "Date Obolum Bel-
lisario," is a historical reference to a
Roman general who imposed Rome's
will on distant provinces but died in
poverty.

The imagery wasn't the only ele-
ment that had switched: Franklin was
reaching out to an English, not a colo-
nial, audience. Stationed in London at
the time, he represented the interests
of Pennsylvania and, more generically,
the colonies as a whole. At this time he
still felt that the relationship between
the colonies and mother England ulti-
mately benefited both sides. "Magna

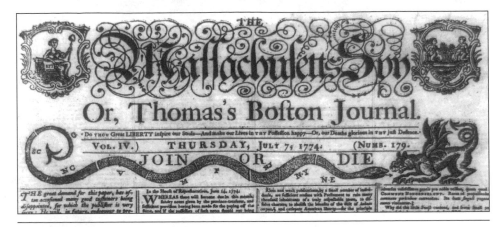

Figure 1.6: Masthead for Isaiah Thomas's *Massachusetts Spy* (1770–1775)

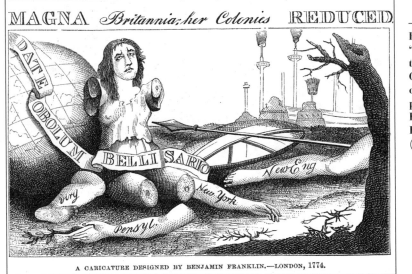

Figure 1.7:
"Magna Bri-
tannia; Her
Colonies Re-
duced,"
probably by
Benjamin
Franklin
(1774)

Free Flow of Ideas, Unencumbered by Copyright

Technological limitations made the mass production of political cartoons difficult in the eighteenth century, but printers did not have to deal with another potentially limiting aspect of cartooning: legal restrictions.

Copyright law was established in England through the Statute of Anne in 1710, providing authors with an initial fourteen-year term of protection and a renewal term of the same length. In 1735, the Hogarth Act gave the same fourteen-year protection to engravers. Unfortunately, similar legal protection of intellectual property never took hold in the American colonies. "It would not be surprising . . . if there were no concern about copyright in the early colonial days," notes historian Maurice J. Holland. "There were few professional authors, although certainly newspapers and gazettes and government documents and the like were published."[a] Holland notes that the Continental Congress recommended, but did not require, the adoption by each of the colonies of a copyright statute modeled on the English version. Although many colonies did develop statutes, they included caveats that copyrights would apply only if all the colonies passed such regulations—since this never happened, the protection was useless. Real copyright protection wouldn't exist in America until the first United States Congress passed legislation in 1790.

The cost of creating an original was a strong incentive to "borrow" from others: etchings were time consuming and expensive, and publishing was, at best, a break-even business venture for many printers. With no threat of copyright infringement penalties, colonial newspaper editors and pamphleteers were constantly on the lookout for high-quality, and essentially free, material. Clever ideas and good artwork were co-opted or reproduced in their entirety with no thought of attribution or retribution. Franklin's "Join, or Die" concept, for example, was applicable to any situation calling for unity—it could apply to a jurisdictional dispute in Maryland, an argument against tariffs in Massachusetts, or a town watch program in a local community. As a result, it is difficult to determine the precise origin of many of the era's political cartoons: lesser-quality efforts disappeared, while the best were so widely copied and distributed that identifying the "author" has become somewhat subjective. ∎

Britannia" was his plea to Britain to work diplomatically as opposed to militarily, to resolve the growing crisis with the colonies, and as a reminder of what happened to great empires that overreached. Franklin arranged to have it printed in English newspapers for a general audience, but also had it printed on small cards that he handed out to influential individuals whom he thought might help steer the king and Parliament away from additional arrogant actions. Ultimately, Franklin's message went unheeded, and two years later, the colonies broke free of England.

By now Franklin had risen from local printer to international statesman. He voiced strong opinions on all of the controversial issues of the day: the tax structure, education and the Penn family, proprietors of the Commonwealth. Franklin's views on public education were as unorthodox as his positions on other issues, and there was no love lost between Franklin the populist and the aristocratic heirs of the estate of William Penn. Because he took such strong public stands on these issues, it was only a matter of time before this

influential American moved from being the first colonial publisher *of* cartoons to being one of the first colonial caricatures *in* cartoons. As historian Sinclair Hitchings points out:

> A few people in every age become popular symbols. No man was more fully taken into the mind of humanity in this way than Benjamin Franklin as a symbol of the culture which had developed in England's North American Colonies. His homely likeness, his scientific achievements, his simplicity, worldliness and charitable nature were known throughout Europe. As a symbol of common sense, practicality, inventiveness, and down-to-earth accomplishment, he also symbolized the aspirations of Americans.[8]

Alas, many editors of Tory papers didn't view the American icon as positively. They savaged Franklin and his positions, depicting him as two-faced, conspiring with the devil, and so forth. Some cartoonists even used Franklin's world-renowned scientific experiments to poke fun at his political activity: the upper right-hand corner of figure 1.8 depicts Franklin's infamous kite-and-key experiment, but the tail of this kite is bound with a string of petitions to the English court. The image is a clever combination of two aspects of Franklin's personality: his scientific inquisitiveness and his enthusiasm for political progress. The politics of Pennsylvania at the time were thick with competing factions, from militiamen to Quakers to merchants to loyalists, and it is no surprise that Franklin, in the midst of so many major issues, would be attacked by competing groups.

A decade after the first appearance of Franklin's "Join, or Die" cartoon, colonists rioting in protest of the hated Stamp Act would resurrect the cartoon's caption to support their own cause. The simple three-word caption, originally intended as a plea for unity, was now reinterpreted as a less-than-subtle threat by mobs so incensed by the new tax that they burned down the homes of local tax officials. By that time, Franklin was in England, attempting to plead the colonial case and find room for compromise—the polar-

Figure 1.8: "Political Electricity; or, An Historical and Prophetical Print in the Year 1770," artist unknown (1770)

izing effect of his slogan had come full circle to work against him.

Boston Cartoonists Go on the Attack

While Franklin was introducing cartoons to readers in the mid-Atlantic region, another revolutionary figure was doing everything he could to foment dissent in the Boston area. Paul Revere, a self-taught silversmith, used his engraving talents to develop a number of renderings, caricatures, and cartoons designed to protest the presence and policies of the British in the American colonies. In the 1760s, he drew protests of the Stamp Act and unflattering caricatures of members of the House of Commons. Along with Franklin, Revere would emerge not only as a leader in the American Revolution, but as a master propagandist who used his cartooning skills to protest English actions and promote revolution.

The British Parliament could live with malcontents in the far-off American colonies: when the colonists began to boycott English goods and damage mercantile interests in London, however, the effects of their protests came closer to home. Economic pressure

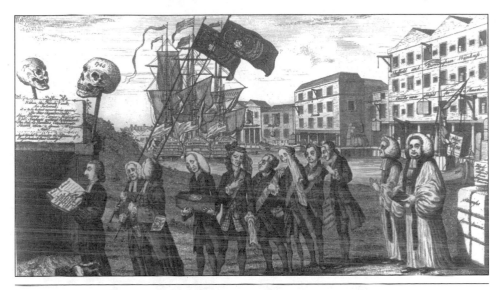

Figure 1.9: "The Repeal. Or the Funeral Procession of Miss Americ-Stamp," by Benjamin Wilson (1766)

combined with political protest, and when the Stamp Act was finally repealed in March of 1766, political cartoonists celebrated by skewering anyone connected with the hated legislation. Figure 1.9 shows Benjamin Wilson's pitiless depiction of the act's demise: a funeral procession for the act, populated with legislators, lords, and clergymen associated with its creation. At the head of the line is Dr. William

Scott, who had written many pro-Stamp Act editorials under the pseudonym "Anti-Sejanus," a funeral speech in his hand and a dog urinating on his leg. The act itself, only a year old, is symbolized by a child's coffin. Empty wharves serve as a backdrop and reminder of the diminution of trade along the Thames.

The repeal was the most temporary of victories, however, because it was ac-

The BLOODY MASSACRE perpetrated in King — Street BOSTON on March 5 1770 by a party of the 29 REG.t

Unhappy BOSTON! see thy Sons deplore,
Thy hallow'd Walks besmear'd with guiltless Gore:
While faithless P—n and his savage Bands,
With murd'rous Rancour stretch their bloody Hands;
Like fierce Barbarians grinning o'er their Prey,
Approve the Carnage and enjoy the Day.

If scalding drops from Rage from Anguish Wrung
If speechless Sorrows lab'ring for a Tongue
Or if a weeping World can ought appease
The plaintive Ghosts of Victims such as these;
The Patriot's copious Tears for each are shed,
A glorious Tribute which embalms the Dead.

But know, Fate summons to that awful Goal,
Where Justice strips the Murd'rer of his Soul:
Should venal C—ts the scandal of the Land,
Snatch the relentless Villain from her Hand,
Keen Execrations on this Plate inscrib'd,
Shall reach a JUDGE who never can be brib'd.

The unhappy Sufferers were Mess.rs SAM.l GRAY SAM.l MAVERICK, JAM.s CALDWELL, CRISPUS ATTUCKS & PAT.k CARR
Killed. Six wounded; two of them (CHRIST.r MONK & JOHN CLARK) Mortally

Engrav'd Printed & Sold by PAUL REVERE Boston

Published in 1770 by Paul Revere Boston

Figure 1.10: "The Bloody Massacre," by Paul Revere (1770)

companied by an equally offensive piece of legislation—the Declaratory Act, affirming the right of the British government to pass legislation that was legally binding in the colonies. Colonists interpreted any such legislation as unacceptable taxation without representation. Clearly, the conflict between the two sides was destined to escalate.

In 1770, the differences finally led to bloodshed, at the Boston Massacre. The shootings proved to be a propaganda bonanza for the revolutionary forces. A mere twenty-one days later, Paul Revere began distributing copies of his version of the event (figure 1.10) through broadsides, advertising their availability in Boston newspapers. Revere allegedly based his work on the drawings of Henry Pelham, an act of plagiarism that must have frustrated the original artist twice over: not only was Revere able to produce and sell his version before Pelham could bring his original work to market, but Pelham was a loyalist who supported the crown. Clearly, Revere did not. Historian Thomas Leanord catalogs the discrep-

ancies between Revere's engraving and reality, all of which conveniently favor the revolutionaries:

The number of soldiers was wrong. The list of mortally wounded was wrong. One martyr, Crispus Attucks, was transformed into a white man in this colored engraving. Revere hid facts that even the survivors acknowledged in their testimony only a few days after the shooting. Citizens were depicted without the clubs they had used to worry the soldiers. The patriots claimed only that the Redcoats fired at will; Revere had them shooting simultaneously, with Captain Thomas Preston apparently in control. Few eyewitness accounts maintained that shots had come from the Custom House. Revere found the idea of secret assassins too good to resist and put a smoking rifle in the second-story window, trained on the street. The Custom House, that symbol of hated legislation and vile importers, was labeled "Butcher's Hall."[9]

Four years later, Revere would use

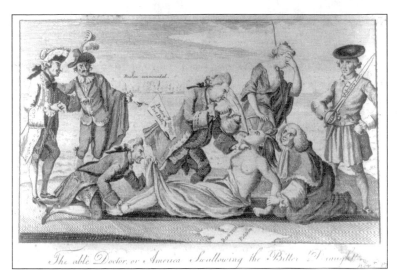

Figure 1.11: "The Able Doctor, or America Swallowing the Bitter Draught. Protest of the Boston Port Bill and the Closing of the Port," by Paul Revere (1774)

another engraving to rail against the tax on tea and the British closure of Boston Harbor, creating an image that was as disturbing as his depiction of the Boston Massacre: a group of bawdy Englishmen attacking a helpless, half dressed woman symbolizing America (figure 1.11). Revere's drawing includes a leering Lord Sandwich, the admiral of England's navy, simultaneously holding down and looking up America's legs, while a repugnant British prime minister, Lord North, forces the "bitter draught" of tea (and taxes)

down her throat. France and Spain look on, unwilling to intercede, while Britannia turns away.

Revere's approach to the political cartoon demonstrates three principles that are still, to some degree, relevant today. First, Revere's fast and loose retelling of each story demonstrates that objectivity and a strict adherence to reality are merely obstacles to be overcome for a cartoonist intent on making a point. Second, the propagandist is most persuasive when simplifying a complex issue and using strong,

English and American Humor—Differences in Substance and Style

There is no doubt that the American political cartoon emerged from the tradition of the political caricature in England. But is it possible that, at their core, the English and Americans have fundamentally different senses of humor? Consider the words of Thomas Craven, editor of *Cartoon Cavalcade* (and, admittedly, an American):

> I have always thought that the Americans are the funniest people on earth. . . . The old-fashioned Englishman who still esteems the senescent *Punch* as the crowning attainment of Anglo-Saxon culture cannot be expected to appreciate the deep ventral humor of our graphic jokesters. It is too rowdy and unrefined for him. . . . Nor can the rough-and-tumble American with irreverence bred in his bones be expected to enjoy the tepid gentility of *Punch*. . . .
>
> For the American springs from a unique and, in many respects, a fortunate background. He has less regard for the past and his ancestors than has any other inhabitant of the planet. He leaves the house in which he was born, conceals his grandparents, and lays down the law to his children, who, in turn break it, as he broke the law of his fathers, and grow up as they please. The American is born and bred with no cultural memories in his heart. . . . As a consequence, he is the most irreverent of all God's children. Nothing is too sacred for him to attack, tear down and rebuild. . . . He coined the word "debunk" and made it the battle cry of a reckless school of writers and cartoonists.[a]

This irreverence, Craven points out, is an offshoot of a unique American ethical code:

> Psychologically, the American habit of taking sides on all questions, of construing life in terms of good or bad, of right or wrong, has impelled our outstanding humorists to proceed from a pronounced moral bias. . . . The moral bias of the American mind, a Puritan inheritance, is largely responsible for the qualities of irreverence and ridicule which we have cultivated so hilariously. . . . Irreverence is not confined to America, but it flourishes here, as flower and weed, as in no other land and clime. It is a part of our fabric of freedom; it is as old as the Boston Tea Party and Declaration of Independence; and should we ever lose it or legislate against it, we should be a poor and colorless lot indeed.[b] ∎

universal themes to sway opinion. And finally, demonstrating a pattern that he would repeat when he copied Franklin's art, Revere had no qualms about honoring a competitor's work by "borrowing" extensively from it.

That same year, an English cartoonist reversed the participants in Revere's artwork; he depicted an incident in which a gang of Bostonians attacked John Malcom, an excise man representing the British government, forcing him to drink some of the hated taxed tea before tarring and feathering him and threatening to hang him (figure 1.12). This cartoon also reframes another image from American history, as the artist suspends a rope from the hallowed liberty tree to show that American freedoms could come at a deadly price.

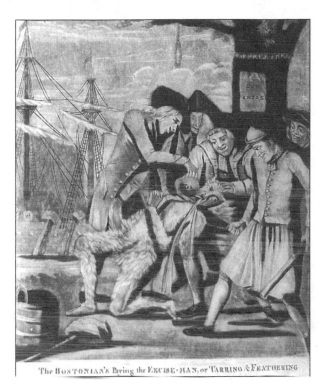

The Bostonian's Bying the EXCISE-MAN, or TARRING & FEATHERING

A New Nation, A New Form of Protest

The works of Franklin and Revere were memorable and influential, but the American editorial cartoon was truly in its infancy during the colonial period. The nation was in its formative stages, and the infrastructure was far less sophisticated than that found in other parts of the world. The vast majority of prints from this period were generated in the most advanced nations of Europe, principally in Germany, France, and England: artists in England actually produced more cartoons about the American revolution than their colonial counterparts. Higher literacy rates, larger cities, more developed economies and media systems, more readily available printing materials—all of these factors made editorial cartooning easier and more profitable in more developed nations than in the fledgling colonies. "We find few prints made in America during those years because type, steel, lead, paper, presses and skilled manpower became scarce during the war, and only the most heroic printers continued their productions on a smaller scale,"[10] notes Sinclair Hitchings. Under these conditions, it is a wonder that men like Franklin and Revere were able to develop any political cartoons at all.

As the tumultuous period of the American Revolution came to a close, politicians, printers, and political cartoonists on both sides of the ocean were forced to rethink their views of the world. English mapmaker John Wallis's 1783 map of the United States of America (figure 1.13) provides a visual clue to the changes that were taking place. Wallis's map includes por-

traits of military hero George Washington, arm in arm with Liberty, and colonial icon Benjamin Franklin; Franklin, who is writing a book, is flanked by the goddesses Justice and Wisdom. New political, economic, and social realities called for a reassessment of power structures, and artists created images that reflected this new world.

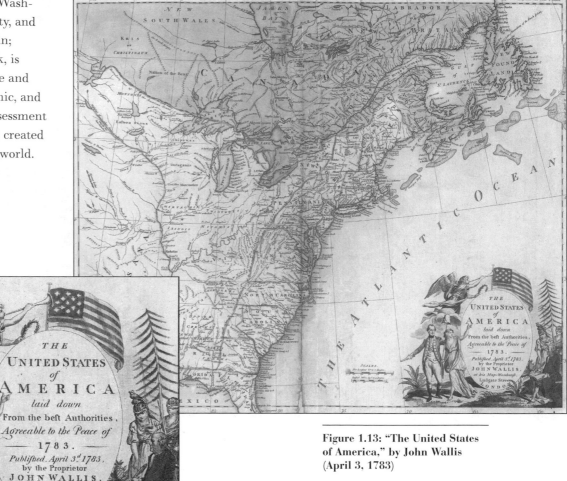

Figure 1.13: "The United States of America," by John Wallis (April 3, 1783)

TWO

Complexity in Government and Media

1786 TO 1860

A hundred years from now when historians look at our cartoons, they can say "that was the dilemma facing the cartoonist that day." Cartoons reflect something that no other historical artifact can reveal.[1]

KEVIN KALLAUGHER, CARTOONIST FOR THE *BALTIMORE SUN*

Figure 2.1: "The Looking Glass for 1787. A House Divided against Itself Cannot Stand. Mat. chap. 13th verse 26," by Amos Doolittle (1787)

WHILE REVOLUTIONARY WAR cartoonists faced many technological challenges, they had the advantage of advocating for a relatively simple position—protesting a common enemy led by an arrogant leader whose soldiers occupied their land. Once the Revolutionary War was decided, however, Americans faced a far more complex set of questions about a new form of government and the men who would lead it.

The debate over the direction of the new nation was fierce, and differences in political philosophy, regional priorities, and the leaders' strong personalities offered wonderful material for political cartooning. For example, Amos Doolittle's cartoon (figure 2.1) lampooning the state of politics in 1787 Connecticut demonstrates the complex-

ity of the issues and the passion of the times. Doolittle depicts two factions, one representing trade interests, the other farming, arguing over currency, taxes, and other issues integral to the new constitution. The characters "Agricola" and "S—H—P—" clearly show that cartoonists of the period had no problem depicting their opponents in the most unflattering forms.

A year after Doolittle's cartoon appeared, the *Massachusetts Centinel* published eleven sequential cartoons to demonstrate progress in the ratification of the Constitution, using the allegory of a new temple, built pillar by pillar and with help from the divine hand of God. The first of these cartoons (figure 2.2) appeared in January, as Massachusetts joined the five states that had already ratified the Constitution, and includes the inscription "United They Stand—Divided Fall." The last cartoon (figure 2.3) ran in August, with eleven pillars in place; the final two, representing North Carolina and Rhode Island, are nearly complete. Cartoonists obviously followed the constitutional debate very closely and strove to pro-

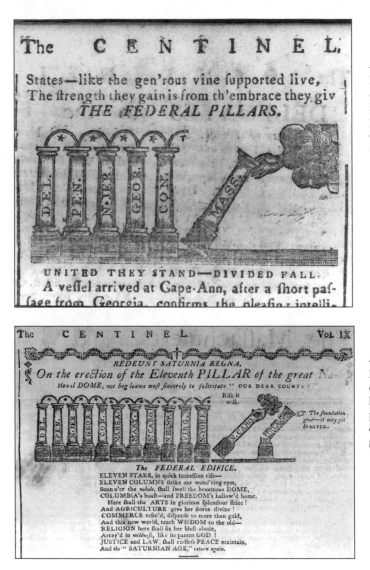

Figure 2.2: "The Federal Pillars," artist unknown (first in a series printed in the *Massachusetts Centinel*, January 16, 1788)

Figure 2.3: "The Federal Pillars," artist unknown (last in a series printed in the *Massachusetts Centinel*, August 2, 1788)

vide their readers with updates as well as interpretations.

It wouldn't take long for the editorial cartoonists of the era to switch from the major issue to the major players. Men such as George Washington, John Adams, and Thomas Jefferson, recalled today as virtuous statesmen, were treated as common politicians during their time in office. Jefferson was probably the most pilloried. For example, James Akins' depiction of Jefferson (figure 2.4) attacked the president for covert negotiations to purchase parts of Florida from Spain. A hornet with Napoleon's head stings the Jefferson dog, forcing him to "cough up" two million dollars in gold coins.

The works of Doolittle and Akins are anomalies, however; generally, printers of the period were barely up to the challenge of reporting on, much less influencing, critical events. Thomas C. Leonard points out that "between the Constitutional Convention of 1787 and the election of Andrew Jackson in 1828, the print shops of America issued only seventy-nine political caricatures as separate publications."[2]

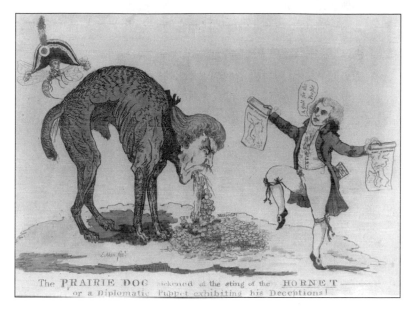

Figure 2.4: "The Prairie Dog Sickened at the Sting of the Hornet or a Diplomatic Puppet Exhibiting His Deceptions," by James Akins (1804)

The PRAIRIE DOG sickened at the sting of the HORNET — or a Diplomatic Puppet exhibiting his Deceptions!

The newspaper industry was stagnant during this era. Part of its lack of progress was a reaction to the conclusion of the war—Tories who had publicly sided with the British folded their papers and moved on, either physically or politically. Leonard describes additional trends that made the future of print seem bleak:

Patriot newspapers that were built on the skill of one or two entrepreneurs

faded as old men (or their widows) were unable to find worthy successors. (This was the fate of the *Boston Gazette*.) A town by-passed by commerce or government could pull printers down with it. Williamsburg, Virginia, had three newspapers in 1776, one when the capital was moved to Richmond in 1780, and no paper for the next 44 years. In 1800 there was no good reason to suppose that a newspaper could support a young proprietor

even into middle age. America had about 200 papers yet not more than a dozen had a clear pedigree to the Revolution. No state south of Maryland had a newspaper that was even twenty years old at the turn of the century.[3]

Printing Advances Provide Modest Help

Technological innovations in the print industry provided some help to the editorial cartooning process. Some were subtle: in the 1790s, publisher Thomas Bewick improved the wood engraving technique by using the end grain of the wood, creating an imprint that would sustain larger press runs. Some were more significant, but only when adopted over time: Bavarian Aloys Senefelder, also working in the 1790s, developed the process of lithography, in which the artist applied a grease pencil to limestone, a material that was far denser than wood. Advances in paper—sturdier, cleaner, and cheaper—and presses—particularly the introduction of steam presses—also improved the quality of cartoon reproductions.

Printers still couldn't overcome a key obstacle to political cartoons production: the time it took to convert the artists' work to paper. Whether lithography or advanced wood engraving was employed, the process still took two to three days from the completion of the drawing to its distribution in the print media. It would be another century before an artist could draw a cartoon one day and see it appear in the paper the next.

At the end of the eighteenth century, the American media system still paled in comparison to its English counterpart, and cartooning in America lagged well behind the profession in Europe. Technology was only part of the story—the larger issue was the market itself. The distribution of the American print audience worked against newspapers. A few urban areas along the seaboard offered a concentration of people, but Americans of the late 1700s were predominantly a rural population. The most popular magazines in America had circulations a tenth of those in England, with commensurate income and profits. Publishers struggling to get by had no interest in paying extravagant fees for artwork.

The twin obstacles of technological limitations and meager funds led to two innovative solutions: piecework and recycled images.

To speed up the creative process, some innovative publishers divided projects into parts, assigning each part to an engraver and then reassembling the piece for publication. Attempts to standardize styles met with limited success, and even when the technique worked, the final project had to be reassembled before production. Still, it was a resourceful method for speeding up the process.

Other editors simply held on to engravings and then, with minor adjustments (sometimes no adjustments at all), used them again for new events. Some events (hangings, election victories, etc.) were so common that a savvy publisher could keep generic images around, then simply add them to individual stories when appropriate. What Franklin found in the eighteenth century, other artists would find in the nineteenth century: their original work would turn up again and again, sometimes co-opted by their political enemies, so that the original message was

not merely lost, it was reversed.

The crude state of the profession invariably led to inaccuracies that bordered on the absurd: artists drawing from memory; a caricature of one politician substituted for that of another; cartoonists using earlier, and highly flawed, images as the basis of their own work; cartoonists using whatever images were available—regardless of their application to the subject—as templates for new cartoons. Lithographs and woodcuts were the only visuals available to readers, and reuse compounded original mistakes exponentially.

The War of 1812

Most cartoons from the War of 1812 were produced in London. English cartoons mocked American president James Madison (referred to as "Mad-ass-son" in many of the British offerings) as inept and cowardly, and took great pleasure in the sacking of the American capital. The few American editorial cartoonists of the era, artists such as William Charles, emphasized the brutality of British soldiers and

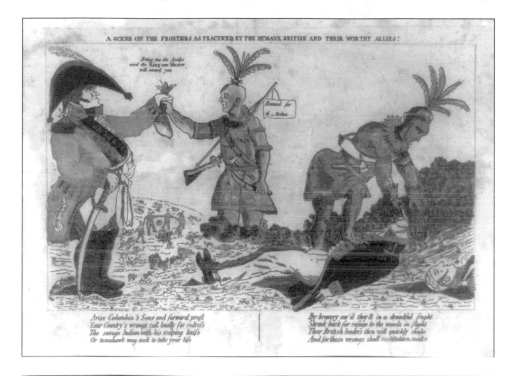

Figure 2.5: "A Scene on the Frontiers as Practiced by the Humane British and Their Worthy Allies!" by William Charles (1812)

methods, drawing on the contrast between the supposedly sophisticated English and their collusion with supposedly savage American Indians (figure 2.5). Charles also enjoyed poking fun at English rulers (figure 2.6), drawing them in the kitchen making a new batch of ships for the war, as an Eng-lishman warns them, "I tell you what Master Bull—You had better keep both your Ships and Guns at home If you send all you've got to the Lakes, it will only make fun for the Yankeys to take them."

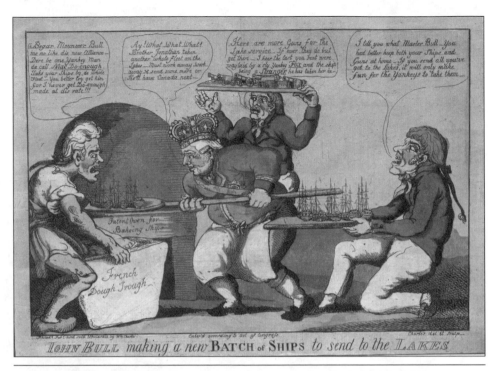

Figure 2.6: "John Bull Making a New Batch of Ships to Send to the Lakes," by William Charles (1814)

The 1830s: Populism in the Presidency and the Press

In 1828, Andrew Jackson, a military hero from the War of 1812, was elected to the White House, ushering in an unparalleled era of populism that was reflected in both the government and the press. Jackson railed against powerful American institutions throughout his time in office, none more powerful than the Second Bank of the United States (figure 2.7). "Old Hickory" proved a rich subject: his military background and demeanor (figure 2.8), coupled with a dogmatic and combative worldview, were strengths cited by his supporters, while his imperial approach to the presidency was a staple of his detractors. A polarizing figure, Jackson nonetheless was reelected to the presidency in 1832, mainly because of his appeal to the average American.

Until the 1830s, many of the characteristics of newspapers worked against editorial cartoonists. Almost all American papers were weeklies, so there was no habit of daily newspaper reading. Newspapers that were not biased political organs emphasized commercial news, a topic rarely covered by the editorial cartoon. Papers were sold for about six cents per issue and sold primarily by annual subscription (a week's pay for the average laborer), payable in advance, ensuring that their distribution would be limited to a small, upscale audience.

During the presidency of Andrew Jackson, however, that scenario changed dramatically. Populism in the presidency was matched by an emerging populism in the press. Publishers, first in New York and then in other large cities around the country, introduced the penny press, a fundamen-

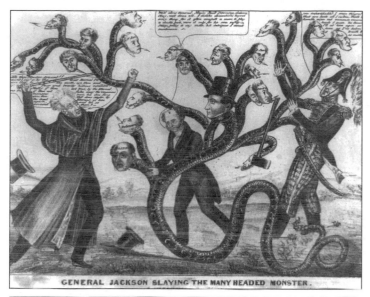

Figure 2.7: "General Jackson Slaying the Many Headed Monster," artist unknown (1836)

Figure 2.8: "Caucus Curs in Full Yelp, or a War Whoop, to Saddle on the People a Pappoose President," by James Akins (1824)

tally new form of journalism that revolutionized the print media. Cheaper paper, more powerful presses, and, especially, a reliance on advertising instead of subscription revenue led to a new democratization of information, as publishers targeted average Americans, a much larger pool than the aristocracy. The newspaper selling price was slashed to a penny, and the distribution was altered to emphasize single-copy sales. The focus on a new audience changed the tone and coverage of these papers, as editors searched for content that would titillate, entertain, or spark a reaction in the most potential readers. Obviously, the editorial cartoonist fit these plans perfectly.

The new economic model was a stunning success. Circulations skyrocketed, taking profits along for the ride. The penny press became a daily staple throughout American society, so significant that it helped increase the nation's literacy rate. The reporting was an amalgam of crime stories, political updates, and, on occasion, pure fantasy. But the penny press newspaper was also far more visually oriented than any form of newspaper that had come before, increasing the need for political cartoonists.

Oblique Effects—Photography, the Telegraph, and Editorial Cartooning

The effect of one medium on another can be difficult to detect, as in the relationship among the photograph, the telegraph, and the editorial cartoon.

The earliest widely used form of photography in America, the daguerreotype, was introduced in America in 1840. The new art proved a huge success, but the process included some serious limitations. The end product cost between two and five dollars, was relatively bulky, and had to be kept under glass for protection, making it a personal, rather than a public, medium. More important to other media, the daguerreotype produced no negative, so that it was impossible to reproduce an image for greater distribution.

The fact that daguerreotypes couldn't be reproduced did not mean that they had no impact on the news process. Instead of *being* the news, the images often were *the basis* for the news, as reporters, graphic artists, and editorial cartoonists drew from daguerreotypes in creating their own work. Since the daguerreotype was a true and detailed image, the new medium ultimately increased the accuracy of other media of the period. A cartoonist who had once relied on another cartoonist's interpretation of a popular subject could now work from a daguerreotype to create a more realistic likeness.

The introduction of the telegraph just four years after the daguerreotype made reliance on the photographic image even more important. The telegraph transported news faster and from farther away than ever before. Artists, cartoonists, and reporters were even more likely to rely on photographic images to flesh out their work because they were getting further and further from the original sources of news.

It would take until the end of the century to develop a process for transferring the photograph to newspapers or magazines. When this happened, readers were thrilled that they could now see a true likeness of a popular person without interpretation. This may have reduced the reliance on political cartoons, but it didn't eliminate readers' interest in them. After all, readers who enjoyed a literal reproduction continued to enjoy the idea of the editorial cartoonist revealing a subject's "true self." ■

The 1850s: Print Media Grow Stronger While the Nation Grows Apart

In the decade before the Civil War, changes in production, content, and distribution produced record profits and power for the men who owned the nation's newspapers and magazines. "Both the numbers of papers and their paid circulations continued to rise," historian Phil Barber writes. "In the 1850's powerful, giant presses appeared, able to print ten thousand complete papers per hour."[4] New York papers led the way in using larger and larger presses: the first eight-cylinder version at the *New York Sun* in 1850, the first ten-cylinder press for the *New York Herald* seven years later.

EMERGENCE OF THE NEWSWEEKLY MAGAZINES

"At this time the first 'pictorial' weekly newspapers emerged; they featured for the first time extensive illustrations of events in the news, as woodcut engravings made from correspondents' sketches or taken from that new invention, the photograph,"[5] Barber notes. Before 1850, a number of American publishers had tried unsuc-

Deadlines Change the Cartoon

Deadlines changed cartoons in expected and unexpected ways. They forced cartoonists to simplify—far fewer brushstrokes, characters, spoken lines. Artists employed more linguistic shorthand, increasing their reliance on well-known symbols (Uncle Sam, Democratic donkeys) and generally abandoning attempts to introduce new icons. Images that could be easily drawn and readily understood became primary shortcuts in the trade.

But there were some unexpected, subtle changes, as well. Regular distribution not only sped up production, it sped up interpretation as well. Before the Frank Leslies and the Fletcher Harpers came along, the cartoon was such a rare occurrence that artists could fine tune a concept over weeks. When the image was finally distributed, a reader might keep it for weeks, even months, and share it with others. With the introduction of the newsweeklies, however, the time for creating the cartoon dropped to seven days—a week later, a new image would be before the readers' eyes. The dailies reduced that time to twenty-four hours. Artists learned to get to the point in a bigger hurry. Readers came to expect a visual interpretation, complete with an opinion, on any breaking story within a day. The good news was that the new expectations added vitality and immediacy to political cartooning. The bad news was that these expectations dramatically reduced the reflection, perspective, and artistic detail that often emanated from longer lead times. ∎

cessfully to mimic the profitable English newsweekly magazines. In 1850, Harper and Brothers, a leading book publisher in New York City, launched *Harper's Monthly*, modeled after the highly successful *London Illustrated News*. The magazine was originally a literary publication, but quickly morphed into a vehicle primarily for political and social commentary. Within five years, Fletcher Harper, the originator, had shaped the magazine into an editorial and economic juggernaut. In 1857 the company began publishing *Harper's Weekly*, which reached an astonishing circulation of two hundred thousand by the Civil War. The Harper brothers' success did not go unnoticed—in 1855 Englishman Henry Carter introduced *Frank Leslie's Illustrated Newspaper*. (Two years later, he would legally change *his* name to Frank Leslie.) Carter was trained as an engraver, but his real talent lay in identifying the potential of emerging technologies and the talents of emerging cartoonists: among his hires were Thomas Nast, Joseph Keppler, and Bernhard Gillam.

The newsweekly was perfectly suited, in production quality, lead times, and distribution, for political cartoons. It also helped legitimize the profession. Prior to 1850, many journalists and editors, as well as politicians and business leaders, considered the political cartoon (and artwork for print media in general) to be a poor stepchild to traditional journalism. They felt that the real power and, to some degree, dignity of the media were in the printed word. Leslie and Harper felt otherwise. They used paper stock that was far superior to that of regular newspapers, allowing them to repro-

duce even the finest details of the work produced by their artists. Their magazines didn't simply include political cartoons—they glorified them.

The idea of making the cartoon a standard component of these publications brought about another change to the profession: the introduction of the deadline. Before the newsweeklies, cartoons were treated more as art than as regular features, and they were created and distributed haphazardly. Weekly magazines created a weekly market, and cartoonists on staff no longer had the luxury of drawing when an idea struck. Ideas now had to strike according to the calendar. And yet, with as long as five days to work on a cartoon, the artists could mull over their ideas and create elaborate works of art. Quality reproduction and relatively long lead times were a wonderful confluence. Historian Gerald W. Johnson describes this period as one in which "the cartoon attained high esthetic merit without much loss in either vigor or venom."[6]

The decade also saw improvements in the distribution of newspapers and weeklies that would increase the reach and power of the editorial cartoonist. By 1858, *New York Tribune* editor Horace Greeley was shipping six thousand papers daily by train to Chicago. Editors of other large papers, predominantly in the large, eastern cities, followed suit, and by the end of the decade they were offering serious competition to their smaller, midwestern counterparts.

CURRIER AND IVES PROFIT FROM POLITICS

The era also witnessed the rise of Currier and Ives, a printing company that owed allegiance more to profit and mass production than any political affiliation. Newsweeklies and dailies might be aligned with parties and politicians, but Nathaniel Currier and James Merritt Ives were happy to print anything that would sell—more than seven thousand different subjects in all. They produced more than eighty political prints covering every presidential election from 1836 to 1976, often creating multiple lithographs lampooning each candidate to ensure that they would strike a chord with readers of all political positions. Figure 2.9 shows one of the company's numerous nonpolitical offerings, while figure 2.10 shows an election-year poster for candidate Zachary Taylor. It was very important to Currier and Ives that both of these drawings appealed to Americans enough that they would buy them—*which* image, the fruit or the president, was not particularly relevant.

To avoid accusations that they were profiting without taking a real political stand, the publishers would conveniently leave their names off their most controversial prints. Currier and Ives, along with a number of competitors, hired artists to produce a barrage of lithographs on topics ranging from household scenes to holidays to national elections. The artwork was fairly limited: figures were stilted and generic, almost an afterthought, while artists spent considerable time on each subject's countenance. Most of the lithographs were cliché driven and heavy on verbiage, with word balloons filling all available space, but the work was extremely popular. Copies were sold in-

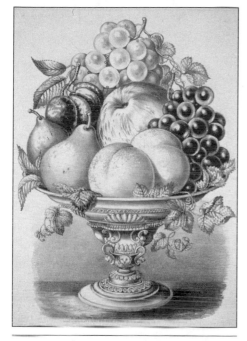

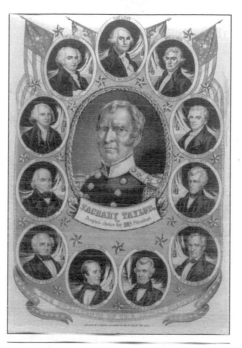

Figure 2.9: "Fruit Vase," Currier and Ives (1870)

Figure 2.10: "Zachary Taylor, People's Choice for 12th President," Currier and Ives (1848)

dividually, like pieces of art, as opposed to being distributed through a regular print medium. Aesthetically, these lithographs bordered on kitsch, but they were so widespread that they became some of the best-known artwork of the nineteenth century.

Making Progress

The period of American history from 1786 to 1860 included a range of colorful figures and significant events, but the media of the period were generally ill equipped to report or comment on

them. The era included technological, demographic, and economic obstacles that publishers struggled to overcome. Many historians describe the decades leading up to the Civil War as relatively insignificant in terms of creative efforts of cartoonists or the style of political cartooning in America. "At first merely a weak carbon copy of the European model, American cartooning displayed only modest wit and originality until well into the Civil War-Reconstruction periods," note Stephen Hess and Milton Kaplan.

Toward the end of this era, however, progress in print technology and economics, coupled with a shift in demographics, produced conditions that set the groundwork for making political cartoons a powerful instrument in American society. When the Civil War broke out, American print media and the cartoonists who worked for them were ready to make a difference.

THREE

The Medium Matures

1860 TO 1900

What was at stake in Boss Tweed's New York was visual thinking about political power.[1]

THOMAS C. LEONARD

Stop them damn pictures. I don't care what the papers write about me. My constituents can't read. But, damn it, they can see the pictures.[2]

WILLIAM "BOSS" TWEED

THE DEVELOPMENT of the editorial cartoon in the second half of the nineteenth century can be best understood in the context of the two dominant events of the era. The first event was the Civil War, when editorial cartoonists, like all Americans, grappled with the greatest crisis in the history of the nation. The enormous stakes, the intense emotional commitment to the cause (on both sides), and the distinctive personalities of the conflict's opposing leaders led editorial cartoonists to produce some of the most powerful and memorable cartoons in American history. "Political prints had played a role in American life since the days of the Boston Massacre; but in 1861 the cartoon, as an art form for the people, was still in its infancy in America," notes historian Gary E. Wait. "The outbreak of the war, with its highly charged emotional issues, gave immediate and lasting stimulus to this new form of journalistic art."[3]

The second great event of this period was the confluence of economic, social, and technological developments that produced the "Gilded Age"—a revolution that fundamentally altered the way Americans lived their lives. The era was marked by the transformation of many of the country's biggest industries—steel, oil, railroads, and, of particular importance to the editorial cartoonist, newspapers. The changes of the industrial revolution would alter the way Americans worked, played, used the media, and thought about the world.

By 1860, American political cartoonists were focusing on issues that would tear the nation apart. By 1900, American political cartoonists were striving to make sense of an increasingly complex and fast-moving society. The second half of the nineteenth century may have been the most tumultuous period in the history of the nation and in the evolution of editorial cartooning.

The Battle of Ideas and Imagery in the Civil War

THE SLAVE IMAGE IN AMERICAN CARTOONING

In the years just prior to the Civil War, the press and the public argued long and hard over the issue of slavery, and the political cartoonists of the time weighed in on the subject in dramatic and, in many cases, alarmist ways. With every new state added in the continual westward expansion of the nation, the slavery issue was argued anew, and it was clear that, one way or another, "the peculiar institution" was going to change. Abolitionist cartoonists drew dire depictions of slavery, such as David Claypool Johnston's twelve-panel piece (figure 3.1) detailing everything from floggings to families sold at auction. Johnston joined other Northern sympathizers in using Jefferson Davis to personify the evils of the South. Antiabolitionists countered with equally compelling cartoons, particularly those predicting horrific scenarios if the abolitionists were to succeed. In figure 3.2, the cartoonist

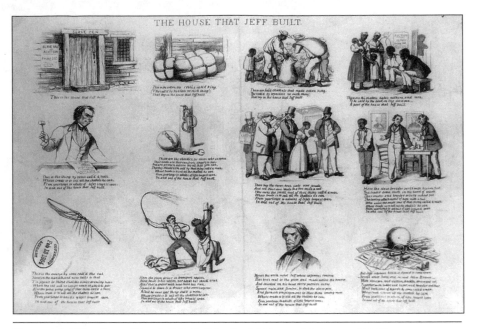

Figure 3.1: "The House That Jeff Built," by David Claypool Johnston (1863)

equates the freeing of slaves with the nomination of a black man for president, while in figure 3.3, another antiabolitionist raises the greatest fear of all: miscegenation. In this scenario, black men court white women, white men court black women, and a black family rides in a carriage driven by a white man. Onlookers from other nations comment on how horrified they are at these scenes.

DEPICTIONS OF THE NORTH AND SOUTH

Once the war was underway, the battles fought through editorial cartoons were similar to the battles in the conflict itself: the secessionists scored a

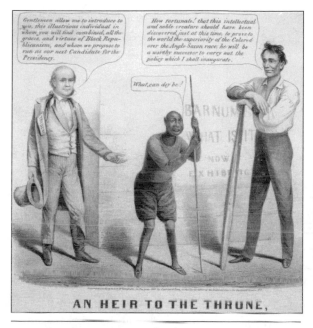

Figure 3.2: "An Heir to the Throne, or the Next Republican Candidate," probably by Louis Maurer (1860)

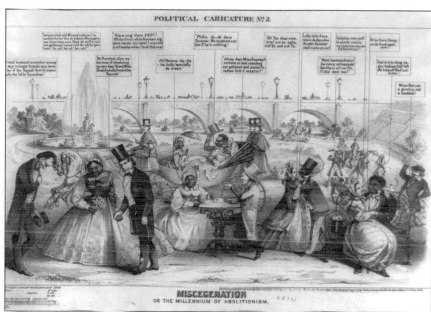

Figure 3.3: "Miscegenation or the Millennium of Abolitionism," artist unknown (1864)

number of glorious victories, but the North ultimately had far more material, personnel, and distribution systems than the South. Pro-Union publications in Philadelphia, Boston, and New York, such as the newsweeklies *Frank Leslie's Illustrated* and *Harper's Weekly*, produced a steady stream of editorials and cartoons praising the Union cause while demonizing Southern secession and leadership. Although the vast majority of the Northern publications were pro-Union, they were not necessarily pro-Lincoln.

More important than the number of cartoonists favoring the North was their quality: the most talented and influential cartoonists of the day supported the Northern cause. The South was also short on the media infrastructure to distribute printed material: no city in a Southern state produced a regular magazine; only one in twenty American paper manufacturers was located in the South; and nearly every major publishing house in the country was north of the Mason-Dixon line.

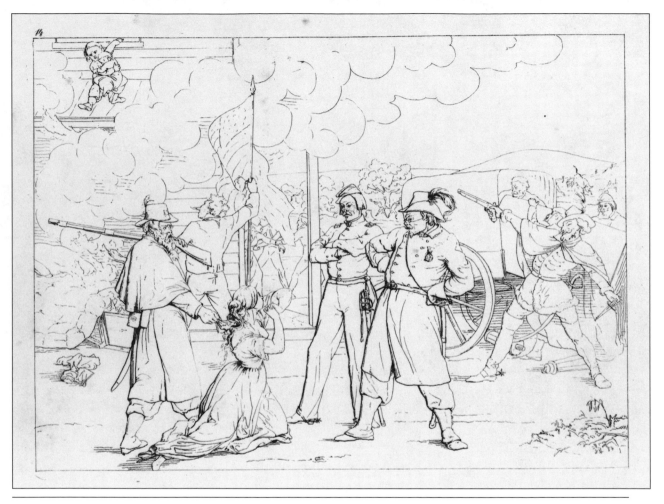

Figure 3.4: "Valiant Men 'Dat Fite Mit Sigel'" by Albert J. Volck (1864)

This did not mean that the Southern cause went unrepresented. Albert J. Volck, a Baltimore dentist who signed his work "V. Blada," railed against Lincoln, abolitionists, and the war of Northern aggression. Volck's copperplate etchings were circulated secretly throughout the Confederacy. The Southern sympathizer held nothing back in his attacks, portraying Abraham Lincoln as a liar, a demon, and even as a light-skinned African American who refused to admit to his ancestry. In figure 3.4, Volck portrays a woman begging a Northern general to save her children from a house being burned by Union soldiers. Like his Northern contemporaries, Volck utilized dramatic, almost theatrical scenes to demonstrate the moral superiority of his cause.

Volck wasn't the only cartoonist targeting the president; he had allies in the North as well. Lincoln was attacked on various fronts: his height, gait, beard, and hat were used to lampoon everything from his unsophisticated style to his philosophical inconsistencies to his Machiavellian politics. De-

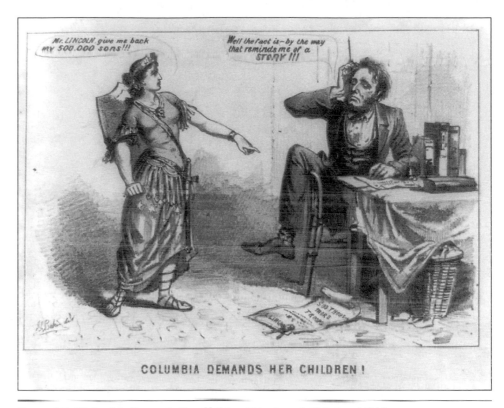

Figure 3.5: "Columbia Demands Her Children!" by Joseph E. Baker (1864)

spite the enormity of the war, many cartoonists of the era treated the president as they did any other elected official—commenting on a mixed bag of day-to-day political appointments, questionable legislation, and political infighting. As the war raged on, however, Lincoln's role led his greatest detractors, and supporters, to begin portraying him in almost biblical proportions. Figure 3.5 lays the blame for all of the war's casualties at Lincoln's

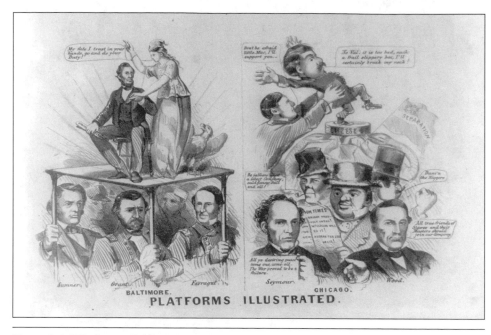

Figure 3.6: "Platforms Illustrated," artist unknown (1864)

feet, as Liberty demands, "Give me back my 500,000 sons!" Conversely, figure 3.6 depicts the two political conventions of 1864 and elevates Lincoln above the political fray. Here Lady Liberty is almost worshipful, imploring the president, "My fate I trust in your hands—go and do your Duty!"

THOMAS NAST COMES OF AGE

From the babble of images, accusations, and counteraccusations of the war, one cartoonist began to emerge as the most skilled and passionate advocate of the Northern cause. Thomas Nast, a German immigrant, was only twenty-two years old when the war be-

gan. He had drawn for *Frank Leslie's Illustrated* as early as 1855, but by the time the war arrived he had become a regular contributor to *Harper's Weekly*. Between 1862 and 1865, he produced fifty-five signed engravings for *Harper's*, melodramatic and moralistic renderings, crammed with noble Northern soldiers, damsels in distress, and, most of all, warmongering, predatory Southerners. There was nothing subtle in his work—he viewed Lincoln as a savior and the Southern cause as the personification of evil. He emphatically defended the president, his policies, and their outcomes; he consistently eviscerated Southern leaders, motives, and traditions.

In figure 3.7, Nast graphically depicts the barbarism of Southern troops, titling the piece "Historic Examples of Southern Chivalry." The collection of vignettes is overpowering: unarmed men being bayoneted and shot, gleeful beheadings, and weeping widows. In figure 3.8, Nast elaborates on the horror of life at the infamous Andersonville Prison, again blaming Jefferson Davis for military atrocities. Finally, in figure

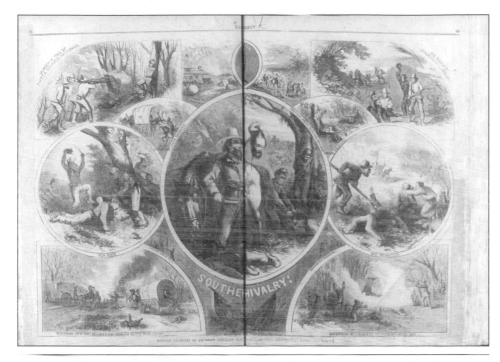

Figure 3.7: "Historic Examples of Southern Chivalry—Dedicated to Jeff. Davis," by Thomas Nast (1868)

3.9, in what may be Nast's most devastating Civil War artistry, he rails against any "compromise with the South." Here Nast shows a proud Southerner, generic but bearing a pointed resemblance to Davis, shaking hands with a one-legged Northern soldier, while the Southerner plants one foot on the grave of Union soldiers who have died "in a useless way." The Southerner still holds a whip in his other hand. The cartoonist uses the symbol of Columbia, who is weeping beside the grave. Background vignettes provide detailed reminders of the devastation of the conflict. Obviously, Nast found no room for subtlety in a war so bloody and fought for a cause so important.

The cartoon "Compromise with the South" was so devastating and so widely distributed, it not only helped further the career of the cartoonist, it is credited by many historians with helping Lincoln win reelection. At an extremely early age for a cartoonist, Nash had become the most influential and celebrated member in the history of his profession. He was immensely talented, the first cartoonist in the nation to have a weekly platform in a national publication, but he was also fortunate to come of age at this critical time in the nation's history. Nast was on his way to becoming a national figure in his own right—courted by political leaders and hailed by the general public for his talent and social significance. The war between the states catapulted his career, but when that war ended, Nast would turn his pen to other issues, railing against national and local politicians for decades to come.

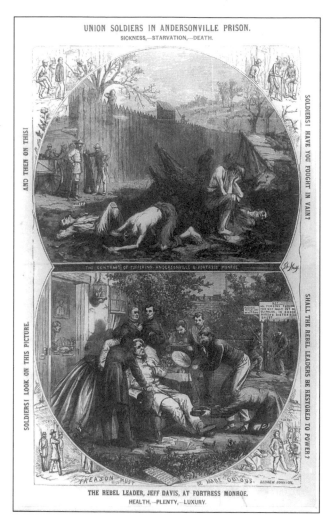

UNION SOLDIERS IN ANDERSONVILLE PRISON.
SICKNESS.—STARVATION.—DEATH.

THE REBEL LEADER, JEFF DAVIS, AT FORTRESS MONROE.
HEALTH.—PLENTY.—LUXURY.

Figure 3.8: "Union Soldiers in Andersonville Prison / The Rebel Leader, Jeff Davis, at Fortress Monroe," by Thomas Nast (1865)

In April of 1865, Nast's hero, Abraham Lincoln, was shot dead only five days after the formal end of hostilities. Cartoonists who had displayed a plurality of perspectives on the president during his administration were nearly unanimous in showering him with praise after his assassination. Lincoln was instantaneously elevated to a position above the pettiness and division of traditional politics. His supporters as well as many of his detractors recast the president as a martyr, reflecting the mood of a nation attempting to deal with the president's death and the death of so many of its citizens. Within a brief period after Lincoln's assassination, the once-controversial president's image crystallized, for many Americans as well as many editorial cartoonists. He was elevated to icon, symbol of the best leader the nation had ever had, and, with his weathered physiognomy and tragic history, a symbol of dashed hopes and unrealized dreams.

Since Lincoln's assassination, car-

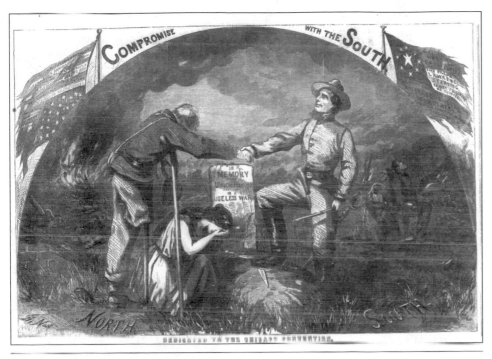

Figure 3.9: "Compromise with the South," by Thomas Nast (September 3, 1864)

With the country at peace and the president buried, cartoonists had to come to grips with the ultimate meaning and outcome of the Civil War. In the late 1860s, two issues dominated the editorial page: the Reconstruction of the South and the aftermath of the Emancipation Proclamation. Cartoonists, including Nast, questioned the federal government's dedication and ethical responsibility in both areas (figures 3.10 and 3.11). Nast depicted Lincoln's successor, Andrew Johnson, as a cowardly Iago, hiding behind a wounded slave–turned–Union soldier Othello. Nast surrounded the two characters with images of chaos and rioting, as Othello chastises the president, "Bear your fortunes like a man." Nast maintained a dogmatic, good-versus evil perception of the American political landscape, even as that landscape grew more complex and nuanced in peacetime. War had been easily portrayed in terms of "us versus them"—policy wasn't as simple. Ultimately, cartoonists after the Civil War were faced with the

toonists have employed his image as a kind of visual shorthand for the nation's hopes. He is usually presented in the most dramatic forms (statue, bust, heroic in Homeric proportions) but, at the same time, depicted as the personification of the purest and noblest of personal qualities: wisdom, inner strength, compassion, honesty, and, most frequently, self-sacrifice. Lincoln has become the quintessential mythic figure, combining the ideals of public and private virtue, making him the perfect icon for cartoonists comparing any other individual to the best of what America has to offer.

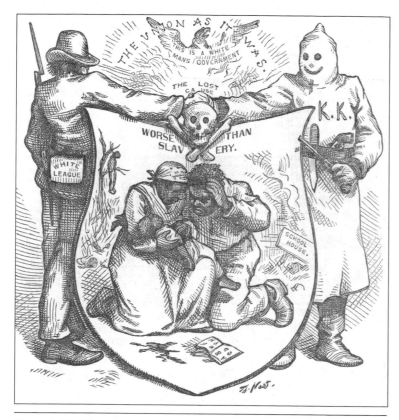

**Figure 3.10: "The Union as It Was. The Lost Cause, Worse Than Slavery,"
by Thomas Nast (1874)**

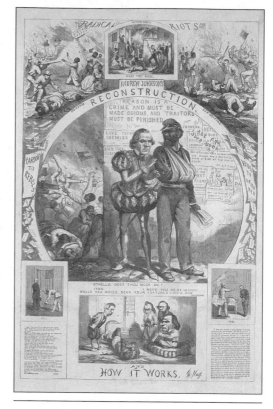

**Figure 3.11: "Andrew Johnson's Reconstruction
and How It Works," by Thomas Nast (1866)**

same dilemma that faced cartoonists after the Revolutionary War: wartime cartooning could be simplified to good versus evil, victory versus defeat, while postwar periods proved far more bewildering and complex.

Nast's vivid imagination went beyond creating cartoons to creative approaches to distributing them. He spent six months in 1867 packaging his hatred of Andrew Johnson into "Nast's Grand Caricaturama," a series of

thirty-three giant (eight-foot-by-twelve-foot) tempera paintings that were wheeled across a stage, accompanied by piano music and narration. The historical oddity debuted in New York City at the end of the year and had a follow-up run in Boston, coinciding with the president's impeachment trial. This is the only time in American history that a political cartoonist's work was used as the centerpiece of a theater production. The assumption that such an oddity would be profitable is a testament to both Nast's popularity and his hubris.

The Gilded Age: Big Cities, Big Money, Big Targets

While the political cartoons of the Civil War reflected the strong, passionate positions of war, post–Civil War cartoons began to focus on nonmilitary issues, using a more intricate and complex set of messages. As America moved through the healing process, Americans thought less and less about war and peace. The reunited nation was entering an era of enormous growth, and for many Americans, it was time to get back to business.

NAST VERSUS NEW YORK CITY

Thomas Nast gave men like Jefferson Davis a terrible time during the Civil War, but the end of the conflict simply allowed him to turn his efforts to a new and powerful target: postwar politics in New York City. "Nast," says historian Draper Hill, "was a very good hater."[4] He applied that hatred most enthusiastically to the political machine known as Tammany Hall.

Tammany Hall was the Democratic coalition that dominated New York City politics from the 1850s until 1871. Beginning in 1868, Nast identified the men whom he considered central to the machine— including Mayor A. Oakley Hall, Peter "Brains" Sweeney, and Richard "Slippery Dick" Connolly—and launched a tenacious, systemic attack on their deals, conflicts of interest, and out right theft.

Nast saved his harshest efforts for the man he turned into a living symbol of the Tammany Hall group, William "Boss" Tweed, possibly the most pilloried target in the history of American political cartooning. Tweed was everything a cartoonist could want: blunt, excessive, greedy, and blessed with a physiognomy that made him easy to caricature. Tweed's wide nose, thick beard, and large midsection (he weighed in at 280 pounds) gave Nast plenty to work with. Tweed's overlapping titles, blatant use of patronage, and innumerable sweetheart deals gave Nast plenty to draw about. In reality, Tweed was never the central or most powerful figure in Tammany Hall, but his features were such a great target that Nast made him the boss. Historian Thomas Leonard notes that "Nast put Tweed in twenty-one cartoons before he knew what, specifically, to blame him for."[5]

Tammany Hall was by no means oblivious to political imagery. "The Ring," as it was known, was famous for its attention to the press and use of symbols. It helped subsidize New York City papers, a method guaranteed to produce sympathetic stories. It hired

journalists to write stories for out-of-town papers, then ensured that these stories were reprinted in the hometown papers, a clever technique that added an aura of independence to the writing. In 1870, members of the Ring even financed their own illustrated publication, *Punchinello*, providing New Yorkers with a far more positive view of their activity. The Ring also went on the offensive against its press enemies: city inspectors investigated the land title of the *New York Times* and the city's school board banned from the classroom any book published by Harper and Brothers Publishing. These actions demonstrated not only the Ring's aggressive approach, but also its command over every area of city government. During its reign, the Tammany Hall Ring built massive public works, such as the city's elaborate courthouse, and operated under the symbol of a menacing tiger, the icon copied from Tweed's well-known fire brigade.

Nast experimented with a variety of images and symbols during his years attacking the Tammany gang. He was initially hampered by the general ambiguity about and lack of evidence of the Ring's sins—no one was quite sure *what* they were stealing, but the Republican press was sure they were stealing *something*. Nast portrayed the Ring as a snake, then switched to a portrayal of the ringleaders as savages, complete with necklaces made of skulls. Ultimately, he opted for a strategy used by the best of propagandists: he commandeered his enemies' own symbols. Nast turned the Tammany tiger into a snarling, predatory animal, preying on innocent New Yorkers. He portrayed the Ring's centerpiece of progress, the new courthouse, as a symbol of greed and excess. He fattened up the already portly Boss Tweed, using his pear shape and unkempt beard to symbolize a voracious appetite and brutal manner. Most important, he made Tammany Hall Irish. What this lacked in truthfulness—a few leaders were Irish, but others were of Scotch, English, and Finnish descent—it made up for in resonance. New York was in the midst of a massive wave of immigration, and anti-Irish sentiment prevailed in many parts of the city. Nast tapped into a reservoir of contempt that made the Ring's alleged thievery, cronyism, low manners, and overall negative impact on the city all the more believable.

Nast, like all cartoonists, was forced to strike a balance. Leonard notes that the cartoonist's most difficult task is "to select information to make the power seem illegitimate without including any of the information to make it look permanent."[6] This was particularly difficult in the case of the Tammany Hall politicians, since their power was not only pervasive, it was exceptionally and deliberately public. Fortunately, Nast had plenty of assistance in his campaign. He was not alone in his *Harper's Weekly* attacks on Tammany Hall—the *New York Times* also featured a series of exposés and editorial attacks on the political coalition—but Nast is credited with a substantial share of the effort. He developed memorable nicknames and points of caricature for each of the principals, and he timed his most damning efforts for publication just before elections to maximize damage to the Democrats. In the three months leading up to the November 1871 elec-

Nast Gets the Last Laugh—Accidentally

The influence Thomas Nast's cartoons had on the political career of Boss Tweed is debatable; the contribution Nast made to Tweed's image is not. From Tweed's words (Nast misquoted him in nuanced but important ways) to his very name (Nast replaced Tweed's real middle name, "Magear," with "Marcy," a disparaging reference to a local politician), the cartoon came to replace the subject. The final chapter in Thomas Nast's five-year feud with William Magear "Boss" Tweed centered on a political cartoon that landed the Tammany Hall politico in jail—for all the wrong reasons.

Tweed helped rule (and plunder) the city of New York from 1865 to 1871, using his roles (president of the Board of Supervisors, public works superintendent, state senator, and, most important, Grand Sachem of the Tammany Hall Society) to develop a stranglehold on a stunning array of patronage jobs and city services. A Democrat, he even exerted control over the rival Republican Party by bribing members of the opposition. One person he couldn't control, however, was cartoonist Thomas Nast, who was merciless in his attacks on Tweed and his cronies. This was not for lack of trying, however; Tammany Hall unsuccessfully exerted as much pressure as possible on the Harper brothers to silence their cartoonist, even managing to terminate the printer's contract for providing New York City with schoolbooks. When the Tammany Hall politicians couldn't muscle the publisher, they went right to the source himself, allegedly offering Nast five hundred thousand dollars (his salary was one-hundredth of that) to pursue other artistic interests. Nast declined.

In 1871, Democratic leader Samuel Tilden, under pressure from Nast's cartoons, opened an investigation into Tweed's financial shenanigans. By that point, Tweed was alleged to have skimmed more than two hundred million dollars from his various illegal activities. Tweed was convicted of corruption and sentenced to twelve years in prison, although he continued to exert tremendous influence from behind bars. In 1872, Nast, ever vigilant with regard to his indomitable adversary, drew Tweed as an oversized figure who could never be wholly contained by a jail cell (figure 3.12.)

Tweed was released from prison only two years later, but was almost immediately arrested again, this time on civil charges. Even in prison, Tweed remained a hero to many working class New Yorkers, and was so powerful that he was allowed to go home on occasion during his incarceration. In December of 1875, during one of his "home visits," Tweed escaped and fled to Spain, where he took a job as a deckhand. For a time it seemed the new lo-

tion, he drew as many cartoons about Tammany Hall for *Harper's Weekly* as he had in the previous three years. This incredible output affected more than the votes of New Yorkers; it affected their reading habits as well: *Harper's Weekly* circulation tripled. In the final run-up to the election, Nast showed the Tammany gang alternately as arrogant bullies, to drum up anger, and as cowards hiding behind a crumbling facade, to instill hope that they could be overthrown. His election-eve cartoon in November of 1871 showed the symbol of the local party, the Tammany tiger, ripping apart yet another victim, with Boss Tweed, as Roman emperor, watching from above. Nast misquotes (or possibly invents) Tweed's words—"What are you going to do about it?"—to mobilize the opposition.

The Tammany Hall Ring lost the election, and, within two years, Boss Tweed was behind bars.

cale would protect him from the long arm of the law and the nimble fingers of his cartooning nemesis. Alas, this was not to be.

The July 1, 1876, issue of *Harper's Weekly* included Nast's "Tweed-le-dee and Tilden-dum" cartoon depicting Tweed grabbing two young vagabonds by their shirt collars (figure 3.13). The accompanying text puts the following words in Tweed's mouth: "If all the people want is to have somebody arrested, I'll have you plunderers convicted. You will be allowed to escape, nobody will be hurt; then Tilden will go to the White House and I to Albany as governor." Nast's point was to show how Tweed might make a show of convicting petty criminals while letting the city's major criminals go free.

Somehow a copy of Nast's caricature ended up in the hands of a Spanish official. The drawing of Boss Tweed was so accurate that the official was able to identify the fugitive from the cartoon, and he arrested him—not on charges of corruption or escaping from jail, but on charges of kidnapping the two children in the picture!

Across a vast ocean, completely misinterpreted, the artwork of Thomas Nast still managed to trip up his adversary. William "Boss" Tweed was returned to jail in New York City. In the end, broken and dispirited, the once-powerful politico was reduced to the hollow-eyed, overstuffed symbol of corruption that Nast had consistently portrayed. Tweed died in April of 1878 at the age of fifty-five, still serving out his sentence. ■

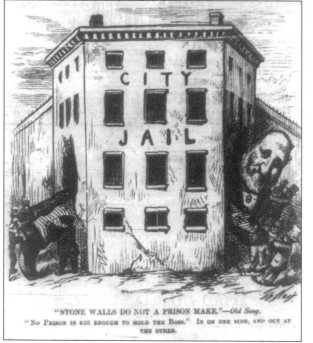

Figure 3.12: "Stone Walls Do Not a Prison Make," by Thomas Nast (1872)

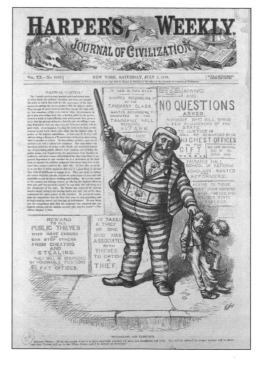

Figure 3.13: "Tweed-le-dee and Tilden-dum," by Thomas Nast (1876)

AMERICAN SOCIETY IN A WHIRLWIND

Government wasn't the only institution undergoing significant change in the post–Civil War era. The period witnessed a whirlwind of change throughout society; it was a time of massive immigration, explosive growth of cities, and laissez-faire attitudes toward business activity. Developments of the Gilded Age radically altered economic and social systems. Many of these changes contributed to the dramatic increase in the power of the political cartoon:

- The emerging industrial revolution led to the development of business interests wielding far more power than had ever been seen before. Megacompanies dominated key areas of the economy (oil, steel, manufacturing, transportation), creating an unparalleled disparity in power—and making the companies perfect targets for political cartoonists.
- The print media continued to grow in power and wealth, mirroring the economies and policies of other large organizations. In 1850 there were twenty-five hundred newspapers in America; by 1880 there were more than eleven thousand. New York City alone boasted more than twenty dailies. The growth wasn't only in the number of papers but in circulation as well. Advances in press technology continued to speed up production, and, by 1890, the nation's largest papers were producing more than a million copies per issue. On the magazine side, *Harper's Weekly* and *Frank Leslie's Illustrated* were joined by a collection of popular magazines of news and commentary: *Puck* (1877), *Judge* (1881), and *Life* (1883). Each enlarged the market for innovative cartoonists.
- The audiences for newspapers and their increasingly strident cartoonists were on the rise. Industrial processes were set up in the largest population centers, and the population of the cities, particularly in the industrial Northeast, grew dramatically—a ready-made audience for newspaper publishers.

Newspapers, like oil companies, steel foundries, and other businesses, experienced a wave of consolidation, producing chains that were far more powerful than individual papers. The 1880s and 1890s saw the introduction of the great newspaper empires, organized by men like Joseph Pulitzer and William Randolph Hearst. Pulitzer, a Hungarian immigrant, started his empire by buying the *St. Louis Post-Dispatch* in 1878, then entered the East Coast market when he bought the *New York World* five years later. In a breathtakingly short time, he transformed the *World* into the paper with the largest circulation in the city. Hearst, Pulitzer's greatest rival, took over his father's paper, the *San Francisco Examiner*, in 1887, and gradually began making his way to the great newspaper market of New York City, buying the *Morning Journal* in 1895. Hearst strung together a powerful network of print media op-

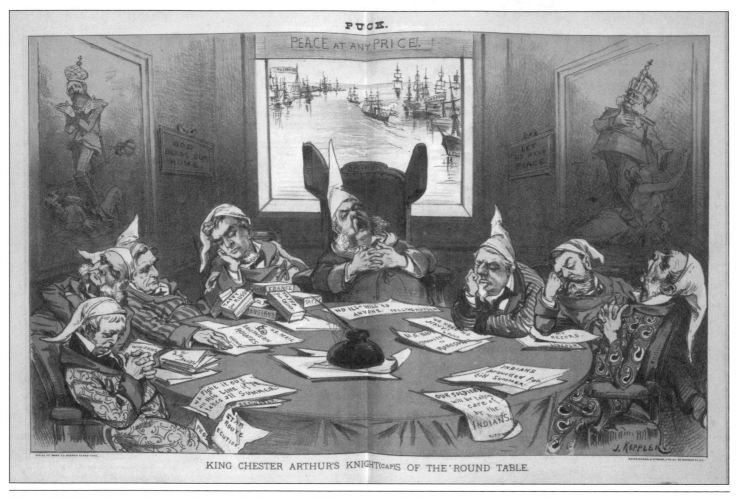

Figure 3.14: "King Chester Arthur's Knight(cap)s of the Round Table," by Joseph Keppler, *Puck* (February 15, 1882)

Photoengraving Changes the Editorial Cartoon

There was one additional event in the latter part of the century that that would radically change editorial cartooning. Historian Jim Zwick notes:

On October 30, 1884, [Joseph Pulitzer's *New York World*] published a cartoon by Walt McDougall satirizing a dinner held the night before honoring Republican presidential candidate James G. Blaine. McDougall's cartoon was printed across the full width of the front page of the paper under the caption "The Royal Feast of Belshazzar Blaine and the Money Kings." The cartoon created an immediate sensation and was credited for contributing to Blaine's defeat in the election five days later. It also contributed to placing political cartoons and cartoonists at center stage in the circulation war that erupted the following year when William Randolph Hearst took control of the *New York Evening Journal*.[a]

The new photoengraving technology allowed publishers to convert a cartoonist's finished drawing into a printed copy in as little as two hours. The day after the front-page cartoon ran, Pulitzer hired McDougall as the nation's first daily cartoonist for fifty dollars per week, and the profession advanced to a new level. Hearst, of course, could not let his primary competitor overshadow him, and the bidding for the nation's top editorial cartoonists was on. Newspapers throughout the country began incorporating the new photoengraving process and hiring full-time cartoonists charged with producing a new image every day of publication.

Historian Charles Press estimates that there were as many as five hundred political cartoonists at the end of the century,[b] and concludes that photoengraving created a fundamental change in the print media: "The messy and meticulous work of engraving, etching or lithographing was finished. No middleman stood between artist and pressman....The impact of this change was to make the cartoon in the daily newspaper first a novelty and then a necessity."[c] ■

erations that influenced both media and politics. At its height, the Hearst empire included twenty-eight newspapers, eighteen magazines, and vast holdings in the emerging media of radio and film.

The two publishing czars had different backgrounds but similar business models. To build circulation, they made their papers as flamboyant and sensational as any in American history, and injected editorial voices that passionately advocated or objected to politicians, ideas, and institutions. Their newspaper philosophy only added to the importance and prestige of the political cartoon, and the two publishers vied for the most talented cartoonists of the era. "The legendary battles of the 'Yellow Journals' went beyond headlines to competition for cartoonists," notes historian Jim Zwick. "One of Hearst's first hires was *World* cartoonist Richard Outcault, creator of the 'Yellow Kid' comic strip. Frederick Opper and Homer Davenport were recruited to draw political cartoons."[7]

Financiers were also putting together new magazines, for economic as well as political reasons. German immigrant Joseph Keppler, a long-term artist at *Frank Leslie's Illustrated*, founded *Puck*, which offered an en-

tirely different cartooning style. Working from the traditional woodcut style and then moving into the lithograph process, Keppler and his artists introduced bold color and densely crowded layouts featuring detailed, grandiose scenes. The style caught on in the pages of one of his new competitors, *Judge*. These magazines crammed cartoons between headlines, around text, and, invariably, into massive two-page centerfold spreads (figure 3.14).

It wasn't only the artistic style that was different, it was the tone as well. *Puck*'s motto was Shakespeare's line "What fools these mortals be," and the magazine took a lighter, more gentle approach to humor than the vicious, moralistic perspective of cartoonists such as Nast. *Puck* aimed for a chuckle, *Harper's Weekly* wanted to root out evil.

The dominant newsweeklies of the time were quite profitable, but they also offered their publishers a mouthpiece for supporting candidates and causes. Most of these publishers assumed that their names on the weekly paychecks gave them the right to dic-

tate the political positions of their writers and cartoonists, and most of the staff went along with that assumption. One exception was, to no one's surprise, Thomas Nast, who had coexisted relatively peacefully with *Harper's* editor Fletcher Harper but battled regularly with Fletcher's successor, George W. Curtis.

The nation's foremost cartoonist was also undergoing a political transformation that stunned his readers and the politicians he drew. By 1884 he and his editors had switched camps, supporting Democratic presidential nominee Grover Cleveland over Republican nominee James G. Blaine. Nast's competitors were overjoyed with the change in his long-held allegiances and took full advantage of his defection from the Republican Party. His detractors, and there were many, frequently portrayed him during that time as a monkey attached to Curtis, shown as an organ grinder. The monkey image became iconic, until other artists could simply show a monkey's tail holding a quill pen to symbolize Nast. It is difficult to think of a symbol that could

possibly be more insulting to such a proud, politically powerful, but physically unimposing, man. It must have also been frustrating because it was fundamentally inaccurate—Nast was one of the most independent cartoonists of the era, and he and Curtis disagreed frequently. However, it is a demonstration of the power of the man that Nast ranks with Benjamin Franklin as one of the few cartoonists who was so much a part of the political fabric that he became the subject, and not simply the creator, of political cartoons. It is also further evidence of his hubris—Nast drew himself as often as he drew the politicians he covered, a practice that made him so familiar to the public that his competitors had no trouble caricaturing him.

It was only a matter of time before Nast, self-assured, combative, and a legitimate powerbroker in his own right, would strike off on his own. In 1886, he left *Harper's Weekly* and, like other cartoonists such as Keppler, formed his own magazine. He was a far better artist than publisher, however, and his *Nast Illustrated Almanac* lasted only six

months. In the final analysis, Nast was at his best relatively early in his career, when his most withering artwork addressed momentous issues (e.g., the Civil War) or oversized villains (e.g., Boss Tweed). His fame and influence dropped off precipitously later in his career, and, while he remained prolific, his work lost its focus and its force.

The Century's End: Immigration and the Trusts

Editorial cartoonists of the era could neither defend nor reject the status quo, because the late nineteenth century really had no status quo. The country was changing rapidly, in ways that Americans, and editorial cartoonists, could barely appreciate. Sweeping trends altering the size and makeup of the population were mirrored by sweeping changes in the size and power of business interests. Both became focal points for editorial cartoonists, as the social impact of immigration and business activity became the dominant themes in political cartooning.

It was no coincidence that the rise in power of the newspaper and magazine titans coincided with a rise in power of American cities. At the beginning of the century, a mere six U.S. cities boasted populations of eight thousand or more. By 1860, one of six Americans lived in a city of ten thousand or more, and, by the end of the century, the number was one in three. Immigration and industrialization fueled unprecedented growth in America's major cities, predominantly along the seaboards. Urbanization provided a massive, densely packed audience for newspapers, as well as the dichotomies that editorial cartoonists thrive on: stark contrasts of rich and poor, powerful and powerless, all crammed onto the tiny island of Manhattan, into the lakeside communities of Chicago, and onto the narrow streets of Boston.

Waves of immigrants entered the great portals of the United States in search of political stability, religious freedom, and economic opportunity. Twenty-six million of them, predominantly European, poorly educated, neither speaking nor writing English, came to the United States between 1860 and 1900. They formed an eager labor pool for industrialists who used their labor to make some of the nation's greatest fortunes in steel, oil, and railroads. The contrast between rich and poor in the United States has never been more striking than it was in this era: many laborers, lacking any organized representation, worked long hours in dangerous conditions for subsistence wages, trudging home at night to the squalor of disease ridden tenements. Meanwhile, company owners, dubbed "robber barons," displayed a ruthlessness in business practices and arrogance in public life that allowed editorial cartoonists to demonize them by simply presenting their words and actions without embellishment. Andrew Carnegie in steel, John D. Rockefeller in oil, and Cornelius Vanderbilt in railroads crushed competition and exploited their workers, all the while amassing unparalleled fortunes and power.

The robber barons were collectively bound up in an image called "the trusts," monopolies that were formed

A Nation of Immigrants—and a Nation Split on Their Impact

Immigration has always had a major influence in the development of the nation, but it took on an entirely new level of importance in the late 1800s. Near the end of the century, more than a million immigrants came to the United States annually from Europe, the Middle East, the Mediterranean, and other parts of the world, through ports in Boston, San Francisco, and Savannah. In the 1890s, the greatest number of these immigrants entered the country through a single port: Ellis Island, just off New York City.

Many Americans, and American editorial cartoonists, reacted to increasingly large waves of immigrants with fear, suspicion, and anger (figure 3.15). Anti-immigration cartoonists blamed foreigners for problems ranging from social ills and political disillusionment to a drain on economic resources. Proimmigration cartoonists, on the other hand, noted that first-generation Americans brought important skills to the workforce or supported the economy by accepting unskilled labor positions and pointed out that, with the exception of the American Indians, every citizen was a descendant of immigrants to the country (figure 3.16).

Regardless of one's perspective, the immigration issue could not be ig-

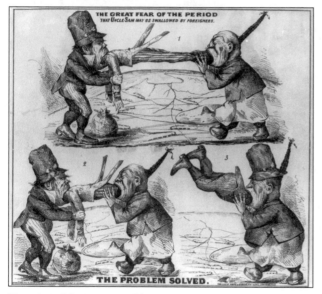

Figure 3.15: "The Great Fear of the Period: That Uncle Sam May Be Swallowed by Foreigners. The Problem Solved," artist unknown (probably published between 1860 and 1869)

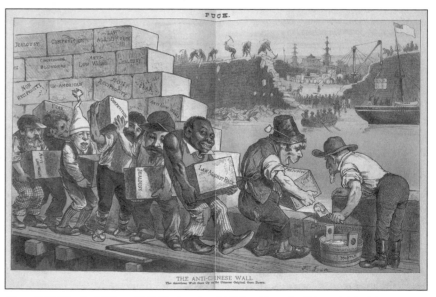

Figure 3.16: "The Anti-Chinese Wall. The American Wall Goes Up as the Chinese Original Goes Down," by Friedrich Grätz (1882)

nored, because it was changing the face of the nation. For many editorial cartoonists, the immigration issue was essentially a political issue, as editorial camps supported or denounced activities designed to restrict the number of immigrants arriving in America. The Chinese Exclusion Act of 1882, the Alien Contract Labor Law of 1886, and even an immigrant literacy test all set out to stanch the waves of immigration. These regulations, along with other events around the world, reduced the number of immigrants in the early part of the twentieth century.

A hundred years later, the immigration issue is not as central to the great debates of editorial cartoonists as it once was, but, as is obvious in figure 3.17, from 1994, the topic remains controversial—and many of the arguments about it remain the same. ∎

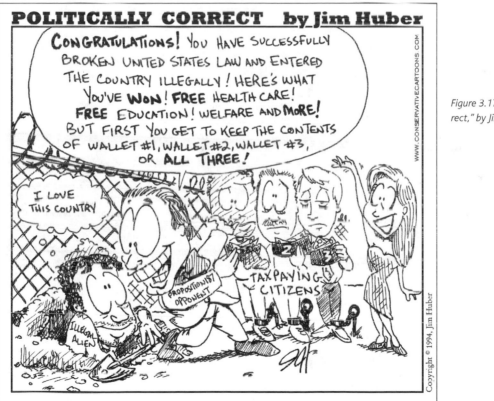

Figure 3.17: "Politically Correct," by Jim Huber (1994)

through political skullduggery and anticompetitive practices that either bought out or drove out the competition, leaving massive conglomerates that could dictate prices and wages. Homer Davenport's drawing of a trust figure threatening a small family (figure 3.18) typifies the perception that these powerful institutions were immoral and destructive. Jim Earl shows the logical extension of the unchecked greed of the trust: even the air is controlled by a monopoly (figure 3.19). These cartoons typified the growing antiauthoritarianism that was inevitable when the most powerful forces in society (government, business, the military, the church, etc.) appeared to be growing even more powerful. The theme would carry over into the next century, when the increasingly frustrated voices of the far Left would find their outlets through some of the most powerful antiauthoritarian publications in the nation's history.

Figure 3.18: "Trust Figure with the Mortgage of a Destitute Family," by Homer Davenport (November 6, 1900)

Figure 3.19: "Air Trust Holds Nozzle of Pure Air for Common People," by Jim Earl (between 1890 and 1925)

FOUR

World Wars and Economic Depression

1900 TO 1945

I'm against oppression. By whomever.[1]

BILL MAULDIN

THE FIRST DECADE of the twentieth century witnessed a series of unrelated events that indicated the significant changes that would occur in the development of American political cartooning. It marked the conclusion of a number of important careers—political, cartooning, and so on—and the ascendancy of new and powerful figures who would dominate the American landscape.

1900–1910: Changes in Political and Cartooning Leadership

At the dawn of the new century, American cartoonists, led by Frederick Burr Opper, were busy skewering the president of the United States, William McKinley, and key members of his administration. Opper had spent nearly two decades cartooning for magazines. He switched to Hearst's *New York Evening Journal*, which provided a powerful platform for his *Willie and His Papa* series (figure 4.1), attacking McKinley, his vice president Theodore

WILLIE AND HIS PAPA.

Figure 4.1: "Willie and His Papa," by Frederick Burr Opper (*New York Evening Journal*, June 27, 1900)

Roosevelt, and powerful business interests aligned with the administration. Opper and his public were so obsessed with the trusts that the cartoonist even developed a series, *Alphabet of the Joyous Trusts*, that used a different letter

every day to go after the monopolies of the era. Opper consistently portrayed the trusts as oversized, at least twice as large and round as the people they abused, and always ready to grab for more.

Nine months into the new century, however, McKinley was assassinated and Roosevelt was elevated to the White House. Thus began what historian Richard E. Marschall refers to as "the Era of Personality." "After Theodore Roosevelt," Marschall notes, "a president's job description included being a lightning rod for artists' satire, leading to a hundred-year gallery of eminently caricaturable faces: Coolidge, FDR, Eisenhower, Nixon, Reagan, Clinton."[2]

Over the next seven years, "TR" would provide political cartoonists with a smorgasbord of material, from his absurdly toothy grin and Rough Rider image to his flamboyant personality and talent for creating new phrases: his "big stick" philosophy and Bull Moose party, for example, provided wonderful metaphors for a variety of cartoon scenarios. Before Roosevelt became president, Opper and his colleagues consistently drew him as a small man relative to the massive trusts. Once he moved into the White House and began flexing his political muscle, however, his stature increased dramatically on the editorial page. More than any other president, Teddy Roosevelt was drawn as an oversized character, whether dominating the Senate or striding across Central America. On the home front, the new president's agenda included promoting conservation, initiating antitrust activity, and alleviating labor strife. Abroad, his political engineering led to the development of the Panama Canal. This was a president operating on the grandest scale.

Unlike most politicians, Roosevelt rarely complained about his depictions in the press. "In fact, sportsman Roosevelt was known to have been publicly irritated by just one cartoon (in the *Wichita Eagle*)," note Hess and Northrop, "and then only because it showed him mounting a war horse with the wrong foot in the stirrup."[3]

Opper was joined in his Roosevelt lampoons by such talented cartoonists as John McCutcheon of the *Chicago Tribune*, Jay Norwood "Ding" Darling of the *Des Moines Register*, and Clifford Berryman of the *Washington Evening Star*. All four tended to draw with a light touch, their gentle humor trumping any political messages. Berryman, in particular, emphasized the positive side of the president. What some saw as a leader's stubbornness, Berryman interpreted as consistency. When some found the president unrealistic, Berryman drew him as bold.

Berryman would even create a new American icon based on the president's exploits. The artist used one of Roosevelt's many hunting trips to create the image of a whimsical "Teddy" bear (figure 4.2); the image became central to Berryman's artwork as well as the basis for millions of children's toys in the years that followed.

Some of Berryman's contemporaries, however, took a very different, and far more serious, view of the early twentieth century. Artists such as Boardman Robinson of the *New York Tribune* and Robert Minor of the *St. Louis Post-Dispatch* wielded grease

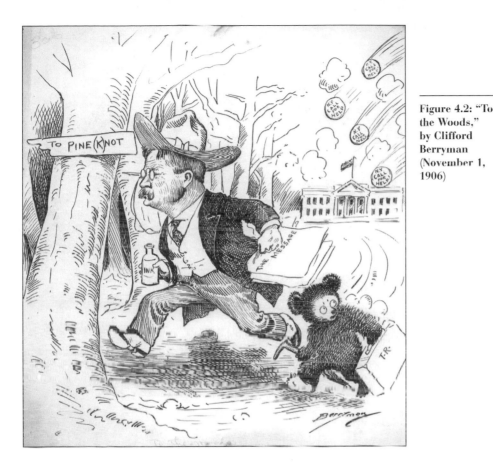

Figure 4.2: "To
the Woods,"
by Clifford
Berryman
(November 1,
1906)

by letterpress," notes Marschall. "In 1900, some newspaper artists still scratched their drawings on chalk-plates, and the printed cartoons were a confusion of awkward, angular lines. Thereafter, pen-and-ink drawing dominated, as photoengraving became standard in the industry."[4]

The market for editorial cartooning was maturing as well: Marschall notes that "a decade [after Teddy Roosevelt became president], almost every major newspaper in the U.S. had at least one full-time political cartoonist."[5] What had been an extravagance within reach of only the most profitable big-city publications at the end of the nineteenth century was becoming a necessity for even midsized papers in the early twentieth. Furthermore, the great newspaper chains fought bidding wars for the services of the top cartoonists, not just with one another but also with the growing array of news magazines. Ultimately, however, this boom in the editorial cartoon market would turn out to be temporary. By the 1920s, the American newspaper industry was going through a wave of mergers, with

pencils to produce grim, ponderous works that reflected a growing unease with world events, a strong contrast to the president's optimism

Roosevelt provided the material,

and evolving newspaper technology provided a continuously improving system for distribution. At the time, "printing techniques made feasible photoengraved line-art mass-produced

the new media powers syndicating the work of their top cartoonists, reducing the total number of cartoonists needed. This trend would continue through the rest of the century.

CARTOONING LEGENDS ARE REPLACED

A year after Roosevelt took office, Thomas Nast died of yellow fever while serving as the U.S. ambassador to Ecuador. Nast's influence had waned as the nineteenth century had come to a close, as he had fallen out of favor with many editors and readers and had turned his talents from political cartooning to creating watercolors and publishing newspapers. Nevertheless, his death marked the end of a golden age in American political cartooning, when the nation's most important cartoonists helped shape local and national policy, helped make and break politicians, and, in some cases, seemed as powerful as their editors and subjects.

The same year that Nast's prodigious career came to a close, the career of one of his successors, Art Young, began to rise. Young worked as a free-

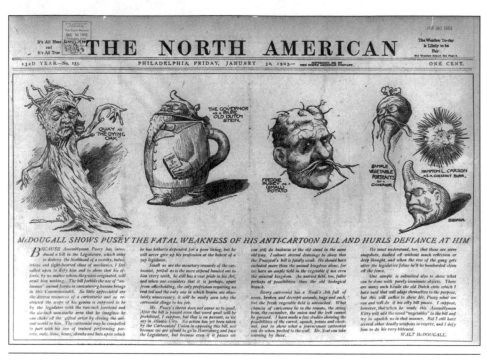

Figure 4.3: "Cartoonists Protest Anti-Cartoon Legislation," by Walt McDougall (1903)

lance cartoonist in New York City, but in 1902 he left the center of American media to work for the campaign of Republican Progressive Robert La Follette, the governor of Wisconsin. Young's political stance shifted rapidly to the left in the years that followed, as he began working with some of the most talented cartoonists and writers of the early twentieth century to give voice to strong antiestablishment positions.

CENSORSHIP ON THE RISE

The new century also saw movement on the legal front, in the form of

How Do You Stop a Cartoonist?

When some politicians are skewered by political cartoonists, they shrug it off. Others seethe quietly. And then there are the activists, who decide to do something about it. Their methods vary, but the outcome is almost always the same—if a cartoonist is out to get them, there's just not a whole lot they can do about it.

The first recourse is usually a threat of libel. Not only does this fail to intimidate, since cartoonists are well versed in their First Amendment protections, but it usually acts as an unintended reward to your enemy—you've just admitted to the cartoonist that he or she has your attention and, even better, has gotten under your skin.

Legislate? Only if you've got enough pull to introduce bills in the statehouse to protect your ego. Alas, history shows that this method tends to fail as well—the legislation proposed is so broad that it's ruled unconstitutional or so specific that it simply spurs the cartoonist to be more creative in demonstrating the myriad other ways the subject can be drawn.

You could pressure the publisher to fire the cartoonist, and occasionally some targets of political cartoons do, but this is a little heavy handed. First of all, a publisher sympathetic to your cause probably wouldn't have printed the cartoon in the first place. Second, if a cartoonist goes after a powerful person with a particularly devastating image and then gets fired the next day, the connection is pretty obvious.

If all else fails, you might grit your teeth and try to win the cartoonist over—but that's also a long shot. Daniel Fitzpatrick of the *St. Louis Post-Dispatch* was so disdainful of the rich and powerful that he refused to meet socially with any prominent businessmen, even going so far as refusing to join the club at which they congregated. It's pretty difficult to schmooze a guy who won't show up.

Finally, there's outright bribery. A representative of the Tammany Hall gang offered Thomas Nast a sizeable sum to go "study in Europe," a barely disguised euphemism for "doing anything other than drawing my employer." Recognizing a bribe when he saw one, Nast negotiated the number up as high as he could and then declined, informing the would-be briber, "I just wanted to see how high you would go."

The best recourse is probably developing a thicker skin and a more charitable sense of humor, taking solace in the fact that a political cartoonist thinks you are important enough to earn his or her wrath. History shows that most other moves will prove counterproductive. ∎

political cartoon censorship. In 1903 Pennsylvania governor Samuel Pennypacker launched an attack on the rights of political cartoonists in reaction to the artwork of Charles Nelan of the Philadelphia *North American*, who regularly depicted the governor as a portly parrot. Pennypacker's legislation, which seems particularly odd in retrospect, was designed to make it illegal to use birds or animals to portray politicians. The proposal had the opposite of its intended effect, inspiring cartoonists to find even more—and more insulting—ways to caricaturize the governor. Walt McDougall of the *North American* responded by drawing proponents of the bill as dying oak trees, lumpy potatoes, and withered squash (figure 4.3). Pennypacker and his supporters learned a harsh lesson to be repeated a number of times in the years that followed: if you think cartoonists are tough on politicians, try censoring them—you

will quickly learn just how vindictive—and creative—they can be.

A law designed to eliminate animal depictions might seem laughable, but Pennypacker's legislation typified government activity at the state level designed to restrict the rights of political cartoonists. New York politicians attempted, unsuccessfully, to legislate against cartoonists for the Hearst chain in 1898. California passed anticartoon legislation in 1899, Indiana in 1913, and Alabama in 1915. The state laws were largely ineffective—they served mainly to motivate political cartoonists to draw more offensive images, with the sponsors of the bills included as targets—but they were indicative of a change in the political climate in America. European unrest was increasing, and the United States was edging toward entanglement in World War I. Cartoonists would soon come under attack not only from state government, but from the federal government as well.

The first decade of the twentieth century came to an end with the birth of Herbert Block. Block wouldn't put pen to paper for years, but his birth is significant because, under the pseudonym "Herblock," he and his colleague Pat Oliphant would eventually lead a new generation of political cartoonists. This modern group would become, if not the twentieth-century equivalent of Nast and Keppler in terms of power and prestige, at least torchbearers for the most influential and antiauthoritarian cartoonists in the country.

1910–1920: The Nation Moves Right and Cartoonists Move Left

The century's second decade included a production change that significantly altered the appearance of political cartoons. "Many artists shifted to the lithographer's crayon on textured paper, a look that was near-universal until mechanical shading (tones applied chemically to the original cartoon) came along in the late 1960s," notes Marschall.[6]

Along with the production change, there was a shift in the tone and political perspective of many of the nation's most important cartoonists. The 1910s produced some of the darkest images in the history of American political cartoons. As war raged in Europe, the American people—and their leaders—engaged in fierce debate over two approaches to the unprecedented bloodshed: isolationism and interventionism. Isolationists used a variety of arguments against the war: that it was Europe's problem, that war wouldn't solve anything; that all wars, and particularly this one, were an exploitation of the powerless. Interventionists argued from a practical perspective—that addressing the war now would keep it from coming to American shores—as well as a philosophical one—that America had an ethical obligation to help keep the peace. Initially, President Woodrow Wilson favored neutrality, but over time the political balance began to tilt toward involvement in the war. When the president asked Congress for a declaration of war in April of 1917, many of the nation's cartoonists lined up to support the administration. But an equally powerful group of artists and

writers was just as forceful in their condemnation of not only the interventionist policy, but also what they perceived as heavy-handed government activity in other areas, including labor law and women's rights.

In Saint Louis, Robert Minor penned antiwar images for the *Post-Dispatch*, the flagship paper of Joseph Pulitzer. Like his contemporary Art Young, Minor had taken a hiatus from his political cartooning, in his case to study art in Europe. He picked a particularly turbulent time to make the move, however, and his year abroad altered his attitudes toward politics as well as art. He returned to the United States in 1914 to work for another Pulitzer paper, the *New York World*. When Minor's editor at the New York paper changed his stance from anti- to prowar and directed Minor to do likewise, Minor refused and was fired.

THE *MASSES*: THE HIGH POINT OF RADICAL CARTOONING

Young, again like Minor, was becoming increasingly strident in his pol-

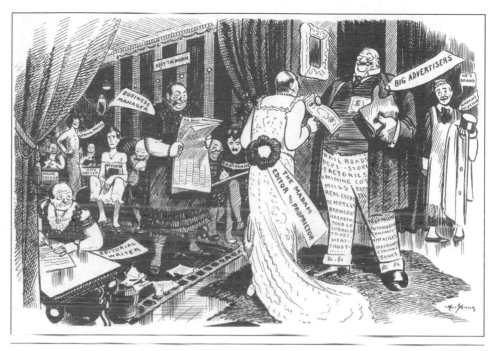

Figure 4.4: "The Freedom of the Press," by Art Young (December 1912)

itics and was being drawn toward a publication that crystallized radical political expression like none other: the *Masses*.

Founded in New York City in 1911, the *Masses* was a socialist publication that featured strong literary and pictorial stands advocating a wide range of

positions: safe working conditions for miners; women's right to vote and receive birth control information; and the formation of a world peace organization. It was best known, however, for attacking authority in any form.

Three cartoons typify the brilliance and passion of the political cartoons in

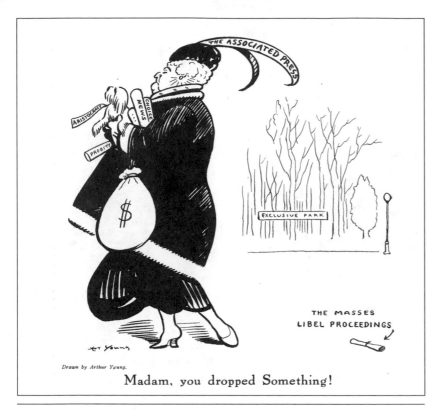

Drawn by Arthur Young.

Madam, you dropped Something!

Figure 4.5: "Madam, You Dropped Something!" by Art Young (February 1916)

Army Medical Examiner: "At last a perfect soldier!"

Figure 4.6: "Army Medical Examiner: 'At Last a Perfect Soldier!'" by Robert Minor (July 1916)

the publication. Figure 4.4 is Art Young's scathing condemnation, not only of business interests, but of the media system that supported them. He further condemned the traditional press in his 1916 depiction of the Associated Press as a stodgy dowager toting a bagful of money (figure 4.5). And figure 4.6 shows Robert Minor's contempt for both soldiers and the administration that enlisted them.

The *Masses* attracted some of the

most talented left-leaning artists of the era: Art Young, Boardman Robinson, H. J. Glintenkamp, John Sloan, Robert Henri, Alice Beach Winter, Mary Ellen Sigsbee, Cornelia Barns, Reginald Marsh, Rockwell Kent, Robert Minor, K. R. Chamberlain, Stuart Davis, George Bellows, and Maurice Becker. This collection of talent drew the attention of many intellectuals, but it also drew the attention of the U.S. government. Federal attempts to dissuade the editors of the *Masses* from voicing antiwar and antiauthoritarian opinions grew increasingly heavy handed as America's involvement in the war increased: from appeals to patriotism, to a restriction on mailing privileges, to the use of the newly passed (and controversial) Espionage Act, federal legislation that was far more sweeping than anything that had been enacted on the state level. Finally, in July of 1917, cartoonists Art Young, Boardman Robinson, and H. J. Glintenkamp and authors Max Eastman and Floyd Dell were charged with conspiracy to undermine the war. Figure 4.7 is the cartoon that the fed

Figure 4.7: "Having Their Fling," by Art Young (1917)

Having Their Fling

eral government presented as evidence against Art Young. It is an imaginative graphic that manages to simultaneously insult four different but powerful American institutions—the media, the political system, business, and the clergy. Neither Young's convictions nor his eloquence were diminished by the

charges: asked during the trial why he drew antiwar cartoons, he responded, "For the public good."

The legal proceedings resulted in two hung juries, but the government's efforts in court, combined with additional efforts to deny the publishers the right to distribute their magazine through the mail, produced the goal federal authorities had sought to achieve all along: the *Masses* folded in December of 1917.

Editor Max Eastman attempted to revive the socialist spirit of the publication almost immediately, in a new magazine called the *Liberator*. Eastman tapped the works of many of the talents who had helped make the *Masses* so powerful: Art Young, Floyd Dell, Boardman Robinson, Robert Minor, Stuart Davis, Maurice Becker, and Cornelia Barns. In 1924, Minor took over as editor; two years later, he renamed the publication the *Worker's Monthly*.

The radical Left cartoonists were not alone in their interpretation of the beginnings of World War I. Press points out that, prior to America's entry into the war, many cartoonists in the American democratic system placed collective blame for the war on the old feudal system of Europe, filled with withering kings who instinctively resorted to war to resolve issues or acquire new wealth. "The shift in American cartoon comment is from one of treating all feudal monarchies as the root cause of war to that of focusing on one type of feudal monarchy as a diseased menace—a kind of special nagging and virulent strain. The type was the Prussian one, in which military pomp and glory were . . . to be the guiding principle of the regime,"[7] Press explains. This interpretation is supported by American cartoonists' near obsession, in both world wars, with the dress and demeanor of enemy leaders in Europe: the kaiser with pointed helmet and epaulettes in World War I, Hitler goose-stepping in massive black boots and gaudy rows of medals in World War II. The four years of World War I would lead to the deaths of nearly ten million people, but it would also create suspicion among Americans, who altered their views about the pomp and ceremony of Old World powers. From the vehemently antiwar to the supremely patriotic, cartoonists of the era produced some of the most imaginative and scathing caricatures in American history.

The 1920s: Women Vote, Cartoonists Lighten Up, Everybody Drinks

The 1920s opened with two constitutional amendments sparking a range of passionate political cartoons. The first was the Eighteenth Amendment, permitting women to vote. A small army of female cartoonists drew in support of the amendment, but the majority of their work was "preaching to the choir," since it appeared in magazines that exclusively targeted women. Many of the suffrage cartoons drawn by men were lighthearted and predictable (figure 4.8), but some recognized that the amendment was a milestone in progress toward gender equality (figure 4.9).

The second constitutional change of

Figure 4.8: "My Dear Lady, I Go Further Than Believing in Woman Suffrage, I Maintain that Man and Woman Are Equal in Every Way: Oh Professor! Now You're Bragging," by William Leroy Jacobs (April 1917)

Figure 4.9: "The Sky Is Now Her Limit," artist unknown (October 1920)

the decade caused even more dissent, because it addressed a topic that had a more direct impact on the day-to-day lives of so many Americans. The Nineteenth Amendment, prohibiting the manufacture, transport, or sale of alcohol, was the subject of an incredible array of cartoons—some for, many against. Cartoonists, like other members of the media, focus on what people are talking about, and they struck

the mother lode when it came to alcohol. Rollin Kirby even developed a special character, "Mister Dry," to symbolize the antialcohol forces. Mister Dry's stern visage and ultraconservative dress indicate how Kirby felt about the movement. It was obvious from the positions Kirby put him in that his character was not favored by much of the public, either: Mister Dry was often shown railing incoherently at a less-

than-enthusiastic audience. Despite—and in part because of—the amendment, the Roaring Twenties were known as a free-wheeling decade when law-abiding citizens broke the rules to drink and lawless mobsters were happy to provide citizens with a product many of them thought it was their right to imbibe. The "Noble Experiment" was a wonderful topic for cartoonists, but it didn't stop the country from drinking.

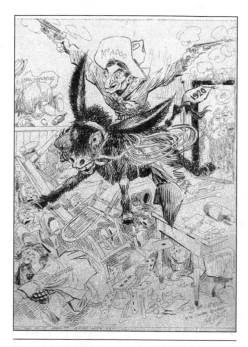

Figure 4.10: "Enter Roarin' Bill, Sheriff of Red Gulch," by Jay Norwood "Ding" Darling (1920)

Perhaps it was postwar exhaustion, perhaps the euphoria of the stock market, but the political cartoons of the 1920s were generally gentler than those that preceded or followed them. While men such as Kirby, Jay Norwood "Ding" Darling of the *Des Moines* *Register* (figure 4.10), and John Mc-Cutcheon of the *Chicago Tribune* could all wield a sharp pen on occasion, they generally portrayed politicians and business institutions in a more digni-fied way than Nast had before or Herblock would after. There were still talented and influential cartoonists, such as Daniel Fitzpatrick at the *St. Louis Post-Dispatch*, who were more interested in changing the world than providing a chuckle, but Kirby and those like him more accurately re-flected the tenor of the times. From his offices at the *New York World*, Kirby would become one of the dominant cartoonists of the decade, winning the first Pulitzer Prize awarded to a politi-cal cartoonist in 1922, then winning again in 1925 and 1929. Cartoons in the decades that preceded him were packed with characters and details, while Kirby chose to focus on a central character in his cartoons, using as few pen strokes as possible to emphasize key features. This style change would be mimicked by many of the artists who followed him.

It was not only the tone of cartoons that was changing, but the media that carried them as well. The technological innovations that made daily cartoons possible in newspapers took some of the luster off the cartoons in newsweeklies, and *Puck*, *Life*, and *Judge* struggled to maintain their voices. In the 1920s, the *Saturday Evening Post* broke the million mark in circulation, making it the nation's dom-inant publication. Unlike the more po-litically oriented weeklies, the *Post* took a gentle, conservative, middle-American approach to cartooning and focused on everyday issues as opposed to overtly political ones. Elite readers found an alternative in 1925, with the introduction of the *New Yorker*, a pub-lication that featured cartoons and es-says clearly designed for a sophisticated audience.

THE WALL STREET CRASH USHERS IN THE GREAT DEPRESSION

The optimism and excesses of the Roaring Twenties came to an abrupt halt in the fall of 1929, when the his-toric crash on Wall Street swept the na-

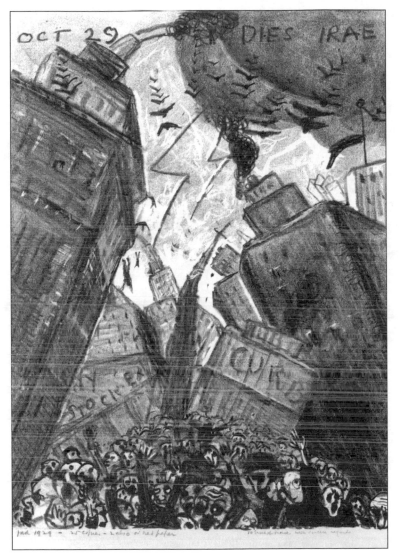

tion into the Great Depression. Artists labored to capture the scope and tumult of the crash, as in the surreal, Armageddon-like image James Rosenberg drew (figure 4.11).

Desperate times produce a multitude of targets for political cartoonists, and the 1930s offered some of the best. Cartoonists such as Herbert Johnson (figure 4.12) called attention to the complicity of the wealthy in causing or at least failing to solve the nation's economic problems. Others, such as Blanche Mary Grambs, emphasized the debilitating suffering of the unemployed. Her image "No Work" (figure 4.13) is heart wrenching because it is so deliberately barren. Cartoonists also took note of the increasingly violent temperament of the times, as poor and unemployed Americans took to the streets in desperation, and their protests were met with violent opposition from the government. Many artists emphasized the plight of the oppressed, as in Jacob Burck's brilliant depiction of a female protester (figure 4.14). Burck's title for the work, "The Lord Provides," made his point even

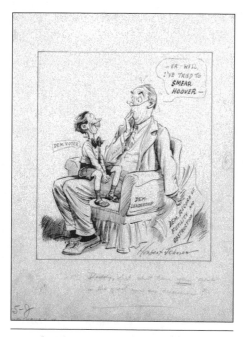

Figure 4.12: "Daddy, Just What Have You Done in the Great War on Depression?" by Herbert Johnson (between 1912 and 1941)

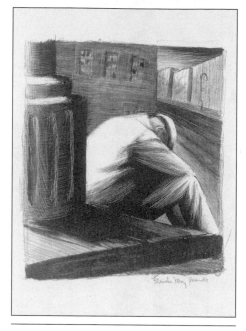

Figure 4.13: "No Work," by Blanche Mary Grambs (1934)

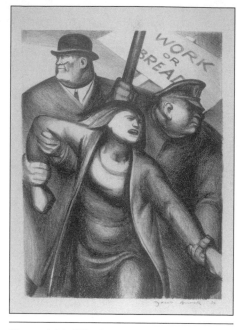

Figure 4.14: "The Lord Provides," by Jacob Burck (1934)

more painful. This work is more reminiscent of the dark, angry work from the *Masses* than the lighthearted efforts from the *Saturday Evening Post*—cartoonists, like many other Americans, felt the painful and destabilizing undercurrents of the times.

THE RISE OF NEW LEADERSHIP: FRANKLIN DELANO ROOSEVELT AND ADOLF HITLER

Nineteen thirty-three brought a new, and far more optimistic, president to the White House: Franklin Delano

Roosevelt replaced the dour Herbert Hoover, and cartoonists had a dramatically different target to caricature. Roosevelt would occupy the White House during some of the most historic moments of the twentieth century: his response to the Great Depression was an

unprecedented expansion of the federal government, and he would lead America in World War II. A larger-than-life figure making bold moves in such historic times was inevitably the centerpiece of enormous controversy, and he would dominate the works of cartoonists for nearly two decades. Fortunately for those cartoonists, he was easy to lampoon. Like his fifth cousin Teddy before him, Franklin offered an oversized smile and a set of programs that provided artists with unlimited material. Cartoonists leapt at his alphabet soup of new policies (NRA, WPA, etc.), collected into the conveniently iconic concept the New Deal.

The U.S. public was understandably focused inward during the Depression, as Americans fought off hunger and bankruptcy, searched for work, and yearned for economic stability. Editorial cartoonists recorded these desperate times but also kept their eyes on the foreign lands that had served as the launching grounds for the calamitous Great War just a generation earlier. A new power was on the rise in Germany, as Adolf Hitler unified and invigorated

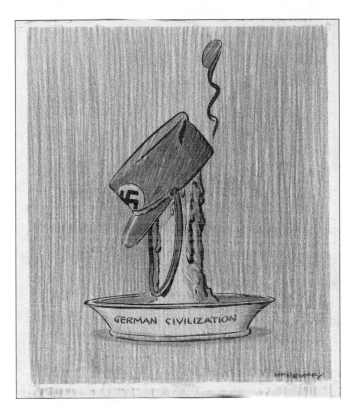

Figure 4.15: "Light! More Light!" by Herbert Block (between 1933 and 1939)

the Nazi Party. In the first half of the 1930s, American editorial cartoonists who noticed Hitler at all usually portrayed him as a political oddity, a quirky, overly emotional xenophobe left over from a period many would have liked to put behind them. As

Hitler grew more influential, however, cartoonists began to draw him as less comical and more menacing. Artists like Jerry Doyle of the *Philadelphia Record* caught on early—recognizing the dangerous potential of a man of Hitler's ferocity and will in a nation

searching for leadership and redefinition. Herbert Block used the dying words of Johann Wolfgang von Goethe to demonstrate the suffocating effects of Nazism on the German people (figure 4.15). When they did turn their attention to growing problems in Europe, artists like Daniel Fitzpatrick of the *St. Louis Post-Dispatch* made up for lost time by creating disturbing images of events overseas. Fitzpatrick's bleak, ominous depiction of a huge swastika chewing up the European landscape provided ample warning to his readers of the potential horrors of Adolf Hitler. Fitzpatrick's art emphasized the symbolic over the personal, and his strength was in bringing broad concepts, rather than individuals, to life.

WORLD WAR II CARTOONS: THE PUBLIC AND THE PERSONAL

As European conflicts escalated and a second world war loomed, political cartoonists in America again took sides between intervention and isolation. The enormity of the stakes for America lent an increasingly dramatic tone to

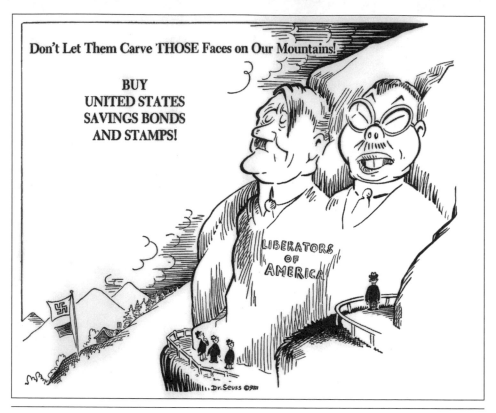

Figure 4.16: "Don't Let Them Carve THOSE Faces on Our Mountains!" by Theodor Seuss Geisel (December 12, 1941)

the cartoons. For example, from 1941 to 1943, Theodor Seuss Geisel, later known by the more popular title "Dr. Seuss," drew prowar cartoons for the New York *PM* publication. The images

were childlike, but the messages were deadly serious. Seuss also produced a series of cartoons designed to sell U.S. savings bonds during the war (figure 4.16) and drew some of the more

scathing depictions of foreign leaders. His output was astonishing, and his message was passionate. Geisel's art work for his political cartoons was not much different from that of his children's books, and some of his political philosophy comes through quite clearly in the whimsical rhymes he would create for young people. But the political cartoons were as harsh as those of any cartoonist of his era: his depictions of Japanese leaders were overtly racist, and his dismissal of the peace movement was disdainful.

Geisel's work typified efforts to tackle the big personalities and issues of the war. But it was another cartoonist, Bill Mauldin, who captured the war on a personal scale. Mauldin had an up-front view of the action as a private in the United States Army's Forty-fifth Division. In 1940, he began drawing two run-of-the-mill soldiers, Willie and Joe (figure 4.17), who came to represent the average men of the war—men who were simply doing their jobs. Mauldin's characters neither glorified nor demonized the war—they simply plodded through it. This made them

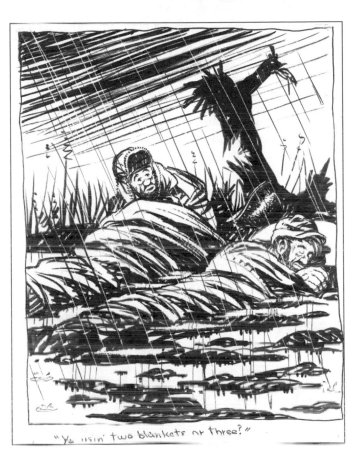

Figure 4.17: "Ya Usin' Two Blankets or Three?" by Bill Mauldin (between 1943 and 1945)

"Ya usin' two blankets or three?"

exceptionally popular with the troops and equally irritating to the generals. The focus on two regular guys and their small, day-to-day triumphs and sacrifices was a stark contrast to the dominant, earth-shattering themes employed by most cartoonists. Mauldin's work was so beloved that it gained a progressively larger distribution: originally appearing in the *45th Infantry*

Division News, advancing in 1944 to the armywide paper *Stars and Stripes*, and, at war's end, appearing on the cover of *Time* magazine.

Success came early in Mauldin's life—he was twenty-three when he received the first of two Pulitzer Prizes—but he would go on to make his mark in a variety of media. He drew for the *St. Louis Post-Dispatch* and the *Chicago Sun-Times*, wrote a series of books, and even appeared in the film *The Red Badge of Courage*. When he retired in 1992 he was syndicated in nearly 250 papers, but his legacy remains the image of two exhausted guys, slogging through the mud. Ultimately, Mauldin succeeded in doing what great cartoonists do: stripping away false impressions and providing readers with a greater understanding of the truth.

A HALF-CENTURY OF DESTRUCTION AND DEPRESSION

Editorial cartooning entered the twentieth century under ideal conditions. This was the last period in which print media would dominate over broadcast. It was a time when the U.S. population continued to grow, providing a ready audience for cartooning. The Youngs and Minors, the Darlings, Duffys, and Kirbys were all brilliant, each in a unique way. They recorded the calamity of two world wars and the nation's greatest economic depression, as well as the thirteen-year presidency of a man who dominated the nation's direction and tone. Some cartoonists drew from a serious, almost apocalyptic worldview that reflected the times. These men and women focused on the broadest possible themes, reflecting a perspective that history was a battle between clearly defined good and evil. Some drew from a gentle, personal perspective, trying to inject humanity into a world that could seem overwhelming and frightening. All these cartoonists helped their readers interpret and deal with an era when large events had significant impact on the day-to-day lives of Americans.

FIVE

Cartooning in the Broadcast Era

1946 TO 2000

The way politics is run in America, the politicians deliver themselves through television and through spin doctors . . . they are trying to deliver a notion of who they are through an image. There's only one person who can de-spin that image and that is the cartoonist, and so they watch them very, very carefully.[1]

KEVIN KALLAUGHER, CARTOONIST FOR THE *BALTIMORE SUN*

THE END OF World War II brought temporary peace to most of the planet and the return of millions of American men to their stateside homes. The years following the war featured new trends in politics (the reemergence of the conservative movement) and demographics (the Baby Boom, a growth spike that influenced every facet of the nation). The biggest changes, however, were technological. America was transformed by new inventions, the most significant of which was television.

The events of the broadcast era fundamentally altered the way people processed information about the world around them. They also dramatically reduced the importance of the editorial cartoonist.

Postwar America: Media and Issues Grow More Complex

When peace was announced in August of 1945, political cartoonists reacted as their predecessors had after earlier conflicts: with an initial burst of joy and relief, followed by a period of reflection and analysis of the war and the nation's role in it. After World War II, however, cartoonists had a new, thought-provoking concept to address: the atomic bomb. Herbert Block introduced his sinister "Mister Atom" character in 1947, then continued to use him to remind readers of the growth and danger of atomic power. Block's attitude toward atomic war: "The little men who have busy days tossing around explosive comments should not be in a position to do the same thing with bombs."[2] Atomic power was a natural draw for a political cartoonist—it was frightening, it was mysterious, and, because it made an impact throughout society, it was controversial. Mister Atom would be a recurring theme for Herbert Block, as figure 5.1 shows—the cartoon was published nearly twenty years after Herblock introduced Mister Atom, and

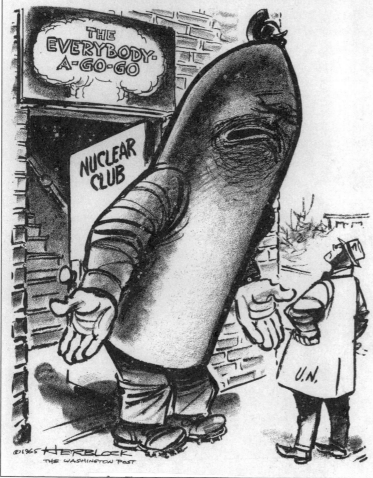

"You Mean You Want To Close The Joint Just When I Was Beginning To Get A Crowd?"

THE EVERYBODY-A-GO-GO

NUCLEAR CLUB

©1965 HERBLOCK
THE WASHINGTON POST

U.N.

Figure 5.1: "You Mean You Want Me to Close the Joint Just When I Was Beginning to Get a Crowd?" by Herbert Block (November 26, 1965)

by this time the menacing bomb towered over fearful people.

But the introduction of atomic weaponry was only one adjustment for postwar America. The GI Bill, suburbanization, the beginnings of the Baby Boom—America at midcentury witnessed changes in the way people lived, worked, studied, and played. But nothing had a bigger impact on society, and on political cartoons, than the introduction of television.

While television was technologically viable during World War II, it gained widespread acceptance only after the war was over. In fact, the adoption rate of television in America was unlike that of any other medium. In 1950, fewer than 10 percent of American households had a television set. A decade later, fewer than 10 percent of American households were without one. In a single decade, America changed from a land of newspapers and radios to a nation dominated by the TV screen. It wasn't just the number of televisions that increased, but the time Americans spent with the medium as well. In 1950 the average

daily viewing time was four and a half hours per day. This average has climbed consistently since then; by the end of the twentieth century, a television was on in the average American household for more than seven hours per day.

Suddenly, print no longer ruled, and newspapers in general and political cartoonists in particular were forced to reconsider their audiences. "In the postwar world, newspaper editorial pages further sharpened their appeal to what was left—the politically knowledgeable. . . . Controversy was not only tolerated in syndicated cartoons, but finally became chic," notes Charles Press.[3] Two of the era's most talented cartoonists, Herbert Block of the *Washington Post* and Pat Oliphant of United Press Syndicate, recognized that they had to rethink their approach to their craft.

Herbert Block Shoots at the Big Targets

By the time television was introduced, Herbert Block had been drawing politi-cal cartoons for twenty years. He began cartooning in 1929 for the *Chicago Daily News* and, beginning in 1933, drew for a decade for the Newspaper Enterprise Association, or NEA, a Scripps-Howard syndicate. In 1946 he arrived at the *Washington Post*, where he spent his remaining fifty years, earning three individual Pulitzer Prizes and sharing a fourth.

A number of factors contributed to Block's brilliance. He was morally consistent throughout his career, a New Deal liberal who lampooned general authority with whimsy and specific politicians with a vengeance. The generic characters in his cartoons were traditional authority symbols, bombastic congressmen, and haughty society matrons. The artwork was not so much vicious as it was deflating—Block took the starchiest characters and added even more starch, until they exploded in self-importance. He exploited individual forms of hubris in world leaders: in France it was the vanity of De-Gaulle; in the Soviet Union, the pomposity of Khrushchev; in America, the cockiness of the Kennedys and the befuddlement of Reagan. In the 1950s he attacked with every creative tool in his arsenal the fear-mongering of the destructive senator Joseph R. McCarthy. Two decades later, he would focus his efforts on exposing the exploits of another politician he found particularly dangerous: Richard M. Nixon.

Herbert Block is a rarity—a timeless cartoonist—because his images transcend the decades in which he drew them. His bureaucrats are lazy, his politicians dissembling, his businessmen carnivorous—perceptions held from the beginning of the twentieth century to the beginning of the twenty-first.

Pat Oliphant, an Australian immigrant, shied away from icons and labels, instead depending on a cast of long-faced characters portrayed from nontraditional angles to make his points. His conceptualization of events was strong, but the strength of the Oliphant cartoon was often the artwork: he could draw a portrait that captured the personality, rather than the physical features, of a politician. His politics were not overly ideologi-

Herblock versus the Class of '47

Herbert Block championed many causes, but perhaps his most passionate was civil liberties. When two Republican newcomers, Senator Joseph R. McCarthy of Wisconsin and Representative Richard M. Nixon of California's Twelfth District, entered Congress in 1947, Block wasted no time identifying them both as threats to the average American. In the decades that followed, Block not only worked tirelessly to combat their efforts, he had a hand in shaping America's perception of both men.

Soon after arriving in Washington, McCarthy and Nixon became stars of the House Un-American Activities Committee (HUAC), a paranoid, fear-mongering group that operated for four years. The HUAC took the approach, as Block later wrote, that "if we couldn't crush communism abroad, a person could nail a neighbor at home."[a] The cartoonist drew both McCarthy and Nixon as sinister figures (figure 5.2) who were bent on destroying individuals and basic rights in their delusional attempt to rid the nation of Reds and fuel their own political careers. Herblock's influence on the public perception of the two men rivals Nast's influence on Boss Tweed's reputation: Herblock coined the term "McCarthyism" and affixed a five-o'clock shadow to Nixon that became one of the president's many obsessions. It is a testament to Block's conviction and clarity of thought that, in an era of hysteria and widespread suspicion, he remained consistent in his principles and convinced that it was HUAC, not communism, that represented the bigger threat to American society.

By the end of 1954, the two politicians' careers were headed in diametrically opposed directions: McCarthy was censured by his embarrassed Senate

Figure 5.2: "Mirror, Mirror, on the Wall, Who's the Fairest One of All?" by Herbert Block (January 2, 1960)

colleagues, which effectively ended his power, and Nixon gained the vice presidency under Dwight Eisenhower. The changes in political power did nothing to dissuade Herblock, however, who continued in his relentless condemnation of the morals and methods of the two politicians. (When Nixon was elected president in 1968, Herblock made one clever exception to his ongoing criticism. He drew a cartoon that shows him giving the newly elected president a reprieve, a clean shave, and an opportunity to change his ways. One of Herblock's many admirers in the profession, Ann Telnaes, would later honor Herblock with her own version of his cartoon (figure 5.3). Telnaes's version, showing Herblock wielding an instrument that is more meat cleaver than barber tool, probably comes closer to showing her hero's true feelings. Whatever reprieve Herblock gave Nixon was short-lived. He later wrote, "The hope, however faint, that the presidency might have an ennobling effect on Nixon was soon dashed. The dark shadow that had been on his face soon spread across the country."[b])

Block skewered Nixon straight into his second term, throughout his impeachment, and even after he had left office. His anger at the two members of the class of '47, and his passion for the rights of the average American, burned in him until his death in 2001. ∎

Figure 5.3: Herblock Preparing to Give Nixon a Close Shave," Gift of Ann Telnaes to Herblock in 2000

cal—he could lampoon the American Civil Liberties Union one day and the National Rifle Association the next.

"His role, as he sees it, is to ridicule idiocy wherever he sees it," notes historian Charles Press.[4] Richard

Marschall notes that when Oliphant is drawing, "humor often creeps in but mostly his visions are apocalyptic, his

Truman Beats Dewey and Cartoonists Eat Crow

Nobody likes to admit that they are wrong, but it's particularly difficult for editorial cartoonists, who are notoriously wedded to their opinions. In 1948, however, many cartoonists, along with other members of the media, were forced to eat crow over their predictions about the presidential election.

Harry Truman succeeded Franklin Delano Roosevelt when the four-term president died in April of 1945. Truman was considered by many an accidental and ineffective president, and when he ran for a second term in 1948, he seemed particularly weak compared to the dashing Republican candidate, Thomas Dewey. Truman's chances were further dampened by the third-party

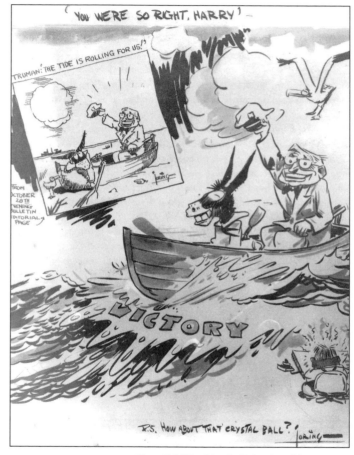

Figure 5.5: "You Were So Right, Harry," by Paul Loring (Providence Evening Bulletin, 1948)

Figure 5.4: "Each to the Other: Now Look What You've Done," by Jay Norwood "Ding" Darling (Des Moines Register, 1948)

candidacy of Henry Wallace, who, in theory, would further deplete Truman's political base. By November, Dewey's election was a foregone conclusion in almost all major media, and cartoonists were already preparing their day-after-election artwork. One of the leading cartoonists of the day, Jay Norwood "Ding" Darling, had drawn Wallace and Truman blaming each other for Dewey's election (figure 5.4).

When Truman won in an upset, the media were stunned. The *Chicago Tribune* had preprinted newspapers with the incorrect headline "Dewey Defeats Truman," a copy of which the president gleefully brandished for photographers. As part of the postelection analysis, a few editorial cartoonists, such as Paul Loring (figure 5.5) and Bruce Russell (figure 5.6), included revised versions of their earlier work to poke fun at their own predictions. The mea culpa from so many prominent artists was unprecedented: it is rare for cartoonists to admit the error of their ways, but then, this was a most unusual election. ■

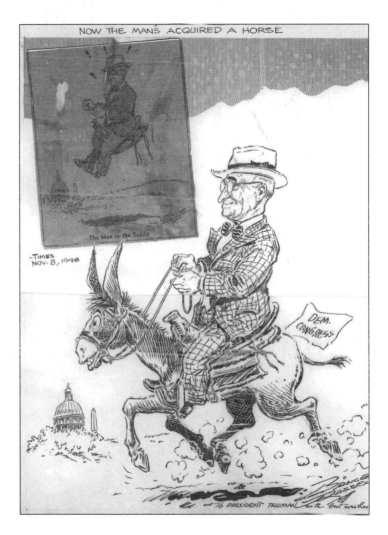

Figure 5.6: "Now the Man's Acquired a Horse," by Bruce Russell (Los Angeles Herald, 1948)

thematic preoccupations somber."[5]

The 1950s presented Herblock, Oliphant, and their colleagues with a unique set of paradoxes as fodder for their work. In many ways, the era was symbolized by the president who dominated it, Dwight Eisenhower: a product of the war who governed over a peaceful, relatively prosperous period. On the other hand, it was the age that gave rise to the paranoia of McCarthy and Nixon, a time featuring the Red menace and the Cold War, and it included an undercurrent of strong racial tensions. Cartoonists could look at the times and come away with dramatically different perceptions of what was happening in such a fragmented society.

The 1960s: Blurred Images

Cartoons of the 1960s tend toward the extreme, a reflection of tumultuous times and extremist positions. Continuing racial tension, a redefinition of sexual mores, increased radicalism and political awareness on college campuses, a series of high-profile assassinations,

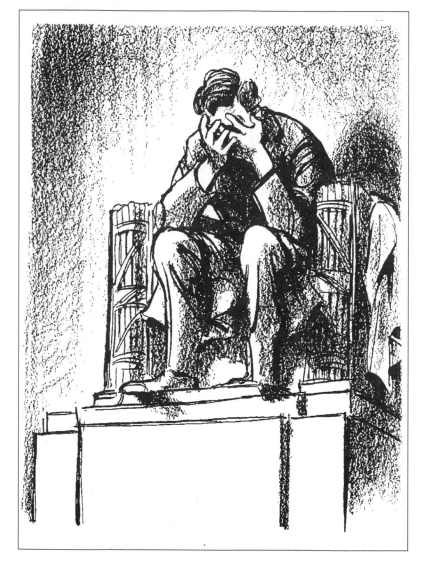

Figure 5.7: Untitled, by Bill Mauldin (*Chicago Sun-Times,* November 23, 1963)

Syndication: Be Careful What You Wish For

As this book goes to print, the cartoon syndication services in America prepare to celebrate their one-hundredth anniversary. There is no question that these services have increased the incomes of many cartoonists and made possible a wider distribution of editorial cartoons than any newspaper ever could on its own. And yet, syndication is the double-edged sword of the cartooning profession.

On the positive side, syndication helps artists gain exposure beyond their home base, providing additional readers, and income, for their work.

But there are short-term and long-term arguments against syndication. The first short-term argument is that syndication prevents the reader and the cartoonist from developing a bond, whereby a newspaper's loyal readers come to understand and agree or disagree with the philosophy of the artist because they see the artist's work on a regular basis. The second short-term argument is that syndication drives cartoonists toward national and international issues: Why, for example, would an editor in San Francisco want to run a cartoon about a dustup between city councilmen in Saint Louis? Ultimately, syndication leads to a reduction in coverage of local issues.

Does that matter? Since many cartoonists feel that they have a bigger impact on local issues than national ones, the answer is yes. Syndication may go beyond homogenizing topics into homogenizing presentation: Hess and Northrop state that cartoon syndicates "are responsible, in large part, for cartooning's look-alike styles."[a]

The most important ramification of syndication may be the negative impact it has on the overall health of the political cartoon profession. When editors can rely extensively or even exclusively on syndicated work, there is no economic reason to hire a full-time cartoonist. Why pay a regular salary for what is, inevitably, uneven output, when you can choose from among the nation's best and pay à la carte? Most cartoonists today feel that syndication, more than any other factor, is rapidly eroding the future of the political cartoon. ∎

and, weaving throughout it all, a war on the other side of the globe all produced a dizzying array of images for political cartoonists.

The decade started on an upbeat note, with a dynamic young president, John F. Kennedy, whose primary political tools appeared to be his family's wealth and his personal charisma. Political cartoonists, reflecting the sentiment of the majority of Americans, were enamored of the new president and showed him predominantly in a positive light. As all presidencies do, JFK's reign began to show cracks over time, with administration mistakes such as the Bay of Pigs fiasco. Cartoonists' treatment grew more critical with each error, and Kennedy, like icons such as Lincoln and Roosevelt before him, was treated as just another politician to cartoonists covering his presidency. When he was assassinated in November of 1963, however, Kennedy passed into the pantheon of sacrificed presidents, which elevated him to a stature similar to, but not quite equal to, that of Abraham Lincoln. Interestingly, one of the most enduring images from the Kennedy assassination—the Bill Mauldin cartoon (figure 5.7) that captured the nation's grief—actually employs the imagery of Lincoln.

The legacies of Lincoln and Kennedy have become increasingly dissimilar over time, however. Unlike Lin-

coln's image, perceptions of Kennedy have been tarnished in the decades following his assassination. While cartoonists—and Americans—sometimes include both men in their lists of great presidents, it is doubtful that history will rank the president from the 1960s with the leader of the Civil War era. This reflects both the amount of time and the periods in which the two men served. Lincoln was elected twice during what was arguably the most critical phase in the nation's history: While he is remembered for his death, he also left a rich and significant record of public service. Kennedy's assassination reinforced perceptions of his youth and charisma, because it precluded the possibility of the nation watching him grow old. He is remembered predominantly for his death and for unfulfilled promise, which far overshadow any tangible impact his presidency had on American society. JFK will remain an icon, but will never be the equal of the Civil War president as one of the nation's premier symbols.

Kennedy was succeeded by Lyndon Johnson, whose presidency is predomi-

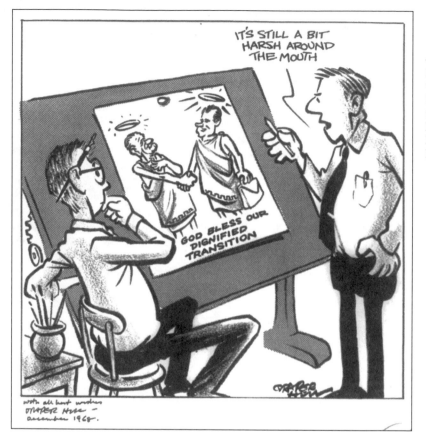

Figure 5.8: "It's Still a Bit Harsh around the Mouth," by Draper Hill (November 30, 1968)

nantly framed by the events of the Vietnam War. In conflicts prior to Vietnam, America faced large, clearly defined "fronts"—military lines that were easily drawn by generals and car-

toonists. In Vietnam, however, it was far more difficult to identify the enemy, the policy, and the rationale for conducting the war. The conflict was initially labeled a "police action," later

described as an internal dispute, and, only over time, called an American war, making it difficult for the media and the public to get a handle on the scope and purpose of the military operation. Cartoonists struggled to find the right tone and imagery to comment on such a complex and ambiguous program, and the most memorable cartoons of the era stressed the frustration and anger of the American people, rather than some clearly identifiable evil.

Some of the American political cartoons of the time used traditional methods to demonize the enemy, but a great deal of the political cartooning of the Vietnam era became as muddled and confusing as the war itself—goals and tactics not only were unclear, but shifted as the war progressed. Leftist and isolationist cartoonists knew that something was wrong with the war, but clearly stating the problem was difficult, making it nearly impossible to suggest solutions. Johnson was left to resolve a war that he hadn't begun and was simultaneously portrayed as victim and aggressor, problem and solution (figure 5.8). Johnson cartoons were also complicated by the contradictions between the man's persona and his policies: he was a lanky Texas good ol' boy with a thick drawl who was a staunch advocate of civil rights.

Along with the war, civil rights dominated the Johnson presidency, but editorial cartoons on the topic demonstrated America's acute sensitivity to race. National African American figures such as Martin Luther King Jr. and H. Rap Brown symbolized different aspects of the civil rights movement, yet they rarely appeared in editorial cartoons, even those focusing on civil rights. Caricature is a critical ingredient in cartooning, and it may be that the cartoonists of the era did not want to caricature these men for fear of being accused of racism. This double standard may actually make it harder for the media to legitimize minority leaders—if they can't be ridiculed the same way as traditional white leaders, they may not have truly "made it" into the arena of public discourse. (See the section of chapter 7, "Ethnics and Ethics," for a discussion of racial presentations.)

Nixon's the One

If political cartoonists thrive in times of hypocrisy and crisis, they were sure to excel during the presidency of Richard M. Nixon. The California Republican had been a target of cartoonists since his arrival in Congress, but when he ascended to the White House in 1969, Nixon was attacked as viciously as any president in American history. It was easy to focus on his physical attributes: Nixon's hunched figure, elongated face, and ski-slope nose made wonderful targets. But his appearance cannot explain cartoonists' obsession with the man—the connection was deeper and more visceral. Nixon may have been the most conniving man to ever serve as president, and the nation's editorial cartoonists were determined to capture his every duplicitous move and calculated obfuscation. Their suspicions were confirmed in the president's cover-up of the Watergate scandal, and when Nixon vacillated, misled, and told outright lies to defend himself, he provided cartoonists with their best material. In 1974, Nixon's

impending impeachment was short-circuited by his resignation, although that didn't stop many cartoonists from continuing to skewer him for many years after he left office.

The Great Communicator

In 1982 Americans selected as their president Ronald Reagan, a polarizing figure who was lionized by his supporters and detested by his detractors. The Republican president provided a number of easy-to-use features for cartoonists: his acting career and his cowboy persona; his unfailing optimism and unwavering ideology; his reputation as the Great Communicator coupled with his frequent mental slips. Reagan was the antithesis of his predecessor, Jimmy Carter, who was perceived as a fundamentally good person but a weak and vacillating president. Like Kennedy, Reagan benefited from a personal optimism and charisma that helped him win over many cartoonists and Americans. Also like Kennedy, Reagan suffered a significant erosion of that image during his years in office, particularly during the Iran-Contra af-

fair, which resulted in questions about both his competence and his ideology. For decades after his presidency, Reagan remained a kind of political Rorschach test: a model of presidential strength to his supporters and an example of the danger of ideological rigidity to his detractors.

As the twentieth century came to an end, cartoonists who had missed the chance to explore the impeachment process with Richard Nixon got a new opportunity with President William Jefferson Clinton. Clinton, like Reagan a two-term president who polarized the nation, was also exceptionally charismatic but always had a touch of sleaze about him. As Reagan was reviled by many liberals, Clinton was detested with the same passion by many conservatives. Even before he took office, he was branded as a schmoozer by those who liked him and a forked-tongued womanizer by those who didn't. His sexual dalliances eventually led to a series of lawsuits, during which he perjured himself while giving testimony, providing his opponents with an opportunity to engineer his impeachment.

Cartoonists, like the nation itself,

were divided on the trial, some portraying it as a Republican witch-hunt while others skewered the president for his words and actions. The circus atmosphere provided plenty of quotes, characters, and situations for cartoonists of every political persuasion. Like Nixon before him, Clinton found that cartoonists focused far more on his hypocrisies than on any particular action, but there was a difference in the tone of many mainstream cartoonists in their portrayals of the two presidents. Nixon's crimes were considered attacks on the central tenets of American justice, while Clinton's crimes were portrayed as offshoots of an overactive libido and a loose moral code. Clinton survived the impeachment process and the corresponding barrage of political cartoons, but not without significant damage to his credibility.

The Close of the Century: Changes in Style and Content

As the twentieth century wound down, more cartoonists began blending the high and low culture associated with the period. Many, such as Steve Kelley

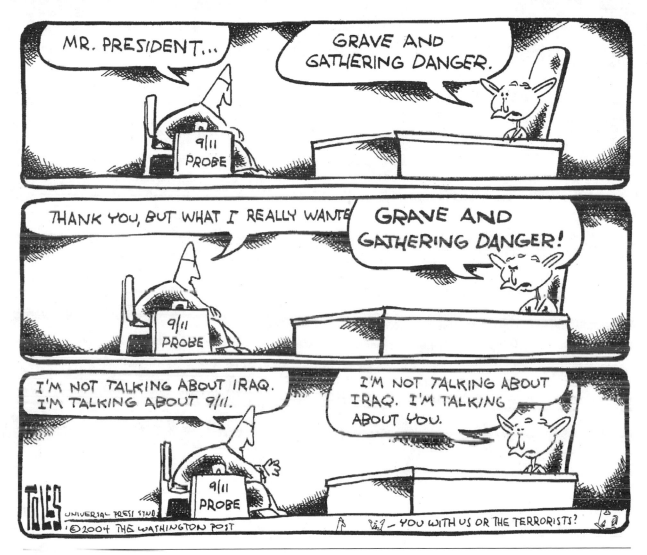

Figure 5.9: "Grave and Gathering Danger," by Tom Toles (January 30, 2004)

of the *San Diego Union-Tribune*; Tom Toles, first with the *Buffalo News* and then the *Washington Post*; Dan Wasserman of the *Boston Globe*; and Jim Morin of the *Miami Herald*, returned to the multipanel approach normally found on the comics page. Toles, one of the nation's most talented cartoonists, continues to use extremely simplistic, minimalist artwork to devastating effect (figure 5.9).

Traditional cartoon characters and scenes began to change during this period as well. Figures became even more homogenized—the average American was white, middle-aged, a little lumpy, and frequently seated on the couch, reacting to television news. In fact, the television screen became a common editorial cartoon scene—"talking heads,"

or people reading or reacting to the news, became a staple in the political cartoon world, and editorial cartoon characters were even drawn from, or placed in, television shows. As more and more Americans spent more and more time in front of a television set, cartoonists who could no longer compete with television co-opted it, making TV a tool of their own medium.

1950 to 2000: Cartooning in a Downward Trajectory

Ultimately, editorial cartooning in the second half of the century suffered a slow, inexorable descent, as the print media struggled to compete with the increasing popularity of television. The issues of the era, from international relations to sweeping social changes, were more nuanced and complex than issues of earlier decades; this complexity brought new challenges to cartoonists who had often presented simplistic positions. An era of clearly defined heroes and villains gave way to an age of indecipherable and perplexing changes in government, social mores, religion, business, and, especially, technology. Along the way, the great post–World War II cartoonists, the Herblocks and Oliphants, continued to evolve. They were joined by a new group of talented and irreverent artists who frequently saw the world in less black-and-white terms but still found plenty of topics to entertain their readers.

PART II

The State of the Art: The Modern Editorial Cartoon

The first five chapters of this book trace the history of political cartoons from the American Revolution to the end of the twentieth century. The final four chapters examine the profession from a number of alternative perspectives.

Chapter 6, "Creators and Consumers," focuses on the artists who draw the cartoons and their audience. Chapter 7, "Process and Effect," examines how cartoons work and discusses research findings about their short- and long-term effects. Chapter 8, "In Their Own Words: Cartoonists on Cartooning," is a collection of observations by editorial cartoonists, editors, and historians on topics ranging from careers in the profession to ethics in cartooning. Finally, chapter 9, "The Future of American Editorial Cartoons," looks at how media mergers, syndication, and advances in technology are influencing the world of editorial cartoonists.

SIX

Creators and Consumers

People do not turn to cartoonists to learn what to think. Rather, they turn to cartoonists to be confronted with an opinion—one that could just as easily be unpalatable as palatable.

CARTOONIST BILL WATTERSON

WHO CREATES CARTOONS and who reads them? This chapter examines the artists and the audience to identify some of the common characteristics of people involved in editorial cartooning.

Cartoonists: A Demographic Profile

"Put today's cartoonists together in a room and you will find a sea of 200 casually clad white males, their ranks interrupted with only an occasional flash of skirt or alternate skin tone," noted Hess and Northrop in 1996.[1] Indeed, the overwhelming majority of editorial cartoonists in American history are white and male. The vast majority of the nation, on the other hand, is not. In 2000, 51 percent of the American population was female and more than a quarter was black, Hispanic, or Latino.[2] The nation will grow increasingly diverse in the coming decades, and if the cartooning community maintains its current demographic profile, the disparity between the people who draw editorial cartoons and the people who read them is sure to increase.

Mike Ritter, a gay cartoonist whose work appears in the *Scottsdale (AZ) Tribune*, suggests that editorial cartooning remains a bastion of white, middle-class heterosexual males because these are people who, from an early age, feel comfortable presenting their opinions. "It's perfectly normal for young boys to be assertive, to be opinionated," he explains. "In fact, it's encouraged. They operate in the mainstream. On the other hand, girls who draw and who have strong opinions are unusual, and they are sent off somewhere else. And a lot of minorities and gay people tend to keep a low profile, because they don't feel comfortable as part of the regular power structure."[3]

Ritter, the 2003–2004 president of the Association of American Editorial Cartoonists, also sees the demographics of editorial cartooning as a reflection of the newsroom itself. "Keep in mind that it's natural that a lot of people tend to hire people who look or seem

like themselves. That's just the way it is, and it's reflected in the newsroom, particularly in the editorial department, which is largely white, middle-class males."[4]

Changes in the gender and ethnicity of the cartooning community are happening, albeit at a glacial pace. Changes are happening beyond these traditional demographic categories as well, from the political perspectives to the sexual orientation of the artists.

The Gender Issue

Editorial cartooning has been called "the ungentlemanly art," but it's almost exclusively "gentlemanly": There have been very few women in the history of the profession. Those women who have managed to make a living at it, however, have excelled at their craft.

The first was Edwina Dumm, born in Sandusky, Ohio, in 1893. She began working as a staff artist for the *Columbus (OH) Monitor* in 1915 and quickly gained a position as the paper's daily cartoonist. Dumm was ahead of her time, and not only in terms of gen-

der—she published political cartoons before she was old enough to vote. The *Monitor* folded in 1917, and Dumm moved to New York City, where she began drawing for the Matthew Adams Service. Although Dumm was no militant feminist—in fact, many of her most memorable characters were male—she was fortunate enough to draw during the suffrage movement, and some of her most powerful cartoons addressed the issue of women's rights. Over fifty years, she produced an enormous body of work, including art for magazines and books as well as a series of cartoon strips (*Cap Stubbs and Tippie, Sinbad,* and *Alec the Great*).

The second successful female cartoonist was also an Ohio native. Lillian Weckner Meisner was born in Akron in 1923 and made her first money as a freelance cartoonist for the *Chicago Tribune.* In 1966 she began a series of jobs for the *Trumbull (CT) Times,* including work as a staff editorial cartoonist. Meisner was the first woman member of the Association of American Editorial Cartoonists, joining in 1975. She returned to the Midwest to

join the *South Bend (IN) Tribune* in 1977, where she contributed a weekly cartoon for the next eleven years.

Female American cartoonists of the 1970s and 1980s include Etta Hulme, who drew for the *Texas Observer* and the *Fort Worth Star-Telegram*; Kate Sally Palmer, editorial cartoonist for the *Greenville (SC) News*; and M. G. Lord, who drew for *Newsday.*

In 1992 a female cartoonist finally won editorial cartooning's highest award, when Signe Wilkinson of the *Philadelphia Daily News* was awarded the Pulitzer Prize. Wilkinson began her career as a freelance cartoonist and a journalist at the *West Chester Daily Local* outside of Philadelphia before taking a full-time staff position at the *San Jose Mercury News* in 1982. She returned to her native Philadelphia three years later to join the *Daily News,* and has proven to be a fiercely independent cartoonist as well as an advocate for female cartoonists. Wilkinson is mildly optimistic about women in the profession, as she made clear in 1999: "Fortunately, in a recent nationwide cartooning contest for kids, girls won first and

Artist? Journalist? Social Critic? Classifying the Editorial Cartoonist

I f it is the concept, and not the artwork, that determines the quality of an editorial cartoon, then how should we classify the cartoonist? Artist? Journalist? Something in between?

Historian Gerald W. Johnson argues that the profession has changed over time, and that the change has been caused by technology:

> The history of the American political cartoon falls into two periods distinguished by a radical transformation in the status of the cartoonist—the period before and the period after the coming of photoengraving, the high-speed press, and other mechanical instruments of rapid reproduction. In the earlier period the cartoonist was an independent artist; in the second, beginning in the latter half of the nineteenth century, he became an organization man, charged with responsibility for only one element in a complex product that is the work of many men.[a]

Johnson notes that the early cartoonist distributed his work, individually, through an independent printer—that it was essentially an independent creative project, with no thought given to its relation to any larger medium. Johnson points out that the distribution was independent, as well—printers would print cartoons of any political persuasion, as long as the work would sell. It is this independence that argues for classifying the cartoonist as an artist.

But an artist normally has the advantage of reflection, of taking whatever time is necessary to complete the art: you wouldn't hold Picasso to a deadline. The modern editorial cartoonist must produce a finished product on time and on a regular basis. This, Johnson argues, makes the profession more similar to journalism. As further proof, he points out that the leading award for the profession, the Pulitzer Prize for Editorial Cartooning, comes from the journalism field.

But this, again, is an insufficient classification. The goal of journalism is to present facts; the goal of the editorial cartoonist is to persuade, to entertain, or to do some combination of the two. The cartoonist uses the tools of the artist, under the deadlines of the journalist, to produce a product that is judged by the standards of neither. The editorial cartoonist is, ultimately, a hybrid form best described as "creative critic." ∎

third place, which proves, I hope, that the cartooning talent isn't based entirely in some Y-chromosome linked gene."[5]

Wilkinson says that she is often referred to as a "female editorial cartoonist," but she doesn't want to be pigeonholed as a cartoonist who does exclusively "female issues." "In fact," she explains, "I sometimes get criticized for not doing *enough* women's issues. Some of the topics I cover are female, some of them are not. I probably do more issues that are family/home/education oriented than some of my colleagues do, but they all seem like normal people's issues to me."[6] Figure 6.1 shows an example of Wilkinson's work that includes commentary on both social issues and television programming.

Nine years after Wilkinson earned the top honor in her profession, she was joined by Ann Telnaes, a freelance cartoonist who won the Pulitzer Prize for political cartooning in 2001. Born in Sweden, Telnaes worked as an anima-

REALITY TELEVISION for the WORKING MOTHER

welcome to TEMPTATION ISLAND!

CLEANING (NO GREEN CARD)

WILL CARPOOL (NO TAXES)

CHEAP CHILD CARE (NO SOCIAL SECURITY)

MASSAGE

LAUNDRY (for Room)

Signe Wilkinson 1·10·01

Figure 6.1: "Reality Television for the Working Mother," by Signe Wilkinson (January 10, 2001)

tor for Warner Brothers and the Walt Disney Company before branching off into political cartooning. She now works as a freelance cartoonist out of Washington, DC, with her work distributed through Tribune Media Services.

"This is a pretty forceful medium, and has always been dominated by men," Telnaes says. "Young girls are not encouraged to speak their minds, [are taught] that it's not lady-like to do so. When a woman speaks her mind she's sometimes referred to as a bitch—but when men do it it's considered a positive. Still, I think some of that is changing." She continues:

People refer to me as a "woman cartoonist" all the time, but I don't mind it. I think it's interesting—it still shows that it's a relatively unique thing to be one—and there aren't that many of us out there. . . . I don't think women cartoonists draw like women—if you didn't know who drew the cartoon, you couldn't tell—but we do a lot of car-

toons about women's issues. I think our cartoons are better about women's issues—if you have a personal interest and experience in it, you'll do better. The stuff you feel most passionate about, you'll do best at.

Accolades for women cartoonists have increased, but representation in the profession has not. As late as 1989, only four of 240 active members of the Association of American Editorial Cartoonists were female,[7] and in 2004, the ratio was nearly the same.

It is difficult to predict the future of women cartoonists in America, because their progress will be tied to a set of conflicting trends. A pair of Pulitzer prizes and the wide syndication of the work of women like Wilkinson and Telnaes may inspire a new generation of female cartoonists, and the growth in the percentage of women in newsrooms and on editorial boards may lead to changes in the culture of the news room that help women to get more jobs. At the same time, full-time editorial cartoonist positions grow increasingly scarce. In the end, career options

for even the best new female cartoonists will probably be limited by the same trend that hampers their male brethren—a shrinking job market.

Coloring the Pictures: Minorities in Editorial Cartooning

AFRICAN AMERICAN CARTOONISTS

A number of African Americans have had a significant impact on the editorial cartooning profession, notably Ollie Harrington at the *Pittsburgh Courier*, Chester Commodore at the *Chicago Defender*, and William Chase of the *Amsterdam News* in New York City. All three presented life from an African American perspective, finding humor in lives scarred by segregation and poverty but buffered by friendships and families.

Oliver Wendell Harrington, the most significant African American cartoonist, lived in Harlem and published in the leading black newspapers of the region from the 1930s to the 1960s. Harrington graduated from Yale University and served as a war correspon-

dent in World War II. His regular feature was Dark Laughter, and among the key characters in the cartoon was a large man named Bootsie (or, sometimes, Bootsy). Harrington's Bootsie was a self-deprecating everyman who suffered through the hardships of his era. Some of his tribulations were universal (romantic problems, job woes), while others were specific to people of color. The character was a poor man, doing his best in a world filled with racism, broken-down cars, and bill collectors. Nevertheless, Bootsie was a survivor, a man who made the best of a difficult situation, adhered to his own moral code, and offered the possibility of a better day to Harrington's readers. The character proved so versatile and resonated so well with Harrington's audience that, in 1935, he broke out from the Dark Laughter series and became a cartoon unto himself.

Harrington temporarily gave up his artwork after World War II, when he signed on to create the public relations department for the National Association for the Advancement of Colored People (NAACP). In 1951, his out-

spoken approach to civil rights made him a target for Senator Joseph McCarthy and the House Un-American Activities Committee, so he left his homeland for Europe. In 1961 he was in Berlin during the construction of the Berlin wall, and for the next thirty years, he sent cartoons from East Germany to the United States for publication in newspapers such as the *Chicago Defender* and *Pittsburgh Courier*. He attacked targets that were familiar to African Americans, such as poverty and racism, but he also addressed issues that had a direct impact on a wider range of audiences, such as war and politics. He was a staunch proponent of civil rights and racial equality in the United States throughout his life. It is ironic that in the 1960s, a decade that brought both topics to the forefront of American consciousness, Harrington made his biggest impression on the United States while drawing in another country, thousands of miles from home.

Harrington was joined by a number of other black cartoonists, including Melvin Tapley, Clifford Van Buren, and George Mercer, although these artists focused mostly on entertainment strips and avoided the political and social commentary that Harrington favored. If there is a twenty-first century counterpart to Harrington, it could be Aaron McGruder, the artist behind *Boondocks*, the daily comic strip that employs multipanel humor to force a national audience to address issues of racism, class structure, and inequality in America. Like Harrington, McGruder points out the immorality of racism but is equally comfortable poking fun at black cultural icons. McGruder's work appears in the comics section of newspapers, but, like the controversial and politically oriented *Doonesbury* comic that preceded it, *Boondocks* may someday be relegated to the editorial page because of McGruder's adult and socially charged approach to humor.

THE HISPANIC CONNECTION: CARTOONING AND THE FASTEST-GROWING AMERICAN AUDIENCE

Hispanics are the fastest-growing ethnic group in America, projected to increase from 12.3 percent of the American population in 2000 to 24.3 percent in 2050.[8]

Lalo Alcaraz is the kind of cartoonist who reaches this group. In 1993, Alcaraz began drawing *La Cucaracha* for the *Los Angeles Weekly*, the largest alternative paper in Los Angeles. He is now self-syndicated to fifteen other papers and appears via Universal Press Syndicate in another twenty publications.

Alcaraz is a first-generation American whose parents immigrated from Mexico to San Diego, California. His earliest artistic inspiration came from the Mexican comics he read as a child. He became politicized during his college years at San Diego State University, where he earned a degree in art with an emphasis in environmental design in 1987. "I joined the Chicano political group MEChA," he recalled, "and I became far more connected with my community." Alcaraz went on to earn a master's degree in architecture from the University of California at Berkeley in 1990, but his passion is clearly in capturing the Latino community in comic form.

"My worldview and my comics are

formed by my background," he explains. "Civil rights, racism, immigration, these are all issues that I've grown up with."

Alcaraz sees his reputation as a Latino cartoonist as a double-edged sword. "I'm fairly unique, so that helps in terms of marketing myself," he said. "At the same time, some people dismiss my work simply because it is Latino. An overwhelming percentage of my hate mail begins 'Go back to Mexico.' That can be a little depressing. A lot of times the response is not even to the cartoon, it's just about me not being white. They don't even think of you as a human being—but then, that's really their problem."

On the other hand, Alcaraz says that he receives a lot of support from the Latino community. "People tell me, 'That cartoon you ran last week was exactly what I was thinking; I just didn't know how to verbalize it.' That can be really rewarding."

Ultimately, Alcaraz faces the same economic pressures that every other cartoonist faces. "I'd love to have a full-time staff position, with benefits and a regular paycheck," he explained, "but I don't think it's going to happen. People love cartoons, and there will always be a market for them. Unfortunately, the market is for cheap cartoons, not expensive ones."

His response to market conditions? "You've got to hustle, keep working, branch out, and keep drawing," he suggests. Alcaraz has written scripts for Hollywood and developed a daily, non-political strip to earn extra income. Ultimately, his view of the economics of his profession is similar to those of other artists: "Editorial cartooning is not for the faint of heart—it's more like a nasty habit you have to pay for," he explains.[9]

Political Orientation: The Right Speaks Up, Too

Beyond gender and race, there is the more ambiguous area of political orientation. Many cartoonists argue that they are equal-opportunity offenders and loathe being pigeonholed into any part of the political spectrum. Others, however, lean unabashedly in one direction or another, more often than not to the left.

In the nineteenth and early twentieth centuries, more American political cartoonists drew from a conservative viewpoint than from a liberal perspective. Today that balance is reversed. Alan Westin explains that "most cartoonists in each era, drawing as they did and still do for expensive and established media, have reflected the dominant social and political attitudes of the day, with only a small minority offering radical ideas, usually in the 'off-beat' publications of each era."[10] He notes that "the center of gravity of American political cartooning was still profoundly conservative"[11] as late as the 1930s, despite the emergence of artists such as Robert Minor and his contemporaries at the *Masses*. "For every new civil liberties decision of the Supreme Court in the 1900–1945 years," he explains, "there were five or ten times the number of decisions rejecting civil liberties and civil rights claims."[12]

In the latter half of the twentieth century, however, the majority of American cartoonists seem to have gravitated to the other side of the political spectrum. Wayne Stroot, a conser-

vative cartoonist who draws for newspapers throughout the Midwest, estimates that today 80 percent of American editorial cartoonists are liberal and only 20 percent are conservative.[13]

Conservatives such as Stroot argue that the preponderance of left-leaning cartoonists reflects the media's general liberal tilt; liberals respond that it's just that there are so many great conservative targets for their work. An alternative explanation focuses on the political alignment of the country—Americans living in urban centers are generally more liberal than Americans in rural areas, and the nation's largest newspapers (with the exception of the national newspaper, *USA Today*) are published in big cities. It would follow that the most widely published cartoonists are drawing for the largest newspapers, which, because they're published in the largest cities, are directed toward more liberal audiences. According to this scenario, liberal cartoonists aren't necessarily in the majority; they simply get more exposure.

Historian Roger A. Fischer suggests yet another interpretation: it may be the inherent nature of the medium that produces a leftist perspective. "One need not be a political liberal or radical to be a creative cartoonist, for from Nast through Jeff MacNelly and Steve Benson, tough-minded conservatives have more than held their own," he notes. "By its very nature, however, the editorial cartoon works best as a vehicle for irreverent iconoclasm and wry satire, not as a sanctifier of the status quo or patriotic icons."[14]

It's also possible that liberal cartooning in the second half of the twentieth century reflects a wave of liberalism that started in the 1960s and provided a point of entry for a generation of influential, left-leaning cartoonists. This interpretation is more difficult to support, however, since a trend toward liberal cartooning would be inconsistent with the rightward movement of the majority of the nation, and certainly the federal government, in the latter part of the century.

Conservative cartoonists may be in the minority, but they remain a viable part of the cartooning community. These artists work on the East Coast (Gary Brookins, *Richmond Times-Dispatch*), on the West Coast (Steve Breen, *San Diego Union-Tribune*), in the Deep South (Scott Stantis, *Birmingham News*), in the Mountain West (Chuck Asay, *Colorado Springs Gazette*), and throughout the Midwest (Gary Varvel, *Indianapolis Star*). They are as widespread, if not as numerous, as their left-leaning counterparts.

The conservative perspective even has a presence in the comics section, in Bruce Tinsley's daily strip *Mallard Fillmore*. Tinsley introduced his conservative duck to his employers at the *Charlottesville (VA) Daily Progress* in 1994. His editors were originally positive about the strip, but as its message became increasingly conservative, they asked Tinsley to alter the tone. He refused and was fired. While the editors of the Charlottesville paper may not have thought Tinsley's comic appropriate, the conservative duck got the last laugh: it now appears through syndication in the comics section of more than four hundred newspapers.

Recent examples of work by right-leaning cartoonists such as Jim Huber (figure 3.17) and Wayne Stroot (figure

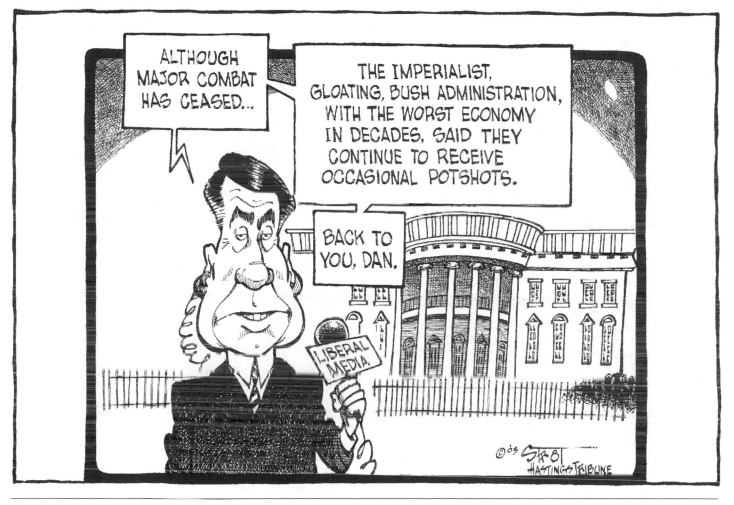

Figure 6.2: "National Potshots," by Wayne Stroot (2003)

Serious Messages on the Funny Pages

Readers traditionally treat the comics page and editorial page as separate entities, and only a few editorial cartoonists have made the transition to the funny pages over the years. But editorial comment, overt or covert, has always been an integral part of the funny pages.

The connection dates back to 1896, with the very first sequence of comics, Richard Outcault's *Yellow Kid*. Ostensibly, the comic follows the exploits of a street urchin in the tenements of New York City, but the little scamp's adventure is a vehicle for social commentary on the differences in the lives of the city's rich and poor. He runs up against corrupt policemen, absurd government policy, and social stratification—all grist for the editorial page as well.

Some comic strips don't start out political, but evolve into editorial packages in response to the times. When Percy Crosby first drew his comic *Skippy*, in the 1920s, his stories were basically about the charming adventures of a small boy. When the artist witnessed increasing radicalism in the early 1930s, however, he politicized his character: Skippy became an outspoken and highly patriotic supporter of traditional American values. Crosby's distributor, King Syndicate, along with a number of newspapers that ran his comic, questioned the politicization but continued to support the artist. As the decade progressed, however, Crosby (and Skippy) became more obsessed with the state of political affairs, resulting in numerous battles with the people who paid his salary.

Crosby's politicization, in both time and temperament, mirrored that of Harold Gray, creator of *Little Orphan Annie*. Annie started out as the wide-eyed female equivalent of Skippy, but evolved into a strong defender of traditional America, at odds with an assortment of leftist radicals. Gray drew the strip for more than forty-five years. When he died, in 1968, his strip was carried on by other artists, who began removing the most overt political statements from the cartoon's panels.

In the 1930s, syndicated cartoonist Al Capp made life uncomfortable for readers and editors with his *L'il Abner* cartoon. Capp created the hillbilly town Dogpatch and populated it with unforgettable takeoffs on American icons, such as the heartless captain of industry General Bullmoose and the corrupt, blustery senator Jack S. Phogbound. At its height, *L'il Abner's* thinly veiled political satire reached fifteen million readers through 253 newspapers. While Capp could devastate pompous conservatives, he became equally adept at lampooning liberals, much to the chagrin of many of his left-leaning followers. In the 1960s, the Vietnam War provided Capp with targets on both sides: hawkish politicians and overmuscled generals versus hippie folksinger Joanie Phoanie and the dull-witted but highly committed antiwar group S.W.I.N.E., or Students Wildly Indignant about Nearly Everything. "For thirty years I attacked lunacy on the Right because that's where it was. . . . If it shifts from Right to Left, as it did, I simply turn my aim," he explained.[a]

In the 1940s, many comic strip characters did what their real-life readers were doing—enlisted in the military services. Steve Canyon signed up with the air force, and Buzz Sawyer became a navy man (twenty-five years later, the macho and highly patriotic character would sign on for a tour of Vietnam). Terry of *Terry and the Pirates* grappled with the comic book counterparts of the era's major villains: Nazis and "Japs." When World War II comics characters weren't signing up or battling on the fronts, they were often involved in patriotic escapades that made their political allegiances obvious.

In 1948, Walt Kelly, serving as both political cartoonist and art director for the *New York Star*, launched a comic strip, *Pogo*, featuring characters who lived in a mythical swamp but reflected the real world. Some were blowhard politicians, some hapless citizens trying to make sense of the world around them. They frequently commented on the dominant social and political issues of the day, sometimes in barely coded form.

When the *Star* folded, Kelly moved up to the *New York Post*, a much larger paper, and within a few years he was syndicated in more than five hundred newspapers. In 1953, he permanently fused the editorial cartoon with the comics page by introducing a devastating character named Simple J. Malarkey. Readers immediately recognized the thuggish bobcat as Senator Joseph McCarthy, and editors immediately recognized that they had a problem: how to deal with a syndicated comic that was so blatantly political. Some chose not to run selected strips; others dropped the strip completely.

Kelly was unfazed: he would go on to create other characters that were immediately recognizable as contemporary political figures, including a pig representing Soviet president Nikita Khrushchev and a goat representing Cuban president Fidel Castro. Herblock and Oliphant were plying their trade on the editorial page, while Kelly managed to get similar points across a little farther back in the newspaper. It is open to debate which had the greater effect.

In the 1970s, the mantle of Kelly and Capp would be assumed by Garry Trudeau in his *Doonesbury* comic strip. Sometimes Trudeau's characters would operate in their own fictional world, sometimes they would comment on current events, and sometimes they would even interact with the leading political figures of the day. Like many editorial cartoonists, Trudeau selected icons (a cowboy hat, a bomb, a feather) to symbolize the key politicians of his time. Occasionally he took such a strong political position or addressed such a controversial issue that editors would use the same approaches that Kelly's had used decades earlier—running selected strips, moving the comic to the editorial page, or, in some cases, canceling the strip entirely.

At the turn of the twenty-first century, two comic strips continue to bring political controversy to America's comics section. *Boondocks*, drawn by African American cartoonist Aaron McGruder, features two cynical young black boys who blast uptight white Republicans and violent, illiterate rappers. McGruder pulls few punches in forcing his readers to confront racial and other social issues in the normally sacrosanct comics page. Meanwhile, Wiley Miller offers *Non Sequitur*, a daily cartoon that sometimes questions the absurdity of life but more often lampoons the political Right. Wiley's characters include a naive horse named Lucy, an intensely cynical young girl named Danae, and a bespectacled, middle-aged superhero named Obviousman, each of whom provides political commentary on a regular basis.

The editorial page and the comics section remain separate parts of the American newspaper, but every decade produces artists who find ways to bring the two together. Strong-willed cartoonists have never minded upsetting traditions, but in making political opinions a part of their comics, they force readers and editors to grapple with how much politics they want in the funny papers. ∎

6.2) demonstrate that the conservatives have plenty of targets of their own

Huber got his start on the college paper at the State University of New York at Buffalo. He now works freelance from his home in Washington, DC, and remains unabashedly conservative. "I'm very comfortable with being on the right," he says. "I don't shy from that label at all."

Unlike many cartoonists, Huber admits to playing political favorites. "I'm an activist," he stated. "I look out for my guys. I generally try to not do cartoons about fellow Republicans. When it comes to targets, it helps if they are Democrats— or Saddam Hussein. In general, I look for people I don't agree with philosophically."

Stroot, on the other hand, doesn't mind targeting conservatives. "When 'the Right' fails to uphold conservative principles, I comment on them as well," he explained. Stroot, a Nebraska conservative, drew for military publications while serving in the U.S. Coast Guard. He now draws on a freelance basis for more than fifty papers

throughout the Midwest, including twenty-one in Nebraska, eight in Kansas, and another in South Dakota.

Both Huber and Stroot said that most cartoonists at the other end of the political spectrum treat them with respect. "Liberal cartoonists are very accepting," Huber said. "Mike Peters, for example, is just the nicest guy—I can't imagine him saying something negative about anyone. Generally I get a pretty good response. I haven't been blacklisted!" Stroot explained, "Some are professionally respectful and some are not." To him, it's not a matter of politics: "It depends on how big their ego is," he said.

Both cartoonists pointed to the general political orientation of the media to explain the dearth of conservative political cartoonists. "I think there are fewer conservative cartoonists for the same reason there are fewer conservative journalists: Media attract less conservative people," Huber observed.[15] Ultimately, Stroot differentiates between the people who work for newspapers and the people who read them. "Without a doubt, the majority of my

readers agree with my perspective," he concluded.[16]

Conservatives can also take heart in the knowledge that the pendulum can always swing back in the other direction, as Charles Press notes: "Styles change and in the long run conservative institutions tend to be dominated by conservatives, so probably present trends should not be regarded as permanent or unchanging, any more than the turn-of-the-century muckraking style dominated comment of the twenties."[17]

GLAD to Laugh: Sexual Orientation and Editorial Cartooning

Beyond race, gender, and political persuasion is an additional characteristic that factors into the diversity discussion: sexual orientation. The exact statistic remains open to debate, but reputable research institutions estimate that 10 to 15 percent of the American population is gay or bisexual. It is even more difficult to determine the sexual orientation of the nation's political cartoonists, and so to compare the

work of straight and gay artists.

Mike Ritter is a rarity: an openly gay cartoonist. "I'm also a male cartoonist, and an American cartoonist, but yeah, I'm a gay cartoonist," he said. He wasn't always so open about it. "I have this high-profile job," he explained, "and I really didn't want people thinking about or focusing on my private life. But then I began to feel that I was kind of avoiding doing cartoons about gay issues because I didn't want to draw attention to myself. I was avoiding important social issues because of personal reasons, and that wasn't right."

Ritter "came out" to his family and friends and then went public with his readers. "It was liberating," he explained. "To maintain the charade is exhausting. Besides, there's a value to this visibility. After all, I do lots of cartoons about taxes and other things that everyone else cares about, and now readers can see that 'this is a gay guy, and he cares about the same things that I care about.'"

Does he get pressure from gays to focus on gay issues? Ritter disagrees

with the premise of the question, because he feels that the concept of "gay issues" is too simplistic. "I was a Republican for a long time, and now I'm a libertarian. Arizona is a pretty conservative state, so I'm going to get into it with the theocrats and the social conservatives anyway. I mean, some of the religious groups out here, it's like the Taliban with potato salad," he said.

"But I've had some gay people yell at me because of some of my positions," he said. "I reject the idea that, because I'm gay, I am supposed to look at all things in a particular way."

"I'm very, very fortunate, however," he said. "I have an editor and publisher who are both terrific, very supportive. This is a privately owned paper, with a real agenda, thank God for that. This isn't a corporate-owned business totally focused on the bottom line. Not to sound too much like a leftist, but I think that the myth of the liberal media really is just that—a myth. When papers are run by bean counters, they are afraid to take a risk, to alienate anybody. Unfortunately, a lot of my colleagues work for papers like that."

While Ritter, like many cartoonists, fears for the future of the profession, he feels that he will not be the only openly gay editorial cartoonist forever. "I would love to see more people who were openly gay, not only in editorial cartooning, but in medicine, law, all professions," he explained. "And I think, slowly, it's happening as society becomes more accepting.

"Besides," he concluded, "I'm a cartoonist. We're supposed to be a little weird and eccentric anyway, right?"[18]

Teddy Bears, Santa Claus and John Q. Public: Transcendent Icons from Political Cartooning

Regardless of who draws political cartoons and who views them, there are some images that have come from the profession that are truly transcendent. Political cartoonists have created, legitimized, and transformed some of our country's most enduring symbols, icons that are permanently embedded in the American culture. A sampling of their contributions:

Brother Jonathan (colonial period)

and Uncle Sam (approximately 1812) were not created by cartoonists but were used as shorthand by cartoonists to represent the country. (Their evolution is discussed in the chapter 7 sidebar "The American Icon: How the Image of the United States Has Evolved over Time.") Edwin Williams Clay was the first to use Uncle Sam in a political cartoon, in a 1837 drawing showing the bearded symbol sick from the country's bank failures (figure 7.5). Clay's picture also includes an American eagle (lower left) and employs the unflattering technique of dressing a man in woman's clothes, in this case Martin Van Buren.

Thomas Nast introduced the Republican elephant in a *Harper's Weekly* cartoon in November of 1874 (figure 6.3). The beast is part of a cartoon combining politics with media chicanery: Nast was commenting on the potential third term of Ulysses S. Grant while referencing a recent hoax in which the *New York Herald* alleged that zoo animals were roaming New York's Central Park. Nast is often credited with creating the other party's symbol, the Democratic donkey, but

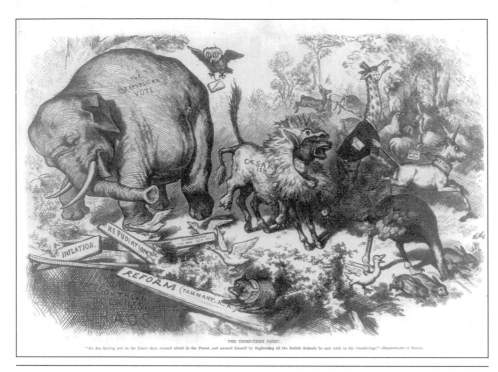

THE THIRD-TERM PANIC.

"An Ass, having put on the Lion's skin, roamed about in the Forest, and amused himself by frightening all the foolish Animals he met with in his wanderings."—SHAKESPEARE OR BACON.

Figure 6.3: The first Republican elephant appeared in "The Third-Term Panic," by Thomas Nast (November 1874).

that image actually predates his work, and his cartoons simply reinforced the existing icon. In various cartoons, Nast tried to affix other symbols to the Democratic Party, including a fox and a tiger, but the donkey proved to be in-tractable, and it remains the icon for the party today. Despite the negative implications of the two animals, both parties eventually embraced the images and now use the animals as part of their communications.

Thomas Nast didn't invent Santa Claus, but he turned him into the character we know today (figure 6.4). Nast, who suffered from dyslexia, instructed his wife to recite Clement C. Moore's 1823 poem "A Visit from St. Nicholas" as he sketched his version of the Christmas figure, making Santa less a religious image and more a jolly old elf. From the 1860s through the 1890s, Nast created seventy-six engravings of Santa for *Harper's Weekly*, many of them for the publication's Christmas issues. Nast plumped up Santa and added elements to the legend, such as Santa's North Pole workshop, his list of good and bad children, and the practice of sending letters asking for presents.

Another icon in the lives of American children, the teddy bear, is entirely the product of a political cartoonist. In 1902, president Theodore ("Teddy") Roosevelt spared the life of a bear cub on a hunting trip, and *Washington Post* artist Clifford Berryman couldn't resist using the incident in his next cartoon. Berryman's cuddly cub became perma-nently linked to the president (figure

Figure 6.4: "Christmas Eve—Santa Claus Waiting for the Children to Get to Sleep," by Thomas Nast (c. 1890)

CHRISTMAS EVE.—Santa Claus waiting for the children to get to sleep.

6.5), and the popular stuffed animal was tagged with a moniker that remains today.

Frederick Opper introduced his symbol of the average American, John Public, in the *Arena*, in 1905. Vaughn Shoemaker of the *Chicago Daily News* added his middle initial twenty-five years later, making the character John Q. Public. The development of the character coincides with periods of great economic disparity—the era of the trusts when Opper drew the original and the Depression when Shoemaker added the middle initial—so that John Q represents not only everyman, but the everyman who is beaten down by forces far greater than himself. Since his introduction, cartoonists have used Mr. Public to display all kinds of American responses (suspicion, guilt, joy) to any number of situations; in 1950, John Churchill Chase placed him under a useless umbrella, unprotected from the threat of atomic fallout (figure 6.6).

Chase, like many cartoonists in the years just after World War II, tried to capture the psychological and poten-

To Go or Not to Go?

March 2, 1909

Figure 6.5: "To Go or Not to Go?" by Clifford Berryman (March 2, 1909)

Figure 6.6: "Atomic Threat," by John Churchill Chase (1950)

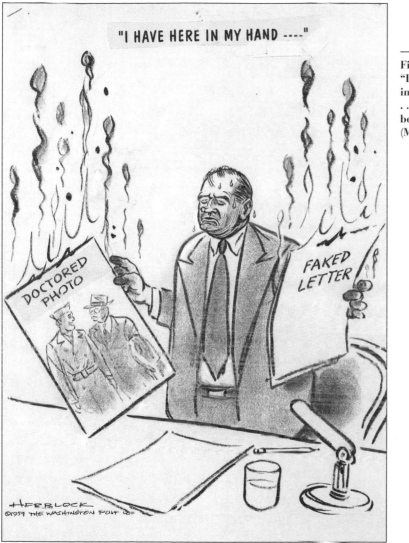

"I HAVE HERE IN MY HAND ----"

HERBLOCK
©1954 THE WASHINGTON POST CO.

Figure 6.7: "I Have Here in My Hand . . . ," by Herbert Block (May 7, 1954)

tially real damage that could be done by atomic weapons. It was the *Washington Post*'s Herbert Block who best captured the nation's fears, with his Mister Atom character (figure 5.1), introduced in 1947. In the early 1950s, Herblock introduced a new word to sum up another form of national paranoia and destructiveness—the anti-Communist government activity he called "McCarthyism" (figure 6.7).

Political redistricting has been a source of hanky-panky in American politics since the first maps of the country were drawn. Elkanah Tilsdale made the practice more personal in a famous cartoon in the *Boston Gazette*, March 26, 1812, when he attacked a redistricting effort designed to ensure the reelection of Governor Elbridge Gerry. Tilsdale's map turned the redistricting of Essex County, Massachusetts, into a menacing, dragonlike image (figure 6.8). His editor titled the map "The Gerry-mander," adding a new term to the political lexicon.

As part of the daily newspaper, the editorial cartoon is normally a transient phenomenon, interesting today but less

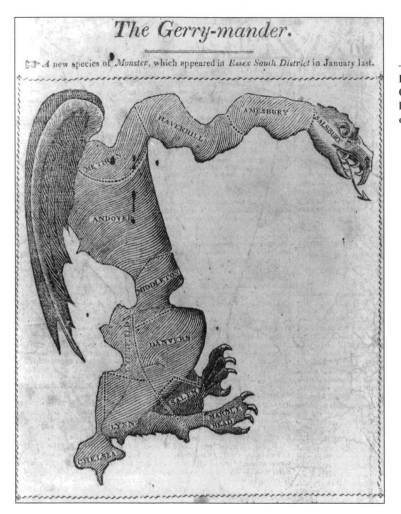

Figure 6.8: "The Gerry-mander," by Elkanah Tilsdale (1812)

valuable as the days pass. As these icons demonstrate, however, there are times when a cartoonist introduces an image that is so creative, so on target, and so memorable that it captures—and holds—the imagination of the American public.

Whither the Gap between Artists and Readers?

Ultimately, the gap between editorial cartoonists and the people who read their work may change for technological as well as social reasons. Syndication and Internet publication make it less obvious who exactly is drawing cartoons, making the demographic characteristics of the artist less obvious and, presumably, less significant. The longer view seems to indicate that whatever changes are occurring in the demographic and psychographic characteristics of cartoonists, they are coming along very slowly. If the cartooning community remains as homogenous as it is today, dramatic changes in the composition of the American popula-

tion will result in an ever-increasing disparity between the people who draw political cartoons and the people who read them.

CONSUMER PROFILE: A SNAPSHOT OF POLITICAL CARTOON READERS

Subtle shifts may be occurring in the makeup of the editorial cartooning profession, but do they reflect shifts in readership? Research indicates that the people who enjoy reading editorial cartoons have some very consistent attributes.

American newspaper readers are better educated, wealthier, and generally more politically astute than non-newspaper readers. Elsa Mohn and Maxwell McCombs found that a third of U.S. newspaper readers are "regular" readers of the editorial page, with three-quarters of readers "usually" reading the editorial page. Readers feel that there should be some political balance represented on the page. Two-thirds of respondents disagreed with the statement "A newspaper has a right to support only Democratic party or Republican party candidates on its editorial page even if it doesn't offer space to those with opposing views."[19]

These findings support the idea that the political cartoon is socially significant. The editorial cartoon is a key component of an editorial page that, in many ways, serves as an "intellectual town hall": a place where some of the nation's leaders in government, education, and industry share views about the most important issues of the day.

SYNTHESIS: MERGING THE CARTOONIST AND THE READER

It is clear that there are significant, and probably increasing, differences between political cartoonists and the general population, but there is one experiment in cartooning that attempts to fuse creator and consumer. Since many political cartoon aficionados secretly wish they could take over the humorist's role themselves, the *Dallas Morning News* allows them to do just that.

In 1989, the editors of the paper began inviting readers to collaborate with the paper's editorial cartoonist, Bill DeOre. The plan was simple: DeOre would draw one of his cartoons but leave the text out of the caption bubbles. Readers would then submit their own punch lines, and the editors and staff would choose the best responses and print them in a later edition.

The "do-it-yourself cartoons" are offered sporadically, but the response has been consistently positive: "We receive hundreds of cartoon submissions every time we offer a do-it-yourself cartoon," says Rena Pederson, the paper's vice president and editorial page editor.[20]

A few other papers have experimented with this approach, with mixed results. Some contributors take the opportunity to hammer home their central tenets, regardless of the image. There is one ramification of the contest that the cartoonists enjoy: critics learn to appreciate how difficult it is to craft a message that is both pointed and funny.

Whither the Industry?

Any discussion of staffing trends in the industry must be placed in the greater context of the overall state of the print media: numerous studies point out that newspaper sales and credibility have been declining steadily for decades.

An alarmist might say that a discussion of employee characteristics at this time is the equivalent of rearranging the deck chairs on the *Titanic*—a largely irrelevant exercise that fails to recognize that the larger problem is that the ship is sinking. On the other hand, a discussion of the closeness of fit between the people who make newspapers—and editorial cartoons—and the people who read them—or might read them—may have a direct bearing on the larger issue of the health of the industry. There is no single decision that will reverse the depressing trajectory of political cartooning specifically or print media in general, but an examination of staffing certainly seems worthwhile.

SEVEN

Process and Effect

The most important part of every cartoon is the idea that drives it.[1]

HISTORIANS STEPHEN HESS AND
SANDY NORTHROP

THE HISTORY of editorial cartooning includes countless examples of creativity but minimal explanation of *how* the humor works. By deconstructing the work of editorial cartoonists, it is possible to identify the methods that they use to make their points. This deconstruction also leads to a much larger issue—the overall *effect* of the cartoons.

Nuts and Bolts: How Editorial Cartoons "Work"

"All forms of the graphic art of the comment are alike in that they muse upon the ridiculous and the incongruous in life," explains historian Charles Press. "They may be based on fantasy, incongruity, and surprise, or they may hone ridicule and satire into a sharp-edged weapon. But the repeated theme in all such art is the contrast between reality and the ideal, between aspiration and practice, between what is and what could be."[2]

Press notes three elements used by political cartoonists to sell their vision:

1. A picture of reality that the artist presents as the essence of truth
2. A message as to what they recommend ought to be done, and
3. The creation of a mood telling us how to feel about what has happened[3]

First and foremost, the cartoonist is attempting to stimulate thought or convince his audience of his position. The primary goal of the editorial cartoon is not aesthetic; artistic expression is subservient to persuasion. If an intricate, graphically balanced approach works, then it is the correct one. If a crude, smudged image works, then that, in turn, is appropriate. The image should be judged not on artistic merit, but on its ability to get the cartoonist's point across.

Artwork in a cartoon need not even be realistic, because the caricaturist

So Where Do All Those Ideas Come From, Anyway?

Cartoonists agree that this is the most common question they are asked. Their answers vary: "You hammer at what outrages you that day,"[a] summarizes Jeff MacNelly.
Jack Ohman says,

I used to respond that I subscribed to an idea service and then attempt to change the subject to lawn maintenance. That didn't work, so I now say that they "just happen," like accidents and babies. People then give me a vaguely ethereal gaze, as if I'm tuned in to some creative Muzak that only cartoonists and possibly dogs can hear. I don't know how I get ideas, other than by pumping all the wrong cholesterol into my arteries from worrying about them.[b]

Mike Peters explains the process this way:

I get my ideas by reading newspapers for four hours early in the morning. I write down different topics and then pick those that I feel something about—the Irish Republican Army or women's rights or what have you. When I try to do a cartoon on something I don't feel anything about, such as South Africa, it's always awful. After I pick a subject, I draw a circle and make a wheel with spokes. In the center of the circle I write the subject: "Women's rights," let's say. Then, in the spokes, I write different things about women: Maybe "the Mona Lisa" or "Whistler's Mother" or "Eve in the Garden of Eden." I try to physically go through a pattern. I take one issue and try to find visuals that make the statement I want. Going around the spokes is almost like going around a table and saying: "O.K., we want to say something about women's rights. What are some approaches we can use?" I'm just brainstorming with myself.[c]

Bruce Plante finds many sources: "I read the *New York Times* and the *Wall Street Journal*. I listen to local talk radio. I listen to Rush to get the dander up. CNN and CSPAN are always on in my office."[d]
Jack Ohman finds the process to be anything but linear:

I try to generate cartoon ideas by Wandering Around. This strategy has yet to bear fruit. I saunter into the newsroom and confer gravely with my colleagues who are also looking for a way to avoid deadlines. We talk about grave matters, like the National Security Council and why the power forward for the Portland Trail Blazers missed a critical rebound to lose to the Denver Nuggets, 124 to 122 in overtime. This approach in other, real businesses is known as goofing off. In newspapers, it's known as the creative process.[e]

For many cartoonists, there are almost too many subjects from which to choose. Herbert Block explains:

There is no shortage of subjects for opinions. I don't long for public misfortunes or official crooks to provide "material for cartoons." Hard as it may be for some people to believe—I don't miss malefactors when they are gone from public life. There are more things amiss than you can shake a crayon at.
 If the time should come when political figures and all the rest of us sprout angel wings, there will still be different views on the proper whiteness and fluffiness of the wings, as well as flaps over their flapping, speed and altitude. And there will still be something funny about a halo that's worn slightly askew. When that happy heaven-on-earth day comes, I'd still like to be drawing cartoons. I wouldn't want to see any head angel throwing his weight around.[f]

What subjects do the cartoonists *want* to draw on? A 1977 survey of editorial cartoonists found that 57 percent of full-time cartoonists preferred national issues, while 55 percent of part-time cartoonists liked to focus on local topics.[g] With the growing influence of syndicates, however, these percentages have probably changed considerably. David N. Ammons, John C. King, and Jerry L. Yeric reported in 1988 that editors estimate that 92 percent of their syndicated cartoons address national or international issues.[h]

V. Cullum Rogers says, "I think we go after hypocrisy. If you mislead people, we'll be after you. You'll see more editorial cartoons where we attack people saying one thing and doing another than cartoons where we attack people for simply saying something."[i] And yet, there are times when concepts are born of sheer desperation. Clay Bennett notes, "We draw 220 cartoons a year—we'll clutch onto anything for an idea. Any ceremony or useful day—Valentine's Day, Arbor Day—I've done Armistice Day!"[j]

So, how can you tell if a cartoonist is really scratching for an idea? Jack Ohman provides an insider's insight: "It's considered the lowest of the low to do a cartoon about the weather." ■

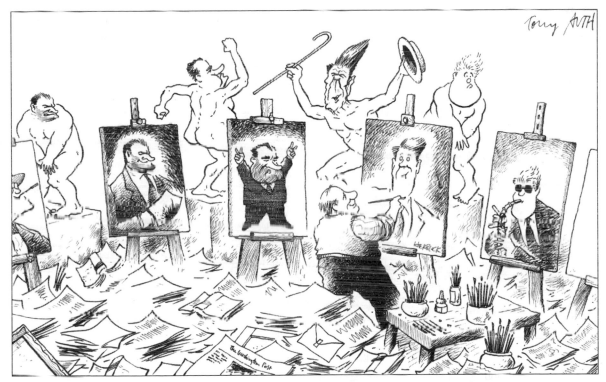

Figure 7.1: Herblock painting McCarthy, Nixon, Reagan, and Clinton, by Tony Auth (Philadelphia Inquirer, 2000)

The Icon Debate

The Russian Bear threatens Uncle Sam. An old man with an hourglass welcomes a baby on New Year's Eve. The Republican elephant tramples the Democratic donkey.

Icons abound in the world of editorial cartooning—but is this a good thing? That depends on whom you ask.

"I find clichés to be enormously useful," said David Horsey of the *Seattle Post-Intelligencer*, as part of a panel at the 2003 convention of the Association of American Editorial Cartoonists. Icons help cartoonists set up the story quickly, providing concise symbols that easily express complex or amorphous concepts. They are also adaptable: Uncle Sam always represents the United States, but he can be posed in a variety of positions and drawn with a wide range of expressions. The country can be angry, hurt, or surprised.

Veteran cartoonist Arnold Roth defended icons as an extension of stereotyping, with a caveat: "We get a big advantage in being able to use exaggeration. I don't know how you can do cartoons without doing stereotypes. Don't do it gratuitously, but do it if it adds to the effect."

Steve Kelley of the *New Orleans Times Picayune* defended traditional imagery. "Symbols are visual shorthand," he says, "and we should use them more often, not less."

Alternative cartoonist Ted Rall took the opposing view, denouncing traditional symbols. "The donkey and the elephant don't work anymore," he declared. "The old labels are done." Rall, whose cartoons primarily appear in alternative publications, tries to avoid traditional icons because he thinks that they are ineffective with the people who read nontraditional publications. "Young people think they're cheesy," he said. "Or even worse, they don't get them. It's the idea that should drive the cartoon."

Perhaps there is room for compromise between those who hate traditional icons and those who find them indispensable. Ultimately, as Kelley pointed out, it would be extremely difficult to produce cartoons covering a range of subjects without resorting to the use of icons. But if Rall is right and younger readers don't understand the more classical allusions, the response may not be to eliminate them—it may be, in the words of Horsey, to "find new and different ways to use them."[a] ■

reaches beyond the physical, striving to show, not what a subject looks like, but what a subject really is. This frees the cartoonist from the shackles of literal reality but simultaneously necessitates that the cartoonist illustrate some greater, somewhat hidden truth about the subject.

"Cartooning lies at the opposite end of the spectrum from the ideal of beauty, and constitutes its total negation," Werner Hoffman noted.[4] Rafael Barajas takes Hoffman's position even further, writing:

The basic technique of satirical drawing is to isolate the physical, mental, social or moral defect of the subject and magnify it, something closer to magical realism than a search for aesthetic beauty. The cartoonist sees only the despicable essence of his prey. The procedure is nearly an act of exorcism, with the difference that cartooning does not seek to remove the demons, rather simply to portray them.[5]

Ironically, this emphasis on exaggeration may lead some cartoonists to shy away from depicting women and

minorities in cartoons. If the former is the target, the exaggeration may seem cruel, particularly if it pokes fun at a woman's physical features. If the latter is the target, the exaggeration may seem racist because it overemphasizes a physical attribute that plays into a stereotype. Ultimately, however, the depiction of the character must resonate with the reader—if a politician is not perceived as a villain by the populace, a drawing of him as a villain will fail.

The best cartoons begin with clarity of thought. The cartoonist must apply a strong perspective to a subject—it is rare that a subtle position produces an effective editorial cartoon. Partisanship is not a disadvantage in editorial cartooning; in fact, it stimulates and clarifies the process. The space inside the cartoon box is reserved for blunt, sweeping judgment, not nuanced, "maybe this, maybe that" messages.

The ethical boundaries of editorial cartooning are very different from those for other parts of a newspaper, although cartoonists disagree on what these boundaries should be. Some feel that literal truth is essential for integrity, others argue that the medium, visual rather than text-based, allows a creative license that is not limited to factual truth. Some even go so far as to argue that the cartoonist's artistic interpretation, though not literally true, may come closer to the actual truth than the written word.

Press notes that, while it is difficult to say exactly what makes a good cartoon, it may be easier and more useful to describe what makes a bad one. He has developed a kind of negative formula: "A good political cartoon does not treat a trite subject as trivial, has a political message that does not obviously ring false, and is not presented with trite imagery or artistry."[6] It would be foolish, for example, for a cartoonist to treat a topic as monumental as civil war with anything other than the utmost gravity. Conversely, a cartoonist who treats an election race between similar candidates for a local office as an earth-shattering event does not grasp its real level of significance, and his image will not resonate with his readers. In fact, cartoons that transcend time, such as Nast's attacks on the South or Mauldin's response to the Kennedy assassination, gain some of their power simply because they comment on critical moments in the country's history.

Cultural Touchstones: From Shakespeare to *The Simpsons*

Cartoonists' goals may be universal, but their cultural references change with time. Cultural references are those images, ideas, and expressions shared by a social group. Political cartoonists draw references from throughout American culture. As that culture changes, cartoonists are forced to change not only the symbols they use, but the sources of those symbols as well.

"A century ago the prevailing cultural reference would have come from Scripture, Aesop, the classics, or Shakespeare," notes historian Roger A. Fischer.[7] But how many modern Americans will recognize, no less understand, literary allusions from these sources? For example, in figure 7.2 Herbert Block casts former president Lyndon Johnson as Julius Caesar and Illinois

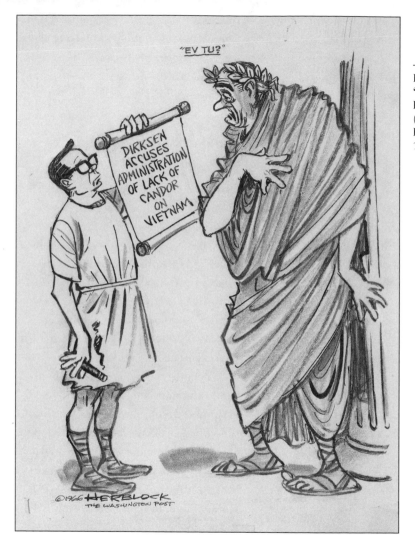

"EV TU?"

DIRKSEN ACCUSES ADMINISTRATION OF LACK OF CANDOR ON VIETNAM

©1966 HERBLOCK
THE WASHINGTON POST

Figure 7.2: "Ev Tu?" by Herbert Block (Washington Post, June 10, 1966)

Republican senator Everett Dirksen as a former ally now questioning the president's position on Vietnam. A reader unfamiliar with Shakespeare or history would have a difficult time grasping Block's reference to treachery.

As society fragments and Americans lose their central cultural heritage, tapping universal imagery becomes increasingly difficult. "It's a frustration in the business, and it's getting bigger," laments *Philadelphia Daily News* cartoonist Signe Wilkinson, who frequently tests the references she plans to use to make sure that her readers will grasp them. "I'll try out an idea in the offices of the newspaper, and if people there don't get the image, I figure people who read the paper won't get it either. If they don't get it, I just have to drop it and start over."[8]

Modern cultural icons may not be drawn from classic texts, but they have some advantages over traditional literary imagery. For one thing, there are more of them—the media, primarily television and film, provide a steady, ever-changing supply of images and

phrases that can be incorporated into a political cartoon: every summer there are blockbusters in the theater, every fall new television shows arrive. While not universally recognized, characters from television shows such as *The Simpsons* are known to a significant segment of American society, and the catchphrases used by characters on the show occasionally become part of the national dialogue. The music industry also provides popular lyrics that can be useful in phrasing an issue. Advertising in a variety of media provides jingles, catchphrases, and slogans that become commonplace through repeated exposure. And when modern media aren't introducing new fictional imagery, they are promoting real world colorful characters (the Beatles, Michael Jackson, Tiger Woods) who can be borrowed to make a point.

This leads, however, to a larger social question: Is there enough *common* cultural heritage to make the use of these symbols effective? As the number of media options increases, Americans, who once shared cultural touchstones

(the Bible and children's stories in the print era, limited network broadcasts at the beginning of the television era), may eventually lose a central, shared group of cultural reference points. The scenario concerns many modern sociologists, and it poses a significant, immediate challenge to editorial cartoonists.

The Semiotics of America: How the Image of the United States Has Evolved over Time

Icons are consistently used as cartooning shorthand, but there is nothing consistent about the icons themselves. A review of the images used to represent the United States shows that these images reflect how citizens of the country have viewed themselves, as well as how other nations, particularly England, have viewed the United States. Some icons that originated in the United States were deliberate designs orchestrated by the government, while others sprang forth in a disorganized manner from the culture itself. Clearly, the evolution of American

icons reflects the evolution of the character of the nation.

The earliest symbols used for the country were a hodgepodge of images demonstrating a dizzying array of ideas. John J. Appel notes that "pictorial devices for the American colonies and their inhabitants included a sculptured bust of a Native American woman, a burning town, a rattlesnake, a wheel on a carriage tagged 'Magna Carta,' a buffalo, a cow, a rearing horse, an eagle and a black dog."[9] Additional animals, some noble (the deer), some less so (the codfish) were also used.

The Indian image as a symbol of America appeared two hundred years before the establishment of the nation. Alton Ketchum notes that cartographers lifted the Indian image from works of French artist Jacques le Moyne de Morgues, which date to 1561, inserting it in cartouches used to embellish the maps of the New World.[10] The Indian also reflects the perception of the colonies, from a cultured European perspective, as wild and uncivilized places (figure 7.3). In-

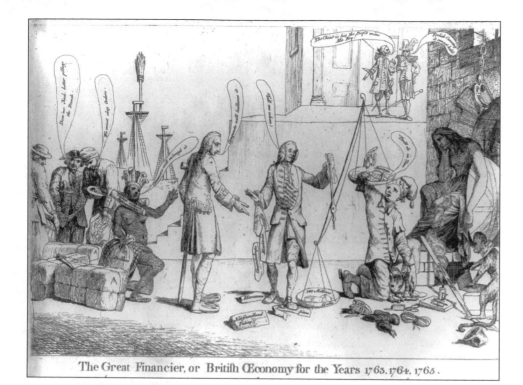

The Great Financier, or British Œconomy for the Years 1763, 1764, 1765.

Figure 7.3: "The Great Financier, or British Economy for the Years 1763, 1764, 1765," artist unknown (1765). The American icon is the fourth figure from the left, an Indian kneeling before English ministers, bearing a yoke labeled "Taxed without Representation."

terestingly, the Indian depicted was more often than not female, often in various states of undress. She was frequently attractive, an alluring figure tempting European powers, if used in a message of warning to colonial powers, or the subject of unwanted attention, even forced attacks, when America was portrayed as the victim. Ketchum notes, "Once the colonies had won their independence . . . the dark skin (of the Indian) lightened considerably to match the predominantly white aspect of the American population."[11] If the graphic was a logical extension of the European view, it quickly became offensive to the revolutionaries who were creating a new nation and a new identity.

Colonists developed symbols more specific to their own heritage and environment. In Massachusetts, they chose the pine tree, an image similar to the biblical tree of life, to represent their

state. Later, the revolutionary Sons of Liberty met beneath an old elm in Boston, which they transformed into the symbol known as the liberty tree.

Benjamin Franklin's snake constructed from the various colonies made sense as an allegory, but it certainly wouldn't have been the animal of choice to represent a nation. While it might seem like a strange symbol in modern times, the snake had certain connotations in the colonial period that made it a useful symbol. The snake's lack of eyelids made it a great symbol of vigilance. It was also a common belief that the snake never attacked first but never surrendered once attacked, a noble philosophy for a reptile—or a nation. Finally, colonists believed that pieces of a snake, once cut apart, could reunite, a wonderful allegory for a collection of disparate colonies moving toward unification.

In the 1750s, the Indian image started sharing the stage with two more homegrown symbols: Yankee Doodle and Brother Jonathan. Both were counterparts to the British image John Bull, and both were originally created by British loyalists as derogatory images to poke fun at the perceived naïveté of the colonial spirit. As often happens with such images, however, the lampooned came to embrace the images as their own, and colonists transformed Yankee Doodle and Brother Jonathan into vigorous, clever figures, a deliberate contrast to the aging, stiff British image. The parallels between the images and the countries were inescapable: John Bull was cultured, educated, and a bit aristocratic—qualities revered by the British but suspect to the earthy colonists. Yankee Doodle and Brother Jonathan were products of the backwoods. They were a little crude, outdoorsy, but men who lived by their wits—qualities revered by new Americans but suspect to Old World Englishmen. The two images became deeply ingrained in American culture—Yankee Doodle through music and visual imagery, Brother Jonathan in songs, poetry, even theater. They had slight differences—Brother Jonathan was the more serious of the two—but they both symbolized the common man making his way in a new world. During the American Revolution, Yankee Doodle and Brother Jonathan became the equals of, and, eventually, superior to, the older, weathered John Bull. In image and reality, America's power was growing.

Brother Jonathan and Yankee Doodle had some distinct advantages over the animals, trees, and other images that had represented America. First, they had a quasi-military flavor to them, aligning them with the spirit of the revolution. Second, as human figures, they were pliable—not only could the cartoonist bend and position them to create unlimited actions in the cartoons, but their facial features could be altered to express a range of emotions: Jonathan behind bars was fearful, Yankee Doodle standing over John Bull beamed victoriously.

In June of 1777, the new Continental Congress adopted the official description of the flag of the United States, standardizing yet another image for cartoonists to use as a symbol of America. The flag itself has obvious symbolic strength—it is easily recognized and can add a level of decorum

to a cartoon—but the elements of the flag became particularly useful to artists. Stars could be mixed with other graphics; the horizontal bars could serve as a backdrop for action or a natural divider for the drawing.

The American eagle also originated in an act of Congress. The same day that the Declaration of Independence was signed, the Continental Congress charged a committee with the preparation of a seal for the United States. The task must have been deemed important, because that committee consisted of Benjamin Franklin, John Adams, and Thomas Jefferson. The trio could not resolve the issue, however, and a second group took up the charge—it, too, failed to reach consensus. It took a third committee until 1782 to come up with an emblem that Congress would accept: an image that featured a fierce-looking eagle with an olive branch in one talon and a bundle of arrows in the other. The eagle itself implies nobility and strength, but the contrasting symbols of peace and war have always allowed those who employ the symbol to apply it to their own purposes. A close-

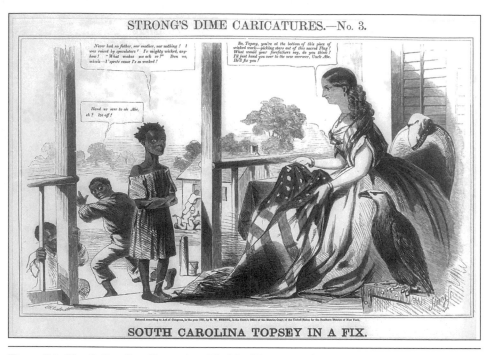

Figure 7.4: "South Carolina Topsey in a Fix," by Thomas W. Strong (1861)

up of the eagle's head usually emphasizes the watchfulness of the eye or the fortitude in the bird's profile. When the full image is used, the icon becomes the antithesis of the docile American flag—the eagle implies action, and the bird is normally on the attack.

If John Bull's American foil was

Brother Jonathan, the new nation also had an answer to England's female icon, Britannia. Her name was Columbia (figure 7.4), and she was the final American symbol to emerge from the eighteenth century. Columbia, a young, statuesque woman with flowing gown and hair topped in a bonnet,

represented many of the finer qualities of the new nation, including tolerance, education, and freedom. Her introduction to American society, around 1800, probably reflected a revival of interest in Greek culture in America at the time, but her exact origins are open to interpretation. She arrived on the symbolic scene at the turn of the century but would evolve through the 1800s: she plumped up, thinned out, grew older, even changed clothes. Her gown started out white, reflecting both her virginity (after all, she is always *Miss* Columbia) and her classical origins, but eventually she was pictured wearing the stars and stripes. In some ways, each recasting of Columbia represented a different ideal for women in American history

The British and American interpretations of the Yankee Doodle and Brother Jonathan icons remained consistent into the early decades of the nineteenth century, exemplifying the growing division in perceptions of America on the different sides of the Atlantic Ocean. During this time, there is no question that the United

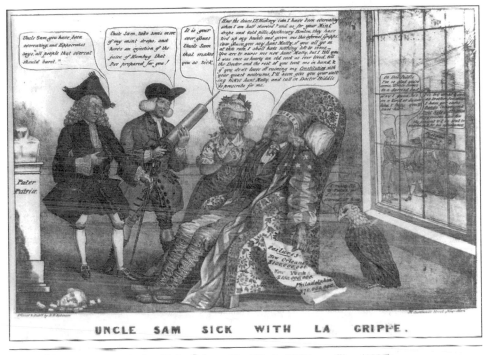

Figure 7.5: "Uncle Sam Sick with la Grippe," by Edwin Williams Clay (1837)

States was making great strides economically, militarily, and culturally, yet Brother Jonathan, in his original form as a somewhat harmless rube, still played well in England. In the United States, the joke was wearing thin. It was time for a new symbol for the country, one with a little more

gravitas. It was time for Uncle Sam.

Bits of Brother Jonathan, Yankee Doodle, and a third character, Major Downing, can all be found in early versions of Uncle Sam. They were defiant, quick-witted and somewhat earthy. Like those of many of the other national symbols, the precise origins of

Uncle Sam are still debated, but the most commonly accepted theory is that he was modeled after Sam Wilson of Troy, New York. Wilson supplied meat to the American army during the War of 1812, instructing his workers to stamp "U.S." (for "United States") on the barrels of meat before they were distributed. His workers began to joke that the stamp stood for "Uncle Sam" Wilson, and a new icon was born.

It took cartoonists to add physical features to the character, although they produced an icon that bore little resemblance to Sam Wilson of Troy. The symbol made his lithographic debut in an 1837 piece by Edwin Williams Clay (figure 7.5), an inauspicious debut because it depicted Uncle Sam as sickly and bedridden. This is a transitional cartoon for both the nation and its symbols: Sam is draped in an American flag, an eagle sits on the floor next to him, and on the right side of the image, Brother Jonathan can be seen in the window. Like Brother Jonathan, Uncle Sam would grow in strength, particularly in relation to his English foil (figure 7.6).

Figure 7.6: "How Do You Like Your Labor Government, John?: How Do You Like Your Belabored Gov't, Sam?" by Oliver Herford (*Life*, June 5, 1924)

Uncle Sam's top hat and tails have been consistent, and, over time, have taken on a quaint obsolescence. Like Columbia's robe, Uncle Sam's suit took on the colors of the flag over time, in his case about thirty years after his creation. In most early cartoons (the Clay drawing being an exception), he was drawn as a young man, self-reliant and a little tough. By the Civil War, however, he was drawn more the way he is perceived today: an older, bearded man, still thin and with that same sense of independence. Although his portrayal with a beard may have been a reflection of contemporary fashion, Press points out that the beard and some of his other characteristics were similar to those of the president at the time— Abraham Lincoln.[12]

The context for Uncle Sam has also changed with the prevailing issues of each age. He has been cast as an American imperialist (figure 7.7), a victim of foreign aggression, and a defender of democracy. In modern times, whenever America is at war or under attack, cartoonists turn to Uncle Sam to demonstrate U.S. resolve and power.

Perhaps the most useful American icon for political cartoonists is the woman who arrived in New York Harbor to commemorate the hundredth

anniversary of American independence. Even before she was dedicated on October 28, 1886, more than a decade behind schedule, the Statue of Liberty had become a regular subject for editorial cartoonists in America and abroad. She was everything a cartoonist could want: oversized, human in form, fraught with symbolism. Furthermore, her pose was so easily recognized that cartoonists couldn't help but take other subjects and put them in her place.

The original interpretation of the statue is evident from sculptor Frederic Auguste Bartholdi's title for the statue: "Liberty Enlightening the World." This was reinforced with the 1903 inclusion of Emma Lazarus's "New Colossus" sonnet as part of the piece, including the famous plea "Give me your tired, your poor, your huddled masses yearning to be free." However, the Statue of Liberty as an icon and her meaning have undergone countless revisions. Historian John Appel notes that the statue "served cartoonists representing conservative Americans' views of the dangers of unrestricted immigration and their concomitant

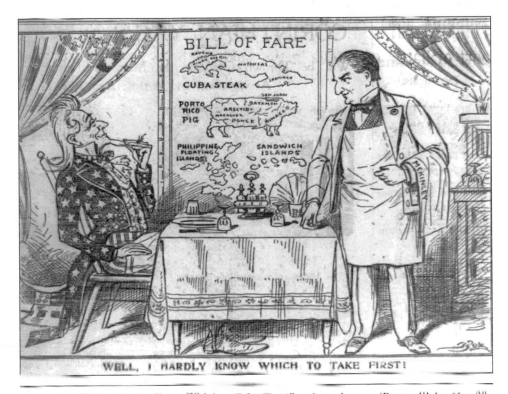

Figure 7.7: "Well, I Hardly Know Which to Take First!" artist unknown (*Boston Globe*, May 28, 1898)

fears of foreign, 'un-American' radical influences." In fact, he points out, "cartoonists often drew the statue rejecting rather than welcoming immigrants allowed to enter the much narrowed golden gates by the racist quota legislation of the 1920s."[13] Regardless of a cartoonist's political philosophy or position on a particular issue, the Statue of Liberty has proved to be a wonderful tool for commenting on life in America.

It is interesting to note that none of the symbols of America represent the highest levels of authority. Instead of being patriarchal (Father Time) or matriarchal (Mother Russia), the symbols for America (*Miss* Columbia, *Miss* Liberty, *Brother* Jonathan, *Uncle* Sam) are at least one step removed from traditional sources of power. This may be a reflection of the long-standing distrust Americans have for absolute authorities, beginning with the monarchy against which their ancestors rebelled.

Animals, Indians, brothers, uncles, and women in every form—there has been a staggering range of symbols for America over the years. Icons have come and gone, and, along the way, cartoonists have used American imagery the same way they have used the symbols of other institutions, massaging and reframing the symbols to make them support the cartoonists' individual perspectives.

The Bottom Line: Cartoon Effects

After the question of *how* editorial cartoons work has been examined, one additional, important question remains: What, ultimately, are the *effects* of editorial cartoons?

Historian Rafael Barajas argues forcefully that the cartoon is an exceptionally powerful force in society:

> The fundamental principle of cartooning is simple—fear of ridicule modifies behavior. . . . Cartooning is one of the few effective critiques possible under a barbaric government, though it is often more savage and aggressive in more tolerant free societies. In either case, cartooning can have powerful effects. The powerful who insist on committing abuses and who fail to modify their conduct often become, in the public eye, the image drawn of them by the caricaturist, undercutting their power in subtle but often powerful ways. Cartooning, in effect, cuts the powerful down to the size of the rest of us mortals, converts them into human beings with all our defects and turpitude.[14]

The question of effects, however, is complicated by the fact that editorial cartoons rarely operate in isolation.

Most of the time, they are one of a number of components of the editorial page, as well as a small part in a much larger, national dialogue about the issues of the day. This was true even in the era of limited media: Thomas Nast, the most influential political cartoonist in American history, was only one of many voices in the press (and other segments of society) expressing outrage at the nefarious Tweed gang. Nast's boss, George W. Curtis, used every weapon in his arsenal—reporting, editorials, and so on—to go after Tammany Hall. George Jones, editor of the *New York Times*, was just as strong a critic of city corruption as Curtis. Furthermore, the New York City debt was so huge, the civic project cost overruns so outrageous, and the Tammany Hall gang so arrogant and corrupt, it is difficult to see how the city officials could *not* end up in jail cells. "It is possible that Nast's role was not so much exerting influence on the New York electorate as it was elevating a local politico into an enduring symbol of civic venality," notes Roger A. Fischer.[15]

The case of Nast and Tweed is held

up as the strongest example of the impact of editorial cartoons, because it represents the rare alignment of an extremely powerful cartoonist helping to oust an extremely powerful politician. "On rare occasions the results [of political cartoonists] are dramatic and irrefutable, such as the downfall of Boss Tweed," note historians Stephen Hess and Milton Kaplan. "But most often the best that can be said is that the cartoonists have been an influence, albeit one of many."[16]

A similar analysis applies to another famous feud between an influential cartoonist and his powerful target. Herbert Block tagged Richard Nixon with his famous five o'clock shadow and may have created the impression in the minds of many Americans that Nixon was a shady character. But Nixon *was* a shady character, as demonstrated by his many words and actions reported for decades. And it was the work of investigative reporters in another office in the *Washington Post*, more than the artwork of Herblock and all of his contemporaries, that provided Americans with the factual information that

caused them to lose faith in their president. Furthermore, by the time "Watergate" became part of the American lexicon, television, a mostly editorial cartoon-free medium, had begun to dominate the American landscape. Did Herblock and his colleagues affect people's attitudes toward Nixon? Probably. Were they responsible for driving him out of office? No.

Examining the effects of the cartoon in the context of the entire editorial page has led some researchers to reexamine the relationship between the artist and the other members of the editorial staff. Should the cartoonist reflect the overall value system of the editorial page or function as a voice independent of the text that surrounds the image? If he or she functions independently, and the artist and the writers disagree on a topic, does this reduce the overall impact of the editorial page? Common sense and some academic research indicate that the greatest change in readers' opinions takes place when the cartoon and the editorial text agree, but the relationship between the written word and the visual

image requires a great deal more exploration.

Cartoonists themselves have differed on the impact of their work. One end of the effects spectrum is represented by Clifford Berryman, who argued that the visual produces a stronger effect than the printed word. Bill Mauldin and Hugh Haynie, on the other hand, felt that the cartoonists achieve their primary goal, not when they change a reader's mind, but when they cause the reader to focus on the subject.

As the twenty-first century begins, media options are more numerous than ever, offering a greater range of opinion than they did even as recently as the Nixon era. Internet sites, cable television, an increasing array of magazines—all provide greater opportunity for political debate. If there ever was an age when an editorial cartoonist or group of cartoonists could sway the electorate, it appears that the explosion of media options has eliminated the possibility of another such age occurring.

And yet, this explosion of media

may intensify another function of the editorial cartoon—not to present readers with additional news, but to help them create context for, prioritize, and evaluate what is already known. "It is not just information we want—all of us get more information than we can absorb," notes Press. "What we long for is interpreters who seem to make sense of things that are and will be important to us."

If we are entering an age of overinformation, the synthesis function of the media—and the editorial cartoon—may become even more important.

Ultimately, the key to understanding the effects of editorial cartoons may come from the cartooning process itself. The cartoonist uses a set of symbols to portray figures or current events from a particular perspective. These symbols must be recognizable to the reader. Readers may be predisposed toward these symbols and, furthermore, toward the perspective of the cartoonist. There is ample research in communication theory to demonstrate that readers gravitate toward information that they agree with—there is no reason to think readers' approach to political cartoons would be any different. The primary effect of editorial cartoons, then, could be to reinforce existing perceptions, rather than to create or change perceptions. The most effective cartoons may tap into existing prejudices, aspirations, hatreds, loyalties, and fears, making it easier for readers to get the artist's point. Such cartoons would solidify readers' worldviews by demonstrating readers' perceptions in creative and humorous ways. The ultimate effect of cartoons may be not confrontation with new ideas, but confirmation of old ones.

Ethical Tests: Who Decides? How Far Is Too Far?

A discussion of the effects of editorial cartoons presents a natural segue to the issue of ethics. Who should determine the content of a cartoon, or whether a controversial idea should make it into the paper? And when it comes to cartooning, how far is too far?

The decision-making process differs from era to era and paper to paper. Generally, artists have struggled successfully to increase their control over their work over the history of the profession. Many of the great publishing moguls of the late nineteenth and early twentieth centuries considered the editorial page their personal fiefdom, and the editorial writers and cartoon artists were mere scribes hired to repackage the thoughts of the owners. Invariably, however, the most talented artists— and Nast immediately comes to mind—used the leverage of their popularity to force their own ideas into the mix, fighting for autonomy with varying degrees of success.

Who decides which cartoons go into the paper can be a critical question, because the different gatekeepers in the process have different standards for what is fair game and what rules of presentation apply. If the players were placed on a continuum, cartoonists would usually be off to one side, in favor of printing nearly anything, while editors, of both the editorial page and the paper at large, would be toward the middle, signing off on all

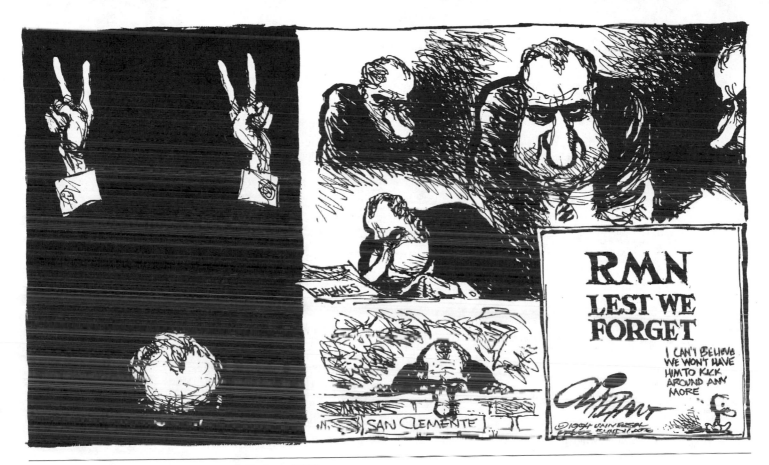

Figure 7.8: "RMN: Lest We Forget," by Pat Oliphant (1994)

but the most controversial cartoons. Interestingly, Ammons, King, and Yeric found that while cartoonists and editors are in harmony regarding the perceived objectives of cartoons, they disagree on who has the upper hand, with cartoonists feeling that they are compelled to express beliefs contrary to their own far more often than edi-

tors think they are exerting pressure.[17]

At the most restrictive end of the continuum would be the public at large, although it would be more accurate to say some portion of the public, depending on the issue and presentation. The far Left will find particularly vindictive antiliberal cartoons the most objectionable, and the far Right will take the same position about images they say are unfair to conservatives; there always seems to be somebody who objects to a cartoon's publication. And on the most controversial, intractable issues (gun control, the Middle East, abortion, etc.), a cartoonist can expect calls to ban his or her artwork from more than one side because feelings run so strong.

How far is too far? A good test of this question is the long and bitter history of cartoonists' representations of one of the nation's most vilified politicians— the thirty-seventh president of the United States, Richard Milhous Nixon. For more than four decades, Nixon's exaggerated features and mannerisms made for easy caricature, while his unethical conduct provided nearly limitless material. As his political career evolved, cartoonists drew him incessantly, portraying Nixon in increasingly villainous forms: liar, pretender to the throne, thief, warmonger, hit man. Of all of the president's media foes, however, Herbert Block may have been the most dogged. Herblock drew his nemesis in every conceivable unflattering position, even crawling out of a sewer. When Nixon resigned the presidency in disgrace in 1974, Herblock and many other cartoonists didn't see his resignation as a reason to stop attacking him— they continued for years to remind Americans of his many flaws.

At some point, most cartoonists left Nixon alone to stew in his postpresidential isolation. But a few even followed Nixon to his grave and beyond. When the former president died in 1994, a number of his long-term cartoonist foes took one final shot at their old adversary. In contrast to eulogists who chose to emphasize the positive highlights of Nixon's life, Pat Oliphant portrayed both the highs and the lows of the president's career (figure 7.8). In subsequent cartoons, Oliphant followed Nixon beyond the grave, plotting a political comeback.

Cartoonist Don Wright, who spent years caricaturing the disgraced president, decided that there was really no ending point for Nixon cartoons. "Frankly, I'm not sure we're out of danger yet. He may come back from the grave. I'm watching him very closely and, when I have the opportunity to comment on him, I do," Wright admitted, years after the former president's funeral.[18]

But is all of this too much? Should attacks on a person's character stop at the gravesite? In the weeks that followed Nixon's death, Americans debated his legacy, but some took time out to chastise (or defend) the cartoonists who had never stopped attacking him. Ultimately, when it comes to a figure as polarizing as Nixon, no one ever really forgives and forgets.

Ethnics and Ethics

Ranting, drunken Irishmen, breaking furniture and guzzling whiskey. Sinister, bucktoothed Asians, smoking

opium in decrepit alleyways. Filthy, bloodthirsty Indians, war whooping as they assault young white women. Hook-nosed, parasitic shylocks, eagerly clinging to buckets of coins. Wide-eyed African Americans, dancing wildly around a fire.

Offensive stereotypes are a consistent component of the political cartoon, normally emphasizing physical features but also encompassing dress, mannerisms, speech patterns, even religious practices (figure 7.9).

Why are stereotypes used so often? The portrayal of members of nondominant cultures as aliens reinforces the identity and perceived superiority of the dominant race, uniting artist and reader as "we" versus some other-worldly "they." Subgroups are portrayed as physically unattractive as well as morally and intellectually inferior. Physiological and cultural anomalies differ, but the presentations of subgroups have one thing in common: it is assumed that members of the groups cannot or will not assimilate into the dominant culture.

Ultimately, how should such racist

Figure 7.9: "The Ignorant Vote—Honors Are Easy," by Thomas Nast (*Harper's Weekly*, December 9, 1876)

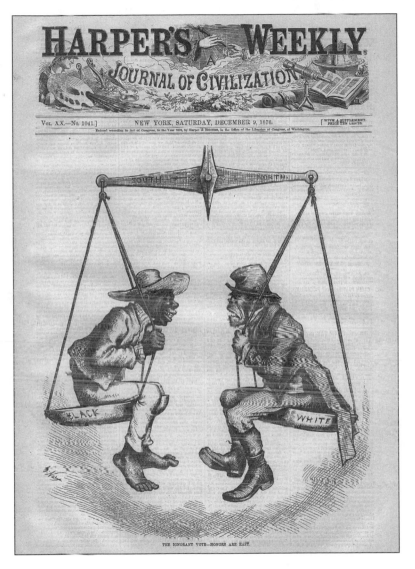

representations in editorial cartoons be judged? Interpretations range from exoneration to damnation.

One view emphasizes the role of racial caricature in the process of creating a cartoon. Cartooning is a form of shorthand, in which the cartoonist conveys abstract concepts or groups of people as quickly and concisely as possible. Stereotypes provide instantaneous, and humorous, caricatures that allow cartoonists to spoof people and readers to recognize groups, quickly and accurately. Cartoons "reinforce and build on a priori beliefs, values and prejudices," notes Fischer.[19] According to this rationalization, ethnic stereotypes are just one more tool used by the craftsperson. Exaggeration helps to make the cartoonist's point and reinforce the joke. Characters butchering the native tongue can be humorous in themselves or can be used to magnify the cartoonist's main point—that these people are, fundamentally, different from us. In fact, it would be difficult for cartoonists to ply their craft *without* using stereotypes.

A second justification is that a cartoon is the product of its time, and that applying the value system of one period to another period is unfair. Take, for example, the highly popular *Darktown* series of images, created by Thomas Worth for Currier and Ives in the 1880s (figure 7.10). Appel notes,

> Most Americans probably regarded Worth's *Darktown* series as good-natured, comic entertainments. From today's vantage point and for anyone committed to civil and human rights, they are vicious, thoughtless lampoons of African Americans as clumsy fools and clowns, without common sense and the capacity to feel pain, hurt, or embarrassment.[20]

Or consider an equal-opportunity-offender cartoon from the Civil War Reconstruction period (figure 7.11), which manages to insult Indians, Asians, and African Americans simultaneously. In graphic and text it stereotypes and denigrates nonwhites in an attempt to argue against revised voting laws. The Indian at the top celebrates "plenty whiskey all time"; the Chinese character, holding firecrackers, says, "No pay taxes—belly good"; and the African American laments, "Massa . . . I spose we'se obliged to carry dese brudders." As if those remarks weren't insulting enough, the figure on the right wants to add a monkey to the group. Should the artist be excused because he was drawing during a particularly emotional debate?

An alternative defense of racism in political cartoons is the argument that cartoons do not create or even reinforce prejudice; they simply reflect it. The political cartoon will not be effective if it fails to resonate with the reader, according to this argument, so it may be possible that the racism in political cartoons simply taps into the prevailing stereotyping of the era. "Distortion is not fabrication, exaggeration not wholesale invention," says Roger A. Fischer. "Centerfold and cover color cartoons tended to reflect and comment on historical phenomena or cultural trends, whether real or perceived."[21]

Xenophobic eras marked by social instability (e.g., massive immigration) or political and military strife (e.g.,

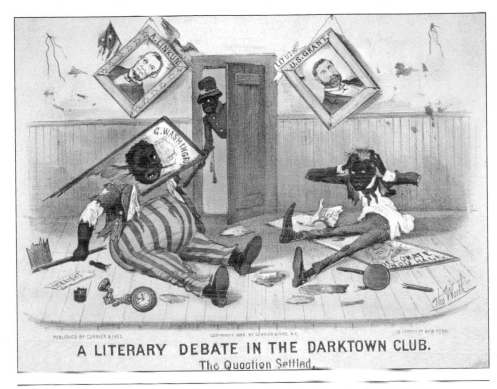

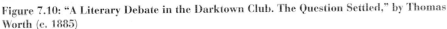

A LITERARY DEBATE IN THE DARKTOWN CLUB.
The Question Settled.

Figure 7.10: "A Literary Debate in the Darktown Club. The Question Settled," by Thomas Worth (c. 1885)

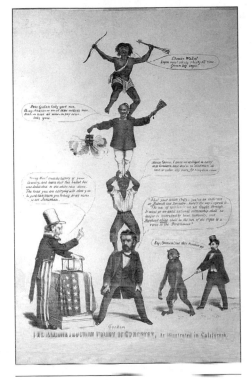

Figure 7.11: "The Reconstruction Policy of Congress, as Illustrated in California," artist unknown (1867)

world wars) have featured some of the most racist cartoons of all. The immigration wave of the late 1800s led to incredibly offensive stereotyping of almost all types of Europeans (with the notable exception of people from Germany, probably because many of America's leading cartoonists of the era were born in that nation). Thomas Nast, born Catholic, was enthusiastically hostile toward the Catholicism that many Irish brought with them to America, as is evident in what may be the most inventive and chilling drawing he ever created (figure 7.12). Both Nast and

Keppler (figure 7.13), the leading artists of the era, consistently portrayed the Irish as drunken, dangerous, and borderline subhuman. In his exposé on the caricature of the Irish, L. P. Perry Curtis Jr. notes that

> the simile of the simian Celt . . . crossed the Atlantic, gaining a higher facial angle and a bigger, squarer jaw en route, and became as closely identified with corruption, clericalism and organized violence in America as in the British Isles. The leading cartoonists in New York in this period used much the same physiognomical device as [English cartoonists] Tenniel, Proctor, and Bowcher in order to convey attitudes about the essence of Irish character which were widely held in both countries.[22]

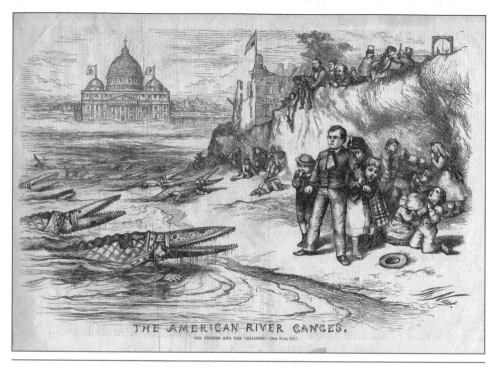

THE AMERICAN RIVER GANGES,
THE PRIESTS AND THE CHILDREN.—[See Page 215.]

Figure 7.12: "The American River Ganges," by Thomas Nast (1871)

There is an extensive history of political cartoonists who have been particularly vicious in their wartime depictions of the enemy. The collective goal of such efforts is to dehumanize the enemy, making him more frightening in order to mobilize opposition and make killing him less morally offensive. This technique is used by propagandists on every side in a military conflict. In World War II, for example, American cartoonists portrayed the Japanese as sinister, monkeylike creatures (figure 7.14) and Germans as hulking, brutish figures. Following the attacks on the World Trade Center in 2001, cartoonists drew Islamic fundamentalists as dirty, wild-eyed subhumans lurking in holes and caves.

In wartime, the cartoonist walks a thin line between demonizing the en-

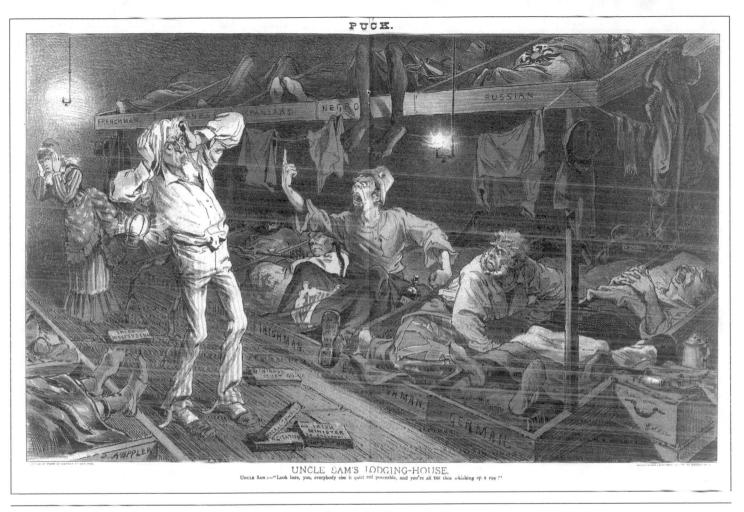

Figure 7.13: "Uncle Sam's Lodging-House," by Joseph Keppler (June 7, 1882)

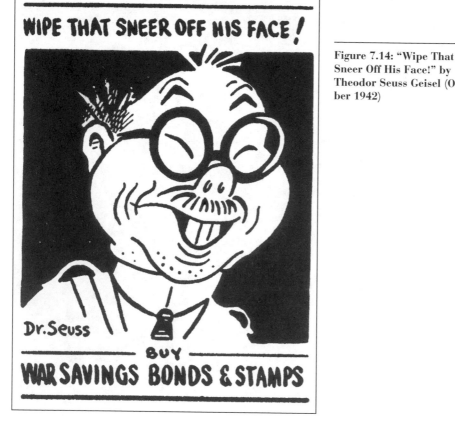

WIPE THAT SNEER OFF HIS FACE!

Dr. Seuss

BUY WAR SAVINGS BONDS & STAMPS

Figure 7.14: "Wipe That Sneer Off His Face!" by Theodor Seuss Geisel (October 1942)

but never moral superiority. Defenders of these tactics point out that desperate times call for desperate measures, and that the cartoonist may be using whatever tools are available to motivate readers and combatants and persuade them to fight against a hostile enemy.

But are these arguments giving a free pass to explicit racism? Consider the potential damage, both personal and social, that can result from stereotyping. An alternative perspective suggests that situations (war, political upheaval, culture clashes) do not excuse racism and that, in fact, the use of stereotypes during times of conflict leads to additional misunderstanding and drives an even greater wedge between groups of people.

Oddly enough, fear of the accusation of racism may cause some cartoonists to minimize, or even eliminate, the presentation of minority groups or their leaders. "Caricatures of [Martin Luther] King, Malcolm X, and the other African American leaders who rose to prominence during this era [the 1960s] are hard to find," note Hess and Northrop.

emy—making him subhuman and menacing—and making him *so* sinister that he appears invincible. Cartoonists during wartime often show the enemy as a large force, deemphasize the humanity of the individual foe, and attribute enemy victories to some moral failure. In these scenarios, the opposition wins because of treachery, ruthlessness, or a misguided fanaticism—

Cartoonists and their newspapers grew so sensitive to the volatility of caricaturing black leaders, fearing that they would be perceived as racial slurs and thereby bring resentment from the black community, that they shied away from any depiction whatsoever. Instead, cartoonists employed generic situations and peopled them with generic black figures. Martin Luther King, Jr. became an invisible man in the cartoons of an era in which he was a prominent player.[23]

Some cartoonists minimize the use of ethnic groups for a more practical reason—to simplify their drawings. The process of cartooning necessitates stripping away all nonessential elements to focus on the key theme, and the inclusion of any "nontraditional" images may serve to distract from the message. As a result, main characters are invariably white, male, middle-aged, and average looking—by design. When the cartoonist employs the "everyman" figure, he deliberately deemphasizes differences, so that no attention is drawn away from the action or verbiage that is central to the message. When cartoonists approach minorities this way, ethnic characters are included only as peripheral participants (members of crowds, people reacting to main characters, etc.), since using them as main characters may overly complicate the cartoon.

This thinking stands the standard attack on displays of racism on its head. If a cartoonist consciously avoids racial presentations of any kind to eliminate charges of racism, then only the dominant group will be portrayed, and "aliens" will be marginalized. They won't be part of the humor, but they won't be part of the debate, either. The minimization of ethnic characters may result in an ironic form of reverse racism: less-powerful groups further marginalized by their lack of representation in political cartoons. Ultimately, it is easier to see *why* and *when* stereotypes work in cartooning than it is to see whether they should be used at all.

EIGHT

In Their Own Words

CARTOONISTS ON CARTOONING

Many cartoonists would be hired assassins if they couldn't draw.[1]

JEFF MACNELLY, CARTOONIST FOR THE *CHICAGO TRIBUNE*

THIS CHAPTER presents perspectives on the political cartooning profession from the artists who draw the cartoons. To provide a variety of viewpoints, the chapter also includes comments from editors who publish the cartoons, as well as men and women who are featured in them. The quotations are drawn from the author's personal interviews of cartoonists, excerpts from interviews by other writers, quotes from political cartoonists at professional conventions, and the writings of cartoonists themselves.

Cartoonists are reflective by nature, so it usually isn't difficult to get them to discuss their craft. Many seem to have thought long and hard about who they are and what they do. They are also free thinkers, so it is no surprise that they disagree with one another about everything from their importance to the future of their profession. The relationship between editors and cartoonists also includes occasional disagreements, since this relationship includes an inherent power struggle over content and expression. Editors and cartoonists have overlapping, but not

identical, agendas. Cartoon subjects also have a complex relationship with cartoonists: some awed by the power of the pen, others disdainful and dismissive, many somewhere in between.

The quotations are arranged according to the following subjects: cartoonist personalities, the process of cartooning, editorial cartooning as a career, ethics/rules, editorial cartoon impact, subject and reader reactions to cartoons, cartoonists' relationships with editors (and other cartoonists), and, finally, what makes a good cartoon. All of the people quoted are professional editorial cartoonists unless otherwise identified.

Cartoonist Personalities

They are a strange breed of journalist, these cartoonists. Almost alone among the Washington press corps, they avoid socializing with politicians, for fear that the cup of friendship will dilute their vitriol, and they flaunt their likes and dislikes the way the writing press guards its reputation for fairness and objectivity. They have no stake in culti-

vating sources; nothing could be less useful to a cartoonist than a secret. Yet they must be alert to every nuance of a politician's image. . . . They love controversy, eccentricity and color, but they are easily jaded.[2]

—JERRY ADLER, *Newsweek* reporter

We all picture ourselves as the little kid looking at the naked emperor. That's our greatest gift to society.[3]

—MIKE PETERS

Cartoonists are used to working alone and being self-motivated. We usually don't want to go to editorial board meetings, and when we do attend, we're more likely to be nursing our own thoughts, doodling on a sketch pad. We are, generally, cats rather than dogs. . . . Are we, as a group, antiauthoritarian? I'm not sure, but I *do* know that "Do this because you were told to do it" will *not* work with editorial cartoonists.[4]

—V. CULLUM ROGERS

Outside of basic intelligence, there is nothing more important to a good political cartoonist than ill will. Cartoons are more likely to be effective when the artist's attitude is hostile, to be even better when his attitude is rage, and when he reaches hate he can really get going.[5]

—JULES FEIFFER

Cartoons are ridicule and satire by definition. A negative attitude is the nature of the art.[6]

—PAUL CONRAD

I'm from a political family—less like the Brady Bunch and more like the McLaughlin Group. We debated everything at the dinner table.[7]

—CLAY BENNETT

Generally speaking, cartooning is not for those who are given to second thoughts. Conrad simply threw out all the hate mail engendered by his savage drawing of Reagan's head tied down on a flatbed truck, captioned: "Removing another nuclear war head." Wright—in Miami, of all places, drew an early-

primary-season cartoon of various Republican candidates tossing their hats into the ring, and Reagan pitching in a cane. The howls of protest from scores of outraged senior citizens left him unmoved.[8]

—JERRY ADLER, *Newsweek* reporter

I've always wanted to be an editorial cartoonist, mainly because that's the only thing that anyone ever said I could do well. I was a poor student and thought doing cartoons would be a way of becoming smart. And I have gotten a real degree in world history and literature by becoming an editorial cartoonist.[9]

—MIKE PETERS

I was always scribbling in my notebook. I took notes in the margins. . . . Looking back, I shouldn't have gone to college. I was one of those people who needed a hiatus—going to class was kind of an extracurricular activity. . . . I don't remember worrying a lot. My father used to worry. He'd tell me I was going to hell, and I better get on the

stick. And I'd agree with him, and that made him madder.[10]

—JEFF MACNELLY

Everybody can love a comic artist. Not everybody can love a political cartoonist. If you want to be loved by everybody, don't become a political cartoonist.[11]

—SYD HOFF

Most [cartoonists] cheerfully admit to being social misfits in their early days: a stutterer, nerd, or general adolescent ne'er-do-well who used his or her quick-draw humor to win friends and gain notoriety.[12]

— CARTOON HISTORIANS
STEPHEN HESS AND SANDY
NORTHROP

As a child, the only thing I wanted to be was grown up. Because I was a terrible flop as a child. You cannot be a successful boy in America if you cannot throw or catch a ball.[13]

—JULES FEIFFER

Political cartoonists would rather be right about what is happening than anything else.[14]

—CARTOON HISTORIAN
CHARLES PRESS

The Process of Cartooning

Every morning, cartoonists across America are confronted by two blanks, the one on the top of the editorial page, where their cartoons are supposed to be by two o'clock, and the other directly in front of them on their drawing pads. White paper is particularly glaring and garish at 8:13 a.m. I like to try staring at the paper for a couple of minutes to see if I can will it away, like Uri Geller bends a spoon with brainwaves. This approach has not, at this writing, produced results, but I'm still trying.[15]

— JACK OHMAN

I draw my cartoons at the *Washington Post*, but don't submit sketches or sit in on editorial conferences. And I don't see the editorials in advance. This is for much the same reason that I don't read idea letters. I like to start from scratch, thinking about what to say, without having to unthink other ideas first. That's something like the old business of trying not to think of an elephant for five minutes. It's easier if nobody has mentioned an elephant at all.[16]

—HERBERT BLOCK

The worst part of the job is coming up with a decent idea, then throwing it out, then coming up with another one. Some days you think, "I'll never have another idea in my life," other times you can come up with stuff for the whole week. If you don't have it, it can be sheer terror.[17]

—SIGNE WILKINSON

When [Jeff] MacNelly began working for the *News Leader* in late 1970, he would begin drawing a day before deadline, worry through dinner, work late, and then get up early to dash to the office to pen the finished product. "Then," he says, "I decided to eliminate the 24 hours before. Now I get to work at about 6 a.m., do the cartoon by 9:30. You have to have an open, flowing

mind, and the best way is not to worry about it."[18]

—JEFF MACNELLY

It's really tough to get angry six times a week.[19]

—HUGH HAYNIE

Whenever the situation calls for it, raise bloody hell.[20]

—HERBERT BLOCK

I try never to do anything which needs further reference, or which presumes any specific knowledge, unless perhaps it is how a nursery rhyme ends. But if I'm doing something out of Shakespeare, I would try to have it self-contained in a way that would banish the thought that I was condescending. It's a dangerous game to play.[21]

—DRAPER HILL

Part of the job as a cartoonist is to confront people with things they really don't want to see.[22]

—TONY AUTH

I try to turn logic on its ear. I take the suppositions of the people I'm disagreeing with to their logical but ridiculous extremes, and try to show how these arguments fail. And through that, I give the reader not just an opinion or an attitude but a perception of what's really going on.[23]

—JULES FEIFFER

A good cartoon consists of 75 percent idea and 25 percent drawing. . . . A good idea has carried many an indifferent drawing to glory, but never has a good drawing rescued a bad idea from oblivion.[24]

—ROLLIN KIRBY

Drawing is the bait in the trap. Get your readers interested enough to look at the cartoon. The message is far more important—get your point across.[25]

—MIKE RAMIREZ

It may not sound very exciting or cartoony, but to me the basic idea is the same as it ought to be with a written opinion—to try to say the right thing.

Putting the thought into a picture comes second. Caricature also figures in the cartoons. But the total cartoon is more important than just fun with faces and figures.[26]

—HERBERT BLOCK

What cartoonists really do is worry. . . . They worry about things that no sane person even gives the slightest millisecond of thought.[27]

—JACK OHMAN

Cartooning is basically a negative art form. We bitch. That's what we do. . . . Cartooning is all about paring down, bringing an image down to its essence.[28]

—CLAY BENNETT

I brainstorm with myself. In drawing a cartoon, all you can do is try to please yourself. You can't try to draw for the public or the people in your newspaper city room. A cartoon may not seem successful to them, but if I have something to say, and I say it simply and get the idea across, and it is fairly strong— then I am pleased.

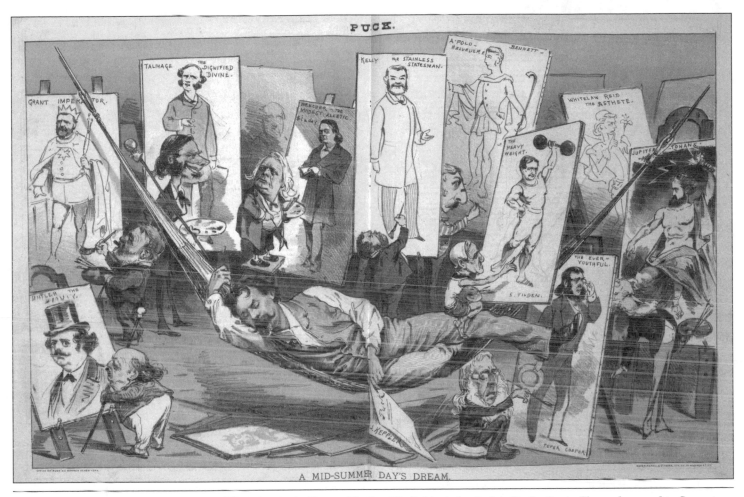

Figure 8.1: "A Mid-summer Day's Dream. While Our Artist Sleeps, His Favorite Subjects Are Left to Do Justice to Themselves, and to Correct His Conceptions," by Joseph Keppler (August 1881)

I work to do that one cartoon out of 10 that is as strong as my feeling on a topic—but, more often than not, I do lousy cartoons on subjects that I am irrationally upset about. The problem is that my feelings can be so strong that the cartoon I eventually give birth to may not be as strong as what I feel. Then it's a very inferior cartoon.[29]

—MIKE PETERS

I don't delve much in caricature because I don't feel that I'm good at it. But also, I feel that if you blame one person too much then that person becomes a scapegoat. Problems are complex and long-term: if we get rid of one crook, we might just get another crook.[30]

—CLAY BENNETT

Political cartoonists who, on technical points, can't draw often find themselves hailed as stylistic geniuses because they have broken new ground by being terrible draftsmen—but save themselves with great writing. There are more political cartoonists now who are good illustrators but who can't do what is most important: write.[31]

—JACK OHMAN

My job is to stir debate, to engage readers in discussion of issues. And on the big, gray editorial pages of America, any humor is appreciated.[32]

—JIM BORGMAN

[Political cartooning] is like being a sleight-of-hand artist. If you watch it too closely, all the fun goes out of it.[33]

—JACK OHMAN

I'm not proud—I'll copy off my contemporaries![34]

—JOEL PETT

Editorial Cartooning as a Career

I started early in life and am largely self-taught. A few art courses in school. But you can't teach a person to think like a cartoonist—it's a very nebulous thing.[35]

—CLAY BENNETT

When I saw [Bill Mauldin's face on the cover of *Time* magazine], I said to myself, "my God! That's it for me . . . that's what I want to be"; I mean if a cartoonist can get his picture on the cover of *TIME*, what more is there? I saw a chance to do something and still have a good time for the rest of my life—being able to draw, get pissed at people, and mouth off whenever you want to. There's nothing better than that.[36]

—MIKE PETERS

Most cartoonists today studied art and apprenticed on college newspapers, unlike their predecessors who had little formal art training and were largely self-taught.[37]

—CARTOON HISTORIANS HESS AND NORTHROP

Cartooning is not a way to get rich. . . . Only in the world of cartooning would freelance writing be considered a gravy train.[38]

—TEDD RALL

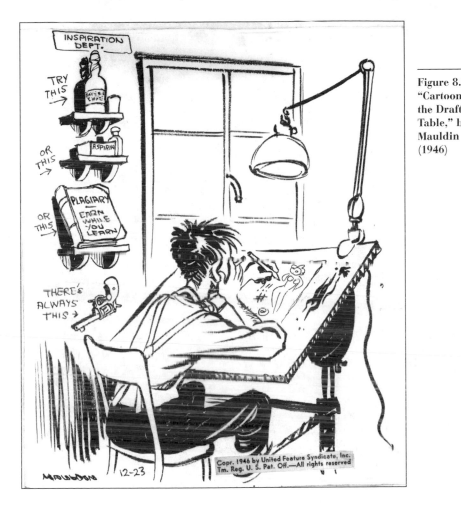

Figure 8.2: "Cartoonist at the Drafting Table," by Bill Mauldin (1946)

When I see some of the stuff going on now, some of the things the government is doing, as a citizen I'm leery. As a cartoonist, I'm in heaven.[39]

—MARK FIORE

The cartoonist . . . gets lots of psychic rewards to make up for the monetary treatment. Deference is shown, important people occasionally request originals, and the cartoonist has an excuse to get close to all VIPs who come along.[40]

—CHARLES PRESS

There is one compensation to us altruists [artists]. We get tons of letters each year from a Boy of Fifteen who wants to be told how to become an artist and he encloses samples of his drawings which are horrible little Gauguin things. Our compensation—our one ray of vicarious joy—comes to us, it is the knowledge that HE will never become an artist.[41]

—ILLUSTRATOR JAMES MONTGOMERY FLAGG

Figure 8.3:
"Family Tree:
The History of
Editorial Car-
tooning," by V.
Cullum Rogers
(1998)

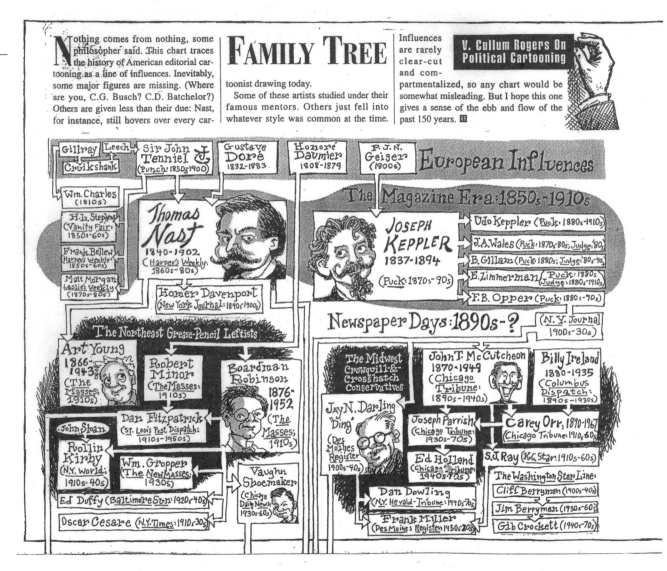

Nothing comes from nothing, some philosopher said. This chart traces the history of American editorial cartooning as a line of influences. Inevitably, some major figures are missing. (Where are you, C.G. Busch? C.D. Batchelor?) Others are given less than their due: Nast, for instance, still hovers over every car-

FAMILY TREE

toonist drawing today.

Some of these artists studied under their famous mentors. Others just fell into whatever style was common at the time.

Influences are rarely clear-cut and com-partmentalized, so any chart would be somewhat misleading. But I hope this one gives a sense of the ebb and flow of the past 150 years.

V. Cullum Rogers On Political Cartooning

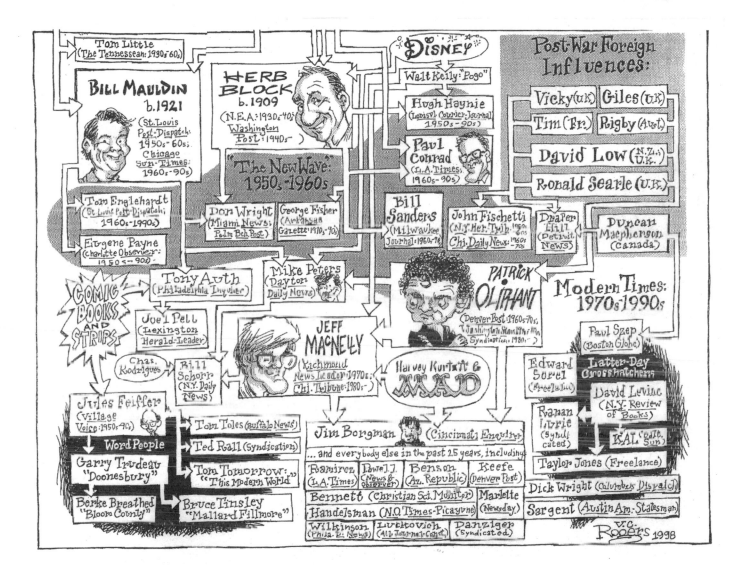

People who come in [to editorial cartooning] now may be entering primarily because they are interested in humor, not editorial opinion. That's a real mistake. If they feel that way, then they ought to be working for the *New Yorker*, not for an editorial page.[42]

—MIKE PETERS

I love my job. You have to have a passion for this work if you're going to stay in it. It's usually not for the money. I love to draw, and now I can express an opinion. The only thing I dislike about it is the business end of it. You have to deal with the business side if you're syndicated or on a paper.[43]

—ANN TELNAES

The craft is one of those great secrets. Where else can you be paid to stand up and spout off about anything you want? I used to get thrown out of high school for drawing cartoons about my principal in the school paper; now I do vicious cartoons about the President and they give me awards![44]

—MIKE PETERS

"No creative person should work more than three hours a day."

Figure 8.4: "No Creative Person Should Work More Than Three Hours a Day," by Bill Mauldin (1950)

Style is handed down from generation to generation of political cartoonists. Oliphant begat MacNelly, Searle begat Oliphant, Low begat Searle, and so on back to cave paintings. However, style is secondary to the message.[45]

—JACK OHMAN

What it means to be a well-known cartoonist—even one of the top two or three cartoonists in the country—is that you can go into the local 7-Eleven and run very little risk of having cartoon groupies tear off your cufflinks and ask for locks of your hair.[46]

—JACK OHMAN

[Political cartooning] takes not only courage, but also a special kind of skill. The courage is needed because there are always some readers who will be offended by the point of view of an editorial cartoon and will demand the job and maybe the hide of the artist. The skill is demanded because it takes a superior craftsman to portray the likeness of the heroes and villains who strut their stuff on the events of the day.[47]

—SYD HOFF

As for being an editorial cartoonist, what do I have to complain about? I get to put my opinions in the newspaper every day and I get to go home happy at the end of the day. And I get paid for it. My letter writers would love to do what I do. The biggest thrill is that people read my stuff.[48]

—SIGNE WILKINSON

Ethics/Rules

There are no rules [to editorial cartooning]. You can be hilariously funny, depressingly serious. . . . If I do have a set of rules, they go like this. First, make the cartoon insightful. If you can't, at least make it funny. And if you can't make it insightful or funny, at least make it timely.[49]

—CLAY BENNETT

[My philosophy] is that politicians should be jumped on as often as possible.[50]

—DAVID LEVINE

Cartooning is not a fair art. You can never treat anyone justly. Most cartoonists like me— who like to attack—are like loaded guns. Every morning we start looking through the newspaper for a target to blast. That's our function. . . . When I started cartooning . . . I decided that since a cartoon is an inherently unfair medium and you've got this ability to attack, I'd do just that· attack and be one-sided. I mean the dream of every editorial cartoonist is to get picketed. It's got to be.[51]

— MIKE PETERS

I always retain the right to change my mind. I'd rather not be categorized, and I resist that as much as possible. The ground I take in my drawings reflects how I feel that day toward a certain subject.[52]

—PAT OLIPHANT

Once, I drew a cartoon based on inaccurate information from a correspondent. I regretted that one.[53]

—WAYNE STROOT

Every once in a while, I worry that I'm not going for the jugular vein. I think maybe I should be a little meaner. But I think you get more people to listen to you if you poke good-natured fun at people. . . . I'm a lot more conservative than most guys you find in my profession. But you can't afford to be dogmatic and funny at the same time. You can't be the conservative cartoonist. That would be too predictable.[54]

—JEFF MACNELLY

Who do I draw for? I draw for myself.[55]

—MIKE RITTER

Is there anything I wouldn't draw? No. Children of politicians are often off-limits, but I did cartoons about Jenna Bush. If you are just doing a cartoon for shock value, that's no good, but if you are doing it to make a point, that's legitimate.[56]

—ANN TELNAES

All societies have taboos of taste, what differs is the willingness of the cartoonist to oppose them.[57]

—MARTIN ROWSON

From time to time the question of cartoon fairness comes up—with some practitioners asserting that they are not supposed to be fair. This is a view I don't share. Caricature itself is sometimes cited as being unfair because it plays on physical characteristics. But like any form of satire, caricature employs exaggeration—clearly recognized as such. Also the portrayal of a person is often part of the opinion. . . . I think fairness depends on the cartoon—on whether the view is based on actual statements, actions or inactions.[58]

—HERBERT BLOCK

Political cartoonists violate every rule of ethical journalism—they misquote, trifle with the truth, make science fiction out of politics and sometimes should be held for personal libel. But when the smoke clears, the political cartoonist has been getting closer to the truth than the guys who write political opinions.[59]

—JEFF MACNELLY

The limitations imposed by the necessity of conforming to the genteel code of taboos which institute the average man's "good taste" are such that they cramp the style of any satirist worth his salt. Social polish, courtesy, and urbanity merely to sooth sensitive feelings are no part of the technique of true satire. . . . The caricaturist, be he right or wrong, must be individual or languish. Caricature must be a critic of the social system, not its servant.[60]

—DAVID LOW

While many American cartoonists have chosen to adopt an Olympian detachment toward the events they describe, the best practitioners since the late nineteenth century generally have not been satisfied to remain observers; they

have sought to shape events rather than merely record them.[61]

—CARTOON HISTORIANS STEPHEN HESS AND MILTON KAPLAN

There are two aspects of current editorial cartooning that concern me: inaccurate cartoons and cheap shots. The inaccuracies I attribute to either sloppy (or no) research or a deliberate political agenda. The cheap shots I believe are largely due to tight deadlines and editors who want "something funny." Often, these cartoons fail to make a point at all and should probably be on the comics page. The proliferation of this material will not increase the public's respect for this profession.[62]

—WAYNE STROOT

Editorial writers go out of their way to be fair. Political cartoonists go out of their way to be unfair, at least to the aggrieved politician with the address 1600 Pennsylvania Avenue engraved on the inside of his forehead. Political cartoonists are equal opportunity satirists.[63]

—JACK OHMAN

I don't do cartoons patting people on the back. Herblock doesn't do stuff telling people they are doing a great job. There's no point to doing feel-good cartoons. . . . I'm liberal, but more in my social views—I'm a registered Independent. Many readers think I'm a Democrat, but I'll do cartoons about anyone who's acting stupid.[64]

—ANN TELNAES

Editorial Cartoon Impact

Pieces of pleasantry and mirth have a secret charm in them to allay the heats and tumults of our spirits and to make a man forget his restless resentments. They have a strange power in them to hush disorders of the soul and reduce us to a serene and placid state of mind.[65]

—BENJAMIN FRANKLIN

Impact is what makes a cartoon good and, in order to have impact, I'm not sure that you should be all that subtle. The best cartoons hit you squarely on the jaw, between the eyes. Magazines like *Newsweek* want cartoons that don't take too strong a position, that are funny. But cartoons should make a statement. And for that, I think we could do with a little less wit and a little more statement.[66]

—DON WRIGHT

As for a comparison of words and pictures—each has its role. Each is capable of saying something necessary or something irrelevant—of reaching a right conclusion or a wrong one. . . . A cartoon does not tell everything about a subject. It's not supposed to. No written piece tells everything either. As far as words are concerned, there is no safety in numbers. The test of a written or drawn commentary is whether it gets at an essential truth.[67]

—HERBERT BLOCK

Politicians pretend they don't mind while the cartoonists pretend they matter. . . . I think we matter, but don't make much difference . . . We are court

jesters, we can say the unsayable, but the problem is that if you're a jester you say what you want to say but at the end of the day, the King remains the King.[68]

—MARTIN ROWSON

In an editorial cartoon, you're trying to compress a message down, the same way you do on T-shirts or bumper stickers. We just have bigger bumpers.[69]

—CLAY BENNETT

Cartoonists are not comedians. They are people who make a difference in the community.[70]

—FRANK SWOBODA, president of the Herblock Foundation

When I worked at the *Philadelphia Inquirer*, we did a poll that found that only 10 percent of readers knew what the editorial board's positions were, but 80 percent knew what Tony Auth [the paper's editorial cartoonist] stood for.[71]

—MAX KING, former executive editor of the *Philadelphia Inquirer*

A picture shows—A cartoon shows and thinks.[72]

—RANA R. LURIE

Judged on the basis of influence per square inch, it would be hard to find a match for the political cartoon in the history of modern American journalism.[73]

—JIM ZWICK, editor of *Political Cartoons and Cartoonists*

The assumption is made that we are powerful. I sincerely believe that what we do is contribute one particle a day in the vast torrent of criticism, analysis, viewpoint and argument that everyone is subjected to.[74]

—TONY AUTH

A good cartoon is as powerful as a thousand-watt spotlight; it evokes a visceral reaction that not even the most stirring editorial can duplicate. Too visceral, in fact, for the *New York Times*, which alone among major U.S. newspapers has never had one on its editorial page, although it recently resumed

running a selection of cartoons in its Sunday news roundup.[75]

—JERRY ADLER, *Newsweek* reporter

The political cartoon is a sort of pictorial breakfast food. It has the cardinal asset of making the beginning of the day sunnier.[76]

—HISTORIAN JOHN T. MCCUTCHEON

Particularly during General Elections cartoons can provide us with an image which lasts. They capture a view, normally one with which a reader of a particular paper is likely to be sympathetic, which helps to fix an elector's determination to vote in a particular way. The political correspondent, John Sergeant, said that cartoons can capture in one space what journalists have spent days researching and ages talking about. Perhaps we smile at the cartoon or only register it with grudging approval, but we are unlikely to stop halfway through as we might do with a much more substantial article.[77]

—AUTHOR ALAN MUMFORD

Former Reagan campaign manager John Sears believes that cartoons are growing more important: today's picture-oriented voter often scans the front page of his newspaper and then turns directly to the editorials, where the first thing to catch his eye is the cartoon. But, like the spotlight, it can only illuminate what was there in the first place rather than create something new. Cartoonists, Sears observes, work with images and perceptions that are already current— Reagan's age, Carter's incompetence, Richard Nixon's duplicity. They can make these characteristics infinitely more arresting, vivid and memorable; Nixon could shave himself raw but never escape the sinister 5 o'-clock shadow with which Herblock cursed him.[78]

—JERRY ADLER, *Newsweek* reporter

The political cartoon remains what it has always been throughout its history—critical comment aimed at the fairly bright, that group of society which . . . manages most of society's affairs. . . . The net impact of the political cartoon today continues to be its ability to join with other media critics in creating a climate of opinion or consensus among that politically attentive segment by peddling assumptions about the conditions and problems facing the society, their nature and even sometimes their solution.[79]

—CHARLES PRESS

Subject Reactions to Cartoons

Cartoonists are not paid to be nice.[80]

—LYN NOFZIGER, press secretary to former president Ronald Reagan

Most politicians would rather be caricatured as a gob of phlegm dripping off a barbed wire fence than not be drawn at all.[81]

—GERALD SCARFE

In England a century ago, the [cartoonist] offender would have been drawn and quartered and his head stuck upon a pole.[82]

—SAMUEL PENNYPACKER, former governor of Pennsylvania, who had an anticartoon bill introduced in the Pennsylvania legislature in 1903

I'm glad Walter Lippmann can't draw.[83]

—PRESIDENT LYNDON JOHNSON

Every cartoonist has a tale of publishing an unusually savage, vitriolic and pointed caricature—and receiving, a few days later, a sotto voce request for the original drawing from the victim's secretary. National politicians learn to be philosophical about such treatment, or hide their feelings.[84]

—JERRY ADLER, *Newsweek* reporter

I think cartoons wound leaders if three factors coincide: if they are quite vulnerable characters anyway; two, if they are based on derision; and three, if they are in tune with the media mood.[85]

—ANTHONY SELDON, biographer of British prime minister John Major

Sometimes I hear from politicians, the subjects of the cartoons, who want the original. But you know what? I also hear from their enemies—they want the originals even more![86]

—SIGNE WILKINSON

What's interesting is the way politicians react—they will quite often buy the cartoons as a way of defusing the magic, defusing the voodoo, taking back possession of themselves.[87]

—MARTIN ROWSON

Reader Reactions to Cartoons

I have toiled for hours on the proper positioning of thumbs, suit jacket wrinkles and brilliantly executed facial expressions, only to be greeted by the deafening silence of my readers who Don't Get It. Nothing is more depressing than the morning barrage of phone calls with the simple request that I explain the day's cartoon.[88]

—JACK OHMAN

Whenever I used to think about who was reading my political cartoons, I always had this vision of the audience—older ladies in their seventies—in my mind. A kid might pick it up now and again, but generally I always thought it was older people reading the editorial page.[89]

—MARK FIORE

I don't use suggestions for cartoons. And the last time I mentioned *that* in a little article, I got twice as many "idea" letters as usual the following week, because all anyone remembered was that there was something in the article about this cartoonist and "ideas"—and he'd probably like some.[90]

—HERBERT BLOCK

One of the drawbacks of being a political cartoonist is that you can't satisfy all your readers at the same time, as a comic book artist can. I am in the business of daily alienation. . . . There is a consistency in making everyone mad.[91]

—JACK OHMAN

The most exhilarating thing I do is to open my daily mail. "Please, Mister Postman, look and see, if there's a letter bomb for me." If I have really reached my stride, I can usually expect one or two newspaper cancellation notices, along with various accusations ranging from questions about my ancestry, allegations of complicity with Mikhail Gorbachev to enslave the human race, recommendations of where to seek competent psychiatric help, and the occasional ripped-out cartoon with red Magic Marker notations referring to my activities with the Trilateral Commission and David Rockefeller.[92]

—JACK OHMAN

The biggest reader response is to religion, guns, and race—those are the big ones. If I lump abortion and vouchers under religion. These are the issues that are where they live—that's what they care about.[93]

—SIGNE WILKINSON

Anything on religion gets a big response. It's very personal, and both par-

THE CHATTANOOGA TIMES
1•19•2000
PLANTE

Figure 8.5: "Stars and Bars," by Bruce Plante (January 19, 2000)

IT'S THE ONLY THING I COULD THINK OF THAT MIGHT OFFEND HIM.

ties have done a damned good job of using religion for personal gain. Gun cartoons will still get you a reaction. And I do a lot of anti-Vatican cartoons, which are taken as anti-Catholic or anti-Christian. They get a lot of response.[94]

—ANN TELNAES

I get lots of negative feedback on anything race related. People who are motivated to respond to these cartoons are looking to be offended. There are even cartoons I've done that aren't about

race, but people perceive them that way. Race is controversial.[95]

—JIM HUBER

There are a couple of topics I just *know* are going to get a huge reaction from readers. Guns, for one. Anything involving the Confederate flag gets an incredible response. I did one about rednecks and their reaction to a sixpack on a flag back in 2000—I *still* get letters about that one. I don't do abortion, but I know that if I did, that would get a big reaction. Churches, anything religious, prayer in schools, ten commandments, all of those topics always get a big response from readers. Oh yeah, and because of where my paper publishes—anything dealing with the University of Tennessee Volunteers football team.[96]

—BRUCE PLANTE

Local issues get the strongest reaction. Readers actually know the people in the cartoon, so they respond personally—*very* personally....You also get a lot of reaction to any social topics, because morality hits very close to the heart.[97]

—WAYNE STROOT

My biggest response now comes via e-mail. It's few and far between to get a letter routed through the paper.... I know that I've really done a good cartoon when I get a lot of reaction to it. If I show it to my husband and he cringes, that's good! On the whole you get more negative than positive feedback. Sometimes, however, I'll get readers who say, "Thank you for saying things that haven't been said—keep doing it until you can't do it any more." I think there are a lot of people thinking what I'm saying.[98]

—ANN TELNAES

Most readers don't write to the editor when they agree. They comment in person or [by] telephone. Ninety percent of the letters are negative—90 percent of the telephone calls, etc., are positive comments.[99]

—WAYNE STROOT

Readers call me. They e-mail me and if they hate the cartoons, they try to add viruses to the e-mails, that kind of thing.[100]

—CLAY BENNETT

American society is increasingly preoccupied with offending and being offended. Rather than reply to an argument or cartoon with which they disagree by saying "I disagree," more and more people are saying "I'm offended." They insist that their subjective state is someone else's objective problem and they demand redress.[101]

—DAN WASSERMAN

Cartoonists' Relationships with Editors (and Other Cartoonists)

This is a serious profession with a deep, long history. I just wish we could just convince editors and publishers of our importance.[102]

—HY ROSEN

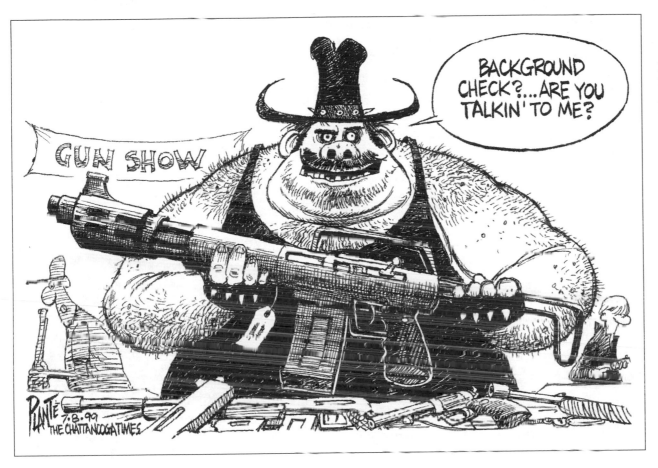

Figure 8.6: "Gun Control," by Bruce Plante (July 8, 1999)

Give me a good cartoonist and I can throw out half the editorial staff.[103]

 —H. L. MENCKEN, former editor of the *Baltimore Sun*

Many editors think you're either a joker or an artist—I'm neither—I'm a visual journalist, I use humour to make a journalistic point.[104]

 —MARTIN ROWSON

In a clash of opinions between boss and employee, as in other fields, the boss's opinion generally prevails, through the

sheer force of logic—economic logic, that is.[105]

—CARTOON HISTORIAN
CHARLES PRESS

In the United States you don't have to worry about censors—only editors. Although I've had many editors who would have made great East Bloc censors.[106]

—CLAY BENNETT

As for the cartoonist's relationship to the rest of the newspaper, that depends on the individual cartoonist and the paper. The editorial page cartoon in the *Washington Post* is a signed expression of personal opinion. In this respect, it is like a column or other signed article—as distinguished from the editorials, which express the policy of the newspaper itself.[107]

—HERBERT BLOCK

My editors don't tell me what to do, they just tell me whether they'll print my stuff. . . . I have regular debates with them about printing certain cartoons. In fact, sometimes I wonder if they even *get* the cartoons. Ultimately, though, I don't care if they *bought* it, I really just care if they *publish* it.[108]

—CLAY BENNETT

I've had four editors, and all four have been great in terms of editorial freedom. Tony Ridder didn't like my cartoons, my stance, but I'm still working for Knight-Ridder. If you look across the Knight-Ridder chain, we have a lot of good cartoonists with different opinions.[109]

—SIGNE WILKINSON

Deadlines are aptly named. If you don't make deadlines, you are dead. You are summarily executed by your editor because you haven't filled the white space at the top of the editorial page. Editors are very leery of big, blank white spaces in their newspapers.[110]

—JACK OHMAN

I can sit in on editorial meetings, and I often do—but we have a kind of infor-mal set of meetings—it's erratic. I do have the opportunity to get involved in the editorial meetings if I want to, however.[111]

—SIGNE WILKINSON

Working with newspaper editors was often frustrating for me. Basically, a lot of the editors are older people and I think that that is reflected in the newspaper. Not that I have anything against older people, but everyone has a certain set of reference points, a way of seeing things. I think a lot of times older editors had a difficult time seeing my reference point in a cartoon—it may have come from something younger people would know about, but they didn't.[112]

—MARK FIORE

Funny cartoons . . . are popular with editors who aren't crazy about having cartoons in their paper that are going to get a crowd angry at them. That's a real shame, because getting people angry and making them think is part of our job. We can't change anyone's mind in one cartoon. But Bill Mauldin told

me when I was a kid that if you make people mad, you make them think. That's what we are supposed to do.[113]

—MIKE PETERS

Newspapers are among the worst offenders when it comes to backing down on issues. It takes only two complaining readers for editors to dive under their desks.[114]

—SIGNE WILKINSON

Political cartoonists are a pretty competitive group of people. The only thing they kvetch about more than politicians is each other's work. One cartoonist . . . threatened to kick another then-green, but now hugely successful, cartoonist in the groin if he came within fifty feet of him. He thought the young cartoonist was ripping off his style. He was, but he grew out of it, perhaps to retain his manhood.[115]

—JACK OHMAN

Figure 8.7: "Thomas Nast and Frank Leslie," by Thomas Nast (between 1860 and 1902)

What Makes a Good Cartoon?

A good cartoon is unabashedly subjective. It represents an opinion.[116]

—CARTOON HISTORIANS STEPHEN HESS AND SANDY NORTHROP

The good editorial cartoon, the kind for which an artist should be remembered in later years, should probably involve caricature or great symbolism in a way that clicks at the time, and also does so later, because it so well sums up the event.[117]

—CARTOON HISTORIAN CHARLES PRESS

Artistic excellence is secondary to a cartoon's main purpose. It can only be supplementary.[118]

—CARTOON HISTORIAN CHARLES PRESS

The best political cartoonists are able to express a basic truth and at the same time to catch the mood of the people. . . . The great cartoonists are able to take the perception at a given time, intersect with it and do a visual that says exactly what people are thinking at that moment.[119]

—ALVIN SANOFF, *U.S. News and World Report* reporter

I say nothing is better than humor as a vehicle for political thought. If the hu-

mor becomes an end in itself and the pacing isn't varied to the demands of the day, the message is horribly weakened, if not nullified. I see dismaying sameness settling over cartooning again—funny cartooning for the sake of skirting an issue. I simply decry it, that's all. God forbid that anyone should be offensive.[120]

—PAT OLIPHANT

The trick of a good cartoon is to cut out the unnecessary detail.[121]

—CARTOON HISTORIAN
CHARLES PRESS

Cartooning is visceral—it comes from your gut. It's passion and heart. The best ones are grounded in emotions. After all, you deal with emotions, just like everybody else.[122]

—CLAY BENNETT

A brilliant caricature in a lousy cartoon has about the same effect as a $900 paint job on a 1967 Dodge Dart.[123]

—JACK OHMAN

When you make fun of a politician because of the way he looks . . . you are letting him off the hook for the things that he's deciding to do that are wrong. Give me a cartoon with a strong idea and great writing over a cartoon with great drawing every time.[124]

—TED RALL

A wide range of work comes under the heading of editorial or political cartooning today, including gag cartoons on current topics. I enjoy many of these and usually put some fun into my work. But I still feel that the political cartoon should have a view to express, that it should have some purpose beyond the chuckle.[125]

—HERBERT BLOCK

Coming up with a good idea for a cartoon is very similar to coming up with a good lead in an editorial—you want a punchy, catchy hook to illustrate the story.[126]

—SIGNE WILKINSON

The question of what's a good cartoon and what is not is something that's up to you. I've often heard formulas for what these things ought to be, but I've never heard one that applied in all cases. There are many cartoonists with many styles of drawing; there are humorous cartoons and others that are stark and dramatic—some with many words and some with none. I've seen outstanding examples in all styles; and along with others in this business, I can only mumble that a good cartoon is a good cartoon.[127]

—HERBERT BLOCK

NINE

Epilogue

THE FUTURE OF AMERICAN EDITORIAL CARTOONS

Cartoonists have little fear of running out of victims, because politicians, unlike other kinds of game, usually survive to make the same mistakes over and over.[1]

— JERRY ADLER

Editorial cartooning is not a dying art. Hiring editorial cartoonists is a dying art.[2]

—V. CULLUM ROGERS

THE HISTORICAL REVIEW of editorial cartoons in this book centers on an examination of three variables: demographics, media systems, and political issues. A discussion of these same variables is equally useful when considering the future of the profession. However, the emphasis on each variable changes significantly. The primary causes for changes in cartooning in colonial America were demographic (surges in population) and political issues (a new notion ripping away from the motherland). Undeniably, the American population in the twenty-first century is undergoing rapid change, with a rapidly aging population and an increasingly nonwhite population. And undeniably, the twenty-first century has certainly started with startling political changes as well, from a disputed presidential election to an unforeseen focus on terrorism. However dramatic and influential these two variables are, however, the most significant changes in political cartooning in

this century will come from the media systems themselves. It is technology, not population or politics, that will have the greatest impact on the future of the political cartoon.

The Numbers Don't Lie

The political cartooning profession in America reached its zenith around the beginning of the 1900s, when, Hess and Northrop estimate, there were nearly two thousand editorial cartoonists working in the country.[3] By the end of the twentieth century, Rogers estimates, there were between 120 and 140 full-time editorial cartoonist positions at American newspapers; he points out that the situation has deteriorated further since that time. "Since then, a number of papers have dropped their cartoonists, and there don't seem to be any new openings created," he notes. "That's the handwriting on the wall."[4] Full-time professional opportunities decreased even further as the twenty-first

century began. In an address to the 2002 convention of the Association of American Editorial Cartoonists, Leonard Downie Jr., the executive editor of the *Washington Post*, noted, "It is alarming that the number of newspapers employing full-time editorial cartoonists has steadily declined . . . to just 84 today."[5] Any way that you measure the life of the profession, it is clear that the number of full-time staff cartoonists, defined as cartoonists who draw a regular salary and benefits from a newspaper, is declining consistently.

As Newspapers Go, So Goes the Editorial Cartoon

"Tell me the future of newspapers and I'll tell you the future of political cartoons," says cartoonist Signe Wilkinson.[6] If her linkage is correct, that future is a flat line at best, and an inexorable downward spiral at worst. Rogers cites the decline in afternoon dailies as the biggest reason for the decline in the cartooning profession, but the number of morning papers has, at most, been holding steady, and they may follow the afternoon papers into an era of decline.

America's ever-increasing media options have contributed to the erosion of the newspaper as an extremely powerful force in shaping public opinion. According to an *Adweek* analysis published in 2002, "Newspaper circulation has been on a general decline for the past decade as more media outlets compete for readers' attention, including the Internet and cable television."[7]

"A lot of people seem to think it's a shrinking market," admits cartoonist Jim Huber. "Newspapers have trouble seeing it as a worthy expense with a tight budget. But people are visual. When someone says a word, you picture the image. People enjoy them, they read them first—it's a shame to see the art form dwindling."[8]

Newspaper publishers pressing for ever-stronger profits are constantly looking for ways to cut costs, and the full-time cartoonist makes a juicy target. The concern is not only on the cost side, but on the revenue side as well—a controversial cartoon may inspire numerous letters to the editor threatening subscription cancellation or phone calls from long-term advertisers threatening to pull their ads. It is far less likely that a reader will pick up a pen or a telephone to volunteer that he or she looks forward to the editorial cartoon, even if this is true. When profits reign, it becomes more challenging to remind a publisher that a newspaper is designed not only to make money but also to stimulate thought.

The irony is that many cartoonists, paid to remind people of what is important, fail to convey their own contributions to their employers. Bruce Plante, former president of the Association of American Editorial Cartoonists, recommends that cartoonists regularly communicate to key audiences their importance to the livelihood of the newspaper: "In developing a consistent message, our concentration should be that every newspaper survey has proven the value readers place on visual elements and local content. They're demanding it! Our job is to re-

mind publishers and editors that the true value of an editorial cartoonist is a visual presentation of local content."[9]

It is unlikely that any one medium will ever dominate the way newspapers did in the past. It is hard to imagine that the confluence of technological, political, and demographic trends that produced such powerful cartoonists as Nast, Keppler, and Opper will ever be seen again. Modern political cartoonists—even the most talented and well known, working for the most important and widely distributed papers in the country—will probably never match the influence enjoyed by their predecessors.

Did Terrorism Change the Rules of Cartooning?

The first major threat to America in the twenty-first century was a sudden and dramatic increase in terrorism, particularly the events of September 11, 2001. Editorial cartoonists attempted to capture the shock, frustration, and anger that followed the attacks on New York City, Washington,

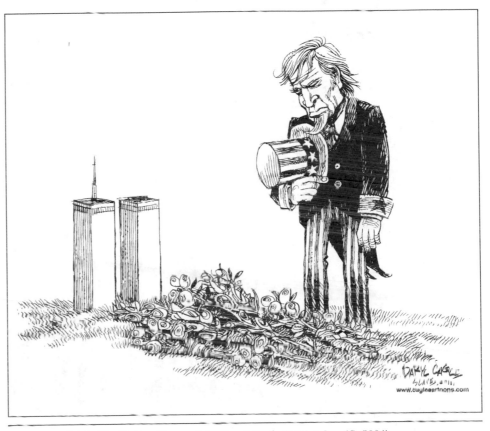

Figure 9.1: "9/11: The Nation Mourns," by Daryl Cagle (September 15, 2001)

DC, and the plane over Pennsylvania (figures 9.1 and 9.2).

It is difficult, while living in the af-

termath of these attacks, to develop a reasonable perspective about the effects of this terrorism on America, to deter-

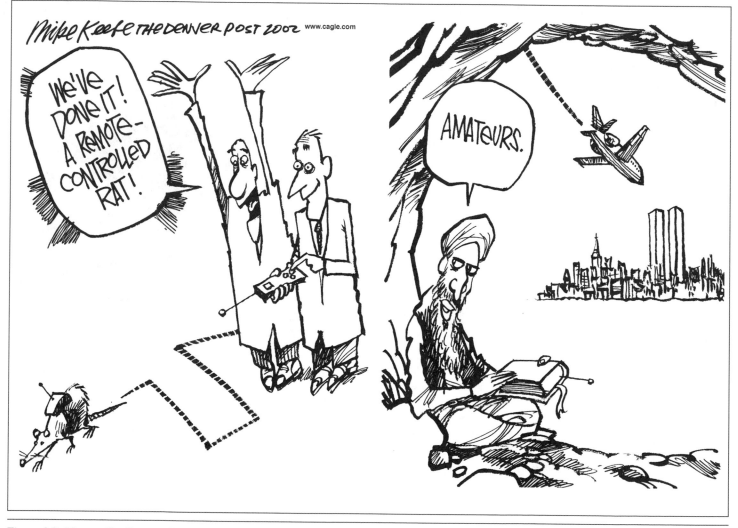

Figure 9.2: "Osama Rat Remote Control," by Mike Keefe (May 2, 2002)

mine whether changes in the government and public attitudes are temporary reactions or indications that America has been permanently transformed. The rush of patriotism, the reduction in personal rights, the Bush administration's redefinition of America's role in world affairs —all not only changed the day-to-day lives of Americans but also influenced the rules of editorial cartooning. "Political cartoonists are dependent on the mainstream media for their livelihood, but the papers that previously relished a provocative cartoon no longer want to see a satirical critique of a government the people are desperate to rally around," note Asa Pittman and Emma Ruby-Sachs.[10]

And yet, some cartoonists are as rebellious and antiauthoritarian as ever. Ted Rall, one of the most controversial cartoonists of the modern era, deliberately employs childish and simplistic figures that create a strong juxtaposition to the frequently confrontational message of his work. Rall even used some of the most sacred aspects of the terrorist attacks on America as material for cartoons. While watching interviews with spouses of Americans who died on 9/11, he noticed that, instead of focusing on their losses, many of the interviewees were "promoting a narrow partisan agenda."[11] He then drew figure 9.3, which he explained as follows:

The cartoon began as a critique of inappropriate means of exploiting death and morphed into a rumination on the commodification of grief. I had noticed a pattern, found it worth commenting on, and did the cartoon.

I didn't count on the fact that not many Americans spend all day watching cable TV news, as I do. Many people, not aware of the behavior of the people I was lampooning, thought I was gratuitously criticizing 9/11 widows and widowers; actually, I was only interested in discussing a few particularly nasty pieces of work. I admit that it was a pretty tasteless cartoon, but so what? I'm interested in making a point, not sucking up to people who behave badly. That's the job, though most of my peers seem to have forgotten that.

. . .

That said, it's kind of a pity that the other two hundred cartoons I drew in 2002 didn't get anything near the same level of exposure. Many of them were smarter, funnier, and made more important points. "Terror Widows" isn't beyond the pale for me, but it is somewhat off the beaten track. It's not really what I'm mostly about, and it's a bit unfair for history to emphasize one single cartoon, often an unusual one, as representative of a cartoonist's work. When I went on *Fox News* to defend myself, I demanded that they air two other examples of my work, which they could pick, in order to make that point. It was an effective way to handle the situation.

Most of my regular readers know where I'm coming from ideologically and didn't have any trouble with "Terror Widows." Many of those who were angry at first looked into my archives online and wrote back to say they agreed with me. But there were many on the extreme Right—I'm afraid most of the rage came from the Bush faction—who will never get over it. I received death threats from New York

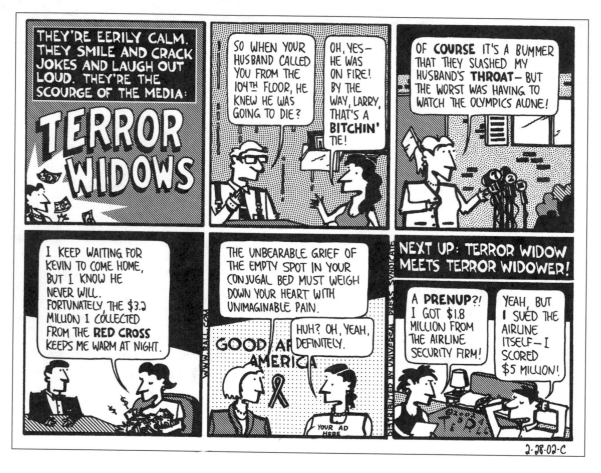

Figure 9.3: "Terror Widows," by Ted Rall (March, 2002)

City police officers. It all goes to show the power of india ink splattered across a page of bristol board. Too bad most newspapers, which are eliminating their editorial cartoonist positions, don't appreciate that power.[12]

When it appeared in March of 2002, Rall's cartoon caused such a strong reaction that it was immediately pulled from the *New York Times* website. The cartoonist was denounced by

editorialists and even some members of the House of Representatives, who called for increased censorship in response to Rall's offenses. It is unusual that reaction to an editorial cartoon reaches all the way to the halls of Congress, but it serves as a reminder that, even in the media rich environment of the twenty-first century, editorial cartoonists still manage to infuriate large groups of readers.

Ramifications of Syndication

Newspapers are in decline, but cartoon syndicates are on the rise, and the opposing trajectories are related. Syndicates make economic sense for papers—instead of paying a salary and benefits for a cartoonist who may not maintain the ideological perspective of the editorial page, newspapers can shop the syndicated services to pay for work on a piecemeal basis. Papers using this approach get the best of what the top cartoonists have to offer for less than what they might pay a full-time staff member. Variety may also improve quality: even the best cartoonist can't create exceptional work on a daily basis, while with a pooling of the nation's top talent the chances are good that at least one member of a syndicate will execute an excellent cartoon.

Top cartoonists also benefit from the syndication services, as syndicated cartoonist Signe Wilkinson points out: "I like syndication because it gets my cartoons to a wider audience. That's very important to me. I don't do the cartoons so that they don't get seen—I want them seen. When I did a cartoon on the Miss World pageant and it ran in the *L.A. Times*, I was really happy. It was a much bigger community—you were part of a bigger conversation."[13]

Undeniably, cartoonists with full-time staff positions can benefit from syndication, because it provides income in addition to their regular salaries. However, the overall impact of syndication on the profession should be considered at the same time. Cartoonist Wayne Stroot points out, "As the number of full-time positions continues to dwindle, cartoonists will have to adapt to freelancing as the main source. Full-time positions at newspapers will continue to erode at all but the largest publications."[14]

Bruce Plante points out, "Our overall success has actually contributed to the slightly fewer number of staff jobs. Most of us consider an individual cartoonist successful if he or she is syndicated. Today there are more syndicated editorial cartoonists than ever before."[15]

Syndication has produced a series of unintended ramifications as well. First, increased reliance on syndication has changed the subject matter in cartoons—many cartoonists who are syndicated begin focusing, consciously or unconsciously, an increasing amount of their work on national and international issues to make it as marketable as possible. Thus, the local cartoonist who uses her pen to champion a zoning regulation or critique a councilman in the city where she lives is at a distinct disadvantage: no one outside of the immediate area is going to pick up her work for further distribution. Since many cartoonists feel that they have their greatest impact on local, rather than national, issues, a refocusing of ef-

forts on national issues may reduce the possibility that the cartoon will produce change. "I think there is no doubt that syndication and the downturn of the local newspaper industry in the U.S. is damaging editorial cartooning," notes cartoonist Kevin "KAL" Kallaugher. "In an age where politicians present themselves more and more via their image, who will be left to de-spin, to unpick that if not the cartoonist who deals in image?"[16]

Second, syndication can also produce the "star system" that applies in many other industries. Syndication makes the most influential cartoonists more so, with their best efforts appearing in dozens of papers on any given day. This, in turn, leads to additional syndication, often at higher pay rates than the norm. On the other hand, such a star system weeds out cartoonists of less-than-stellar talent, whose cartoons are picked up by fewer and fewer papers, and further reduces their opportunities to land a full-time job.

Finally, the diminishing number of full-time positions also influences the power struggle between editor and car-toonist—in a buyer's market, an editor can select the work of a cartoonist who generally agrees with the editor's political philosophy or, even more significantly, agrees to draw cartoons at the direction of the editor.

End of the Road versus Adaptation

Despite the dire predictions, some members of the profession see the situation, not as an inevitable disaster, but as a call to shake up the profession's traditional structure.

Signe Wilkinson brings a historical perspective to the health of the profession: "They had political satire before they had editorial cartoons, and they'll have political satire after editorial cartoons are gone. As long as there are politicians, there will be people to criticize politicians. Thomas Paine didn't start out saying, 'Okay, where's my 401(k) plan?' They didn't start out as moneymakers."[17]

Pulitzer Prize–winning cartoonist Anne Telnaes says, "You hear a lot of doomsday scenarios, but I'm not a defeatist about it. . . . You'll find a lot of moping at the [cartoonists' annual] convention—'There's no jobs out there'—but really, I think we have to be adaptable. It's like any other profession—you have to evolve. We don't do that very well."[18]

FLEDGLING EXPERIMENTS WITH TELEVISION

Some cartoonists have attempted to adapt by turning to media that traditionally compete with newspapers.

As early as 1981, cartoonist Mike Peters began targeting alternatives:

Looking to the future, I see television as a natural medium for editorial cartoons. Right now, editorializing on TV is still back in the days of John Cameron Swayze. You have a guy sitting behind a desk and saying, "We of this station think that Mother's Day is a wonderful thing." They're back in the 1940s, while the nightly news has gone into the 1980s, with its emphasis on visuals. Eventually, I think editorials will also emphasize the visual. That's why I think that animated editorial cartoons are going to be used, though

Snapshot of a Frustrated Cartoonist

It's a tough world out there. Just ask cartoonist Ted Rall, who may hold the record for being syndicated in the most American newspapers without ever having been invited to work on the staff of any of them. In 1997 Rall spoke with Kent Worcester of the *Comics Journal* about life in permanent syndication:

KW: What does it mean to be syndicated? Do they pay your health care?

TR: You are a contract worker. You receive no benefits. No 401(k), no health care, no dental, no life insurance, no retirement. It's a bad state of affairs.

KW: And what do they take as their percentage?

TR: Fifty per cent. That's business-wide.

KW: Why do creators put up with this?

TR: Because they have to. It's a buyers' market.

KW: The alternative for some cartoonists is to be on the payroll of a daily paper.

TR: But those jobs are being eliminated. Political cartoons are deceased, and it comes down to this whole staff job thing. This is a form of comics that's uniquely American, it's as uniquely American as jazz, and it's under siege. There may not be any political cartoons at all in twenty years. It's insane. And it's ironic, because there may never have been a time when there were better cartoonists. Basically, the daily newspaper editors have figured out that they can buy five syndicated cartoons for fifteen to twenty dollars a week. They're under pressure to cut their budgets. And so they use syndicated work and they figure they can fire some guy they've been paying eighty thousand dollars a year to. The big joke is that syndication fees are based on the premise that it's beer money, extra money. You were supposed to be getting a salary, and benefits. In 1980 there were 280 full-time cartoonists on staff. Now there are fewer than seventy. The fees haven't changed, but the newspapers don't want to subsidize the system. They're looking at the short-term view. They don't realize that you have to be in 200 papers to make a living at this.

KW: How many political cartoonists appear in over 200 papers?

TR: If it's twenty-five I would be shocked. There's no way to make a living in this business. Then there's the fact that newspapers are running fewer and fewer editorial cartoons at all, because the newspapers are becoming more and more subject to corporate chain ownership, and they don't like cartoons, because cartoons make strident political statements. They stir up controversy. You can't have controversy. I went for a staff job at the *Asbury Park Press* a few years ago, and the editor pointed over his shoulder at the parking lot and asked me "How can you assure me that I'll never look out that window and see protesters out there holding up signs about one of your cartoons?" And I just looked at him and said "Well, if I do my job, hopefully it'll happen pretty often." Obviously I didn't get the job. The other problem is that the readers don't care. They don't notice if you're missing and if they do notice they don't write to complain about it. A newspaper can't cancel *Henry* . . .

KW: Or *Mary Worth* . . .

TR: But they can get rid of Tom Toles, no problem, even though the guy's one of the best cartoonists in the country. The newspapers don't have any respect for editorial cartooning.[a] ■

they are not going to be the only technique. Film is just as effective—and probably even more so.[19]

One alternative cartoon, dealing more in social than in political criticism, has been enormously successful in the transition from newspapers to television. Matt Groening's strip, *Life in Hell*, is a biting, multipanel view of

modern life that includes among its characters a dysfunctional, but very American, family named the Simpsons. Groening transformed the cartoon family first to short films, then to an add-on to a variety television show, and finally, to the most successful animated TV program in American history.

While the half-hour situation comedy has maintained the satiric edge of the multipanel "Life in Hell," the concept has lost a lot of its political emphasis.

A few television networks have experimented with running political cartoons in their original form, sometimes as content within the program, but also as a closing thought just as a news program fades to black. The highlight so far may be the work of Mike Peters, who had a very short run on the NBC *Nightly News* in 1992. To date, however, the move from newspapers to television has been hit or miss, and no one has found a successful way to include traditional editorial cartoons in programming.

THE INTERNET: THE MEDIUM WITH THE MOST PROMISE

If newspapers are losing ground to the Internet, will editorial cartoonists follow readers to the new medium?

Some cartoonists are experimenting, but there are drawbacks. *Philadelphia Daily News* cartoonist Signe Wilkinson noted, "You can make money off of them, but time is a factor. They are labor intensive, and turnaround time is important. Right now, you couldn't do a daily animated cartoon."[20]

Cartoonist Ann Telnaes agrees, but sees some advantages as well. "I look at it as a marketing tool, a way to reach other people." She maintains her own site (www.anntelnaes.com) and contributes a cartoon every week to a women-oriented site (www.womensenews.org). Telnaes appreciates the adaptability—and speed—of the web. "With the syndicate I have to go through so many steps it can take a day and a half. But on the web I can upload far more quickly—the turn-around is so much faster," she says.[21]

Jim Huber sees advantages as well. "The web helps with distribution and marketing," he says. "There are plenty of people—and this includes newspaper editors who might buy my cartoons—who wouldn't see some of my work if it wasn't on the web. Technology hasn't had a big effect on content or design, but the fact that I can e-mail images to my publishers and they can download them—it just simplifies things."[22]

Washington Post cartoonist Pat Oliphant began featuring his work on the MSNBC.com website in October of 2000. The animated cartoons, thirty to sixty seconds long and complete with sound, appeared three times per week in the site's "Opinion" section. "It's an adventure," Oliphant said at the time. "It's freedom of the press all over again. You can express yourself a little more openly, without being juvenile about it."[23]

The same year, Daryl Cagle affiliated his cartoon collection website, Daryl Cagle's Professional Cartoonists

Internetitorial Cartoons—Shifting to a New Medium

If you are looking for the future of editorial cartooning, you might want to look to Mark Fiore.

Fiore is one professional who has made the transition to an alternative medium, and in the process he has learned to deal with new technologies, topics, and audiences.

Fiore's early career mirrored that of many aspiring cartoonists—he started as a freelancer, calling editors, faxing his work out, constantly selling and drawing, selling and drawing. When he landed a full-time position at a newspaper, the *Mercury News* in San Jose, the San Francisco–based artist says that he felt as though he'd "finally grasped the brass ring." A consistent paycheck, a real office, benefits—stability.

Nirvana didn't last long. "Without going into details, it was a mess," Fiore said. "Management changes all over the place, political conflicts with a new editor, it all turned me off to working in that kind of structure." Six months after his arrival at the paper, he was back out on his own. Instead of returning to freelancing for traditional papers or looking for another staff position, however, Fiore decided to tap the Internet cartoon market.

"A big plus is that Internet sites pay more than newspapers do," Fiore explained, "a lot more." On the other hand, Internet cartoons incorporate animation and sound, so it takes longer to make them. "If a traditional print cartoon takes five hours to draw, a short, animated editorial cartoon can take two to three days," he said. "However, the economic realities are the same as traditional freelancing—if you can get enough clients, it's something that you can make a living doing." Fiore posts his cartoons at his own website (www.markfiore.com) and is syndicated through a number of political- and media-oriented sites as well.

Fiore is particularly excited about exploring the application of sounds to his work. "I'm learning as I go, but working with sound is almost like finding an amazing new pen or brush—using it is incredible. I'm figuring out how audio scores influence people's emotions, and I'm finding better source material." He's building a collection of sound effects, through CDs and websites, and, like other pioneers, he's improvising when he can't find what he needs. "Yeah, I do some of the voices myself, or have my girlfriend help out," he admitted.

Animation allows Fiore's characters to interact with each other more realistically, moving through time and space in ways that they never could in traditional print.

All of these new elements take up computer space, however, and the cartoonist finds that it's a challenge to maintain a technological balance. "When I started doing flash, you could do sound but the files tended to be bigger. A couple years ago, the flash plug-in changed, so you could use more sound. MP3 technology definitely helped. I'm still staying a little bit behind the real, real cutting-edge systems, because I don't want to get ahead of the people who are going to look at the work."

The move to the Internet has changed the content as well as the production of Fiore's cartoons. Fiore sounds a lot like other cartoonists who have gone into syndication: "I do fewer local and state issues, more national and international topics," he said. "I've got clients in New York and California—I can't sell a local San Francisco cartoon to the *Village Voice*."

Fiore feels like he's dealing with a younger, more sophisticated audience with his online work.

When I had the staff job, I always had this vision of the audience as older ladies in their seventies reading the paper. Now my mental image is a kid surfing the Internet. With cartoons distributed through the Internet, you get older people, but you get a lot younger ones, too. Judging by the e-mails, the online work is read by lots of students. Oh, and people goofing off at work—there must be a lot of them out there, too!

In fact, that's one of the great thing about the Internet distribution—with website log files, you can actually see when people are looking at your work. I've found that there's a peak right around lunchtime, right after lunch, right before six o'clock—it's obviously people at work.

In the end, does the Internetitorial political cartoonist predict that the Internet is the great untapped medium for editorial cartoonists? Not so fast, Fiore warns. "First of all, it's hard to imagine the print political cartoon ever going away," he says.

"I definitely don't see that happening. I do, however, see newspaper political cartoons going farther along the road to light, fluffy gags—because of the consolidation of the media. With syndication, with more control of cartoonists' content, many cartoons are getting watered down as you try to do something that plays as well in New York and San Francisco as it does in Dubuque.

"In the end, however, I definitely think that there will be more people like me," he concludes. "And we'll also see bigger productions, longer cartoons. No matter what happens, what medium you are using, it still comes back to an issue of quality—you've still got to create a cartoon that works."[a] ■

Index (www.cagle.com), with *Slate* online magazine, joining the largest collection of online political cartoons with one of the nation's leading websites for political analysis. Such projects remain in the experimental phase, as cartoonists, site designers, and Internet experts attempt to develop a model that not only allows for a wide distribution but also makes a profit.

The introduction of new technologies goes beyond the distribution issue, however, to the very creation of the cartoons. Clay Bennett explained the potential application of technology to his work:

Things are obviously going toward digital, toward a combination of media.

This isn't something I fear; in fact, I actually look forward to it. It gives me more possibilities, and that includes not only the final product, but the input that goes into the product. When I started to create cartoons online and started adding sound, I found a whole different set of things to work with because the sounds led to different ideas. And as we move forward into electronics, there will be more software developed to make it possible to make pictures move, add sound, do things that we couldn't do before.[24]

Cartoonist Kevin Kallaugher pointed out that there is a maturing market for cartoons in alternative media: "Kids today don't grow up with comics and cartoons as we use to. They have computer games. The cartoon of the future will be animated in a virtual world, maybe 15 seconds long, and sent to your mobile phone or laptop. I think there's a bright future for visual satire."[25]

In 2002, Mark Fiore, whose cartoons already appear on the Internet (see sidebar above, "Internetitorial Cartoons—Shifting to a New Medium") said:

In 70 years, political cartoons will still be around because there will still be weird people that get angry and are compelled to change the world through little drawings. These political cartoons may be immersive, surround-sound an-

imated works that people download to their flying cars, or they may be charcoal drawings scratched on the side of an ammo box as we fight for scraps of food, I'm not sure which.[26]

Will political cartoons survive?

The answer is yes, in some form or another. The symbols that cartoonists use may change, the media that deliver the images may evolve, the demographic characteristics of the cartoonists themselves may even change, but there are a number of constants that ensure the continuity of political cartooning.

The final word—and it is, of course, a humorous one—comes from cartoonist Clay Bennett:

> As for the future of the industry, many times I feel like I am one of those dinosaurs wallowing in the tar pits of print journalism. Then I reconsider and think that as long as there are toilets and taxi cabs, newspapers will keep going because people need something

Figure 9.4: "No Rest for the Wicked—Sentenced to Hard Labor," by Thomas Nast (December 2, 1876)

portable to read. And as long as there are refrigerator doors that people have to adorn, we'll be able to find work.[27]

The final image, equally poignant, is Thomas Nast's self-portrait from an 1876 cover of *Harper's Weekly* (figure 9.4), which captures the timeless, unyielding stance of the cartoonist: chin thrust up in indignation, Nast sharpens his pencil and contemplates his next target. As long as there are issues in society that people find controversial, and as long as political cartoonists can find humor in any situation, the political cartoon will be a part of American culture.

NOTES

Preface

1. Jacinto Octavio Picon, *Apuntes para la historia de la caricatura* (Madrid: Establecimiento Tipografico Canos, 1877), 7.

2. Herbert Block, "The Cartoon," in *Herblock's History: Political Cartoons from the Crash to the Millennium*, June 3, 2003, at www.loc.gov/rr/print/swann/herblock/.

Chapter 1: Cartoons and the Birth of the Nation (1740 to 1785)

1. E. H. Gombrich, "El arsenal de la caricatura," in *Meditaciones sobre un caballo de juguete y otros ensayos sobre la teoria del arte* (Madrid: Editorial Debate, 1988), 139.

2. Michel Vovelle, prologue to *La Caricature revolutionnaire/La Caricature contrarevolutionnaire*, by Antoine de Baecque, Librairie du Bicentenaire de la Revolution Française series (Presses du CNRS, 1988), 11.

3. William J. Gilmore-Lehne, "Communications History: The United States, 1585–1880; Family and School in Literacy Training and Education," last revised March 18, 1999, at www.stockton.edu/~gilmorew/0amnhist/comuhis5.htm.

4. Charles Press, *The Political Cartoon* (New Brunswick, NJ: Associated University Press, 1981), 34.

5. William J. Gilmore-Lehne, "Communications History: United States, 1585–1880; Newspapers," last revised March 18, 1999, at www.stockton.edu/~gilmorew/0amnhist/comuhis1-4.htm.

6. David A. Copeland, *Colonial American Newspapers: Character and Content* (Newark: University of Delaware Press, 1997), 17.

7. Benjamin Franklin, "The Autobiography," in *Franklin: Writings* (New York: Literary Classics of the United States, Inc., 1987), 1,411.

8. Sinclair H. Hitchings, foreword to *The American Revolution in Drawings and Pictures*, by Donald H. Cresswell (Washington, DC: Library of Congress, 1975).

9. Thomas C. Leonard, *The Power of the Press: The Birth of American Political Reporting* (New York: Oxford University Press, 1986), 45.

10. Sinclair H. Hitchings, quoted in

Donald H. Cresswell, *The American Revolution in Drawings and Pictures* (Washington, DC: Library of Congress, 1975), ix.

SIDEBAR: BARBS IN BRITAIN'S BACKYARD

a. David Johnson, "Britannia Roused: Political Caricature and the Fall of the Fox-North Coalition," *History Today* 51, no. 6 (June 2001): 22–28, at www.findarticles.com/cf_0/m1373/6_51/75496902/p1/article.jhtml?term=political+cartoon+readership, 2.

b. Johnson, "Britannia Roused," 2.

SIDEBAR: THE SNAKE SHEDS ITS SYMBOLIC SKIN

a. Stephen Hess and Sandy Northrop, *Drawn and Quartered: The History of American Political Cartoons* (Montgomery, AL: Elliott and Clark, 1996), 24.

SIDEBAR: FREE FLOW OF IDEAS, UNENCUMBERED BY COPYRIGHT

a. Maurice J. Holland, "A Brief History of American Copyright Law," in *The Copyright Dilemma*, ed. Herbert S. White (Chicago: American Library Association, 1978), 9.

SIDEBAR: ENGLISH AND AMERICAN HUMOR

a. Thomas Craven, ed., *Cartoon Cavalcade* (New York: Simon and Schuster, 1943), 4 and 5.

b. Craven, *Cartoon Cavalcade*, 7.

Chapter 2: Complexity in Government and Media (1786 to 1860)

1. Stephen Hess and Sandy Northrop, *Drawn and Quartered: The History of American Political Cartoons* (Montgomery, AL: Elliott and Clark, 1996), 20.

2. Thomas C. Leonard, *The Power of the Press: The Birth of American Political Reporting* (New York: Oxford University Press, 1968), 101.

3. Leonard, *Power*, 54.

4. Phil Barber, "A Brief History of Newspapers," updated December 31, 2004, at www.historicpages.com/nprhist.htm.

5. Barber, "Brief History."

6. Gerald W. Johnson, *The Lines Are Drawn: American Life since the First World War as Reflected in the Pulitzer Prize Cartoons* (Philadelphia: J. B. Lippincott, 1958), 12.

7. Stephen Hess and Milton Kaplan, *The Ungentlemanly Art: A History of American Political Cartoons* (New York: Macmillan, 1968), 16.

Chapter 3: The Medium Matures (1860 to 1900)

1. Thomas C. Leonard, *The Power of the Press: The Birth of American Political Reporting* (New York: Oxford University Press, 1968), 97.

2. There are other versions of this quote, and there is even some scholarly debate over whether Boss Tweed ever uttered this sentiment. This, however, is the most widely cited version. For example, the quote appears in Laura Ridge, "The Politics of Satire: A Look at American Satire from the Stamp Act to *The Simpsons*," *Harvard Political Review*, at www.hpronline.org/main.cfm?include=subApplication&subApplicationName=quickRegister&fuse=registrationOrLoginRequired&thereferer=http%3A//www.hpronline.org/news/2003/01/25/BooksAndArts/The-Politics.Of.Satire-357280.shtml; as well as the Ohio State University Cartoon Research Library, at cartoons.osu.edu/nast/bio.htm.

3. Gary E. Wait, "Cartoons and Caricatures of the Civil War," *Dartmouth College Library Bulletin*, n.s., 37, no. 2 (April 1997),

at www.dartmouth.edu/%7Elibrary/Library_Bulletin/Apr1997/Wait.html.

4. Interview with Draper Hill, June 20, 2003.

5. Leonard, *Power*, 114.

6. Leonard, *Power*, 114.

7. Jim Zwick, ed., "Political Cartoons and Cartoonists," March 7, 2005, at www.boondocksnet.com/gallery/pc_intro.html.

SIDEBAR: PHOTOENGRAVING CHANGES THE EDITORIAL CARTOON

a. Zwick, "Political Cartoons and Cartoonists."

b. Charles Press, *The Political Cartoon* (New Brunswick, NJ: Associated University Press, 1981), 267.

c. Press, *The Political Cartoon*, 47.

Chapter 4: World Wars and Economic Depression (1900 to 1945)

1. Bill Mauldin, quoted in Alan F. Westin, ed., *Getting Angry Six Times a Week: A Portfolio of Political Cartoons* (Boston: Beacon, 1979), 88.

2. Richard E. Marschall, "The Century in Political Cartoons," *Columbia Journalism Review* 38, no. 1 (May/June 1999): 54.

3. Stephen Hess and Sandy Northrop, *Drawn and Quartered: The History of American Political Cartoons* (Montgomery, AL: Elliott and Clark, 1996), 78.

4. Marschall, "Century," 55.

5. Marschall, "Century," 55.

6. Marschall, "Century," 56.

7. Charles Press, *The Political Cartoon* (New Brunswick, NJ: Associated University Press, 1981), 98.

Chapter 5: Cartooning in the Broadcast Era (1946 to 2000)

1. Kevin Kallaugher, interview by Lawrence Pollard of the British Broadcasting Corporation, at news.bbc.co.uk/2/hi/europe/2194967.stm.

2. Herbert Block, *Straight Herblock* (New York: Simon and Schuster, 1958), 79.

3. Charles Press, *The Political Cartoon* (New Brunswick, NJ: Associated University Press, 1981), 301.

4. Press, *The Political Cartoon*, 319

5. Richard E. Marschall, "The Century in Political Cartoons," *Columbia Journalism Review* 38, no. 1 (May/June 1999): 55.

SIDEBAR: HERBLOCK VERSUS THE CLASS OF '47

a. Herbert Block, "1946–1955: The Era of Fear and Smear," *Washington Post*, December 31, 1995, at www.washingtonpost.com/wp-srv/politics/herblock/essay1.htm.

b. Herbert Block, "1966–1975: The Agonizing Age of Nixon," *Washington Post*, December 31, 1995, at www.washingtonpost.com/wp-srv/politics/herblock/essay3.htm.

SIDEBAR: SYNDICATION: BE CAREFUL WHAT YOU WISH FOR

a. Stephen Hess and Sandy Northrop, *Drawn and Quartered: The History of American Political Cartoons* (Montgomery, AL: Elliott and Clark, 1996), 149.

Chapter 6: Creators and Consumers

1. Stephen Hess and Sandy Northrop, *Drawn and Quartered: The History of American Political Cartoons* (Montgomery, AL: Elliott and Clark, 1996), 10.

2. *Profiles of General Demographic Characteristics: 2000 Census of U.S. Population and Housing*, March 2005, at www2.census.gov/census_2000/datasets/

demographic_profile/0_United_States/2kh00.pdf.

3. Mike Ritter, telephone interview by author, August 21, 2003.

4. Mike Ritter, telephone interview by author, August 21, 2003.

5. Signe Wilkinson, "The Rare Female Cartoonist: If Only She Wore Khaki," originally printed in the *Hartford (CT) Courant*, January 25, 1999, at www.asne.org/index.cfm?id=1744.

6. Signe Wilkinson, telephone interview by author, December 14, 2002.

7. Lucy Shelton Casswell, "Seven Cartoonists," in *The Festival of Cartoon Art* (Columbus: Ohio State University Libraries, 1989), 69.

8. Population Projections Program, Population Division, U.S. Census Bureau. *Projections of the Total Resident Population by 5-Year Age Groups, Race, and Hispanic Origin with Special Age Categories: Middle Series, 2050 to 2070*, March 2005, at www.census.gov/population/projections/nation/summary/np-t4-g.txt.

9. All Alcaraz quotations in this section are from Lalo Alcaraz, telephone interview by author, January 21, 2004.

10. Alan F. Westin, *Getting Angry Six Times a Week: A Portfolio of Political Cartoons* (Boston: Beacon, 1979), viii.

11. Westin, *Getting Angry*, xi.

12. Westin, *Getting Angry*, xi–xii.

13. All Stroot quotations in this section are from Wayne Stroot, e-mail interview by author, August 21, 2003.

14. Roger A. Fischer, *Them Damned Pictures: Explorations in American Political Cartoon Art* (North Haven, CT: Archon, 1996), 164.

15. All Huber quotations in this section are from Jim Huber, telephone interview by author, May 16, 2003.

16. All Stroot quotations in this section are from Wayne Stroot, e-mail interview by author, August 21, 2003.

17. Press, *Political Cartoon*, 324.

18. All Ritter quotations in this section are from Mike Ritter, telephone interview by author, August 21, 2003.

19. Elsa Mohn and Maxwell McCombs, "Who Reads Us and Why," *Masthead*, Summer 1988, 1.

20. Comically Speaking, *Presstime*, November 1997, 12.

SIDEBAR: ARTIST? JOURNALIST? SOCIAL CRITIC?

a. Gerald W. Johnson, *The Lines Are Drawn: American Life since the First World War as Reflected in the Pulitzer Prize Cartoons* (Philadelphia: J. B. Lippincott, 1958), 10.

SIDEBAR: SERIOUS MESSAGES ON THE FUNNY PAGES

a. Al Capp, quoted in Stephen Hess and Milton Kaplan, *The Ungentlemanly Art: A History of American Political Cartoons* (New York: Macmillan, 1968) 117.

Chapter 7: Process and Effect

1. Stephen Hess and Sandy Northrop, *Drawn and Quartered: The History of American Political Cartoons* (Montgomery, AL: Elliott and Clark, 1996), 11.

2. Charles Press, *The Political Cartoon* (New Brunswick, NJ: Associated University Press, 1981), 11.

3. Press, *Political Cartoon*, 62.

4. Werner Hoffman, *La caricature, de Vind à Picasso* (Paris: Editions Aimery-Somogy, 1958), 17.

5. Rafael Barajas, "The Transformative Power of Art," *NACLA Report on the*

Americas 33, no. 6 (May/June 2000): 7.

6. Press, *Political Cartoon*, 26.

7. Roger A. Fischer, *Them Damned Pictures: Explorations in American Political Cartoon Art* (North Haven, CT: Archon, 1996), xiii.

8. Signe Wilkinson, interview by author, December 12, 2002.

9. John J. Appel, "Ethnicity in Cartoon Art," in *Cartoons and Ethnicity* (Columbus: Ohio State University Libraries, 1992).

10. Alton Ketchum, *Uncle Sam: The Man and the Legend* (New York: Hill and Wang, 1959), 10.

11. Ketchum, *Uncle Sam*, 17.

12. Press, *Political Cartoon*, 220.

13. Appel, "Ethnicity."

14. Barajas, "Transformative Power," 10.

15. Fischer, *Them Damned Pictures*, 13.

16. Stephen Hess and Milton Kaplan, *The Ungentlemanly Art: A History of American Political Cartoons* (New York: Macmillan, 1975), 46.

17. David N. Ammons, John C. King, and Jerry J. Yeric, "Unapproved Image-makers: Political Cartoonists' Topic Selection, Objectives and Perceived Restrictions," *Newspaper Research Journal* 9, no. 3 (Spring 1988): 82.

18. Don Wright, quoted in Alan F. Westin, ed., *Getting Angry Six Times a Week: A Portfolio of Political Cartoons* (Boston: Beacon, 1979), 38.

19. Fischer, *Them Damned Pictures*, 15.

20. Appel, "Ethnicity in Cartoon Art."

21. Fischer, *Them Damned Pictures*, 72.

22. L. Perry Curtis Jr., *Apes and Angels: The Irishman in Victorian Caricature* (Washington, DC: Smithsonian Institution Press, 1971), 64.

23. Hess and Northrop, *Drawn and Quartered*, 110.

SIDEBAR: SO WHERE DO ALL THOSE IDEAS COME FROM, ANYWAY?

a. Jerry Adler, "The Finer Art of Politics," *Newsweek*, October 13, 1980, 74.

b. Jack Ohman, *Drawing Conclusions: A Collection of Political Cartoons* (New York: Simon and Schuster, 1987), 15.

c. Mike Peters, quoted in Alvin Sanoff, "If You Make People Mad, You Make Them Think," *U.S. News and World Report*, June 22, 1981, 56.

d. Bruce Plante, "Twenty Questions with Bruce Plante," interview by J. P. Trostle, September 2002, AAEP website, at info.detnews.com/aaec/.

e. Ohman, *Drawing Conclusions*, 9.

f. Herbert Block, "The Cartoon," from *Herblock's History: Political Cartoons from the Crash to the Millennium*, June 3, 2003, at www.loc.gov/rr/print/swann/herblock/.

g. Ernest C. Hynds, "Survey Profiles of Editorial Cartoonists," *Masthead*, Spring 1977, 13.

h. Ammons, King, and Yeric, "Unapproved Imagemakers," 80.

i. V. Cullum Rogers, telephone interview by author, January 7, 2003.

j. Clay Bennett, speech at Swarthmore College, November 12, 2002.

SIDEBAR: THE ICON DEBATE

a. Quotes in this sidebar are from a panel at the 2003 convention of the Association of American Editorial Cartoonists, July 20, 2003.

Chapter 8: In Their Own Words: Cartoonists on Cartooning

1. Jeff MacNelly, quoted in Roger Fischer, *Them Damned Pictures: Explorations in American Political Cartoon Art* (North Haven, CT: Archon, 1996), 16.

2. Jerry Adler, "The Finer Art of Politics," *Newsweek*, October 13, 1980, 74.

3. Mike Peters, quoted in Adler, "Finer Art," 74.

4. V. Cullum Rogers, telephone interview by author, January 7, 2003.

5. Jules Feiffer, quoted in Alan F. Westin, ed., *Getting Angry Six Times a Week: A Portfolio of Political Cartoons* (Boston: Beacon, 1979), 14.

6. Paul Conrad, quoted in Adler, "Finer Art," 74.

7. Clay Bennett, speech at Swarthmore College, November 12, 2002.

8. Adler, "Finer Art," 74.

9. Mike Peters, quoted in Alvin Sanoff, "If You Make People Mad, You Make Them Think," *U.S. News and World Report*, June 22, 1981, 56.

10. Jeff MacNelly, quoted in Rudy Maxa, "Portrait of the Artist: Hottest Pen Going," *Washington Post*, December 17, 1978, 4.

11. Syd Hoff, *Editorial and Political Cartooning* (New York: Stravon Educational, 1976), introduction.

12. Stephen Hess and Sandy Northrop, *Drawn and Quartered: The History of American Political Cartoons* (Montgomery, AL: Elliott and Clark, 1996), 10.

13. Jules Feiffer, quoted in Hess and Northrop, *Drawn and Quartered*, 10.

14. Charles Press, *The Political Cartoon* (New Brunswick, NJ: Associated University Press, 1981), 178.

15. Jack Ohman, *Drawing Conclusions: A Collection of Political Cartoons* (New York: Simon and Schuster, Inc. 1987), 9.

16. Herbert Block, *Herblock's History: Political Cartoons from the Crash to the Millennium*, June 3, 2003, at www.loc.gov/rr/print/swann/herblock/.

17. Signe Wilkinson, telephone interview by author, December 14, 2002.

18. Jeff MacNelly, quoted in Maxa, "Portrait," 4.

19. Hugh Haynie, quoted in Westin, *Getting Angry*, 128.

20. Herbert Block, quoted in Press, *The Political Cartoon*.

21. Draper Hill, quoted in Westin, *Getting Angry*, 154.

22. Tony Auth, quoted in Westin, *Getting Angry*, 116.

23. Jules Feiffer, quoted in Westin, *Getting Angry*, 14.

24. Rollin Kirby, "My Creed as a Cartoonist," *Pep*, December, 1918, 16.

25. Mike Ramirez, comment made in panel session at the 2003 convention of the Association of American Editorial Cartoonists, June 20, 2003.

26. Block, *Herblock's History*.

27. Ohman, *Drawing Conclusions*, 8.

28. Bennett, speech at Swarthmore College.

29. Mike Peters, quoted in Sanoff, "If You," 56.

30. Bennett, speech at Swarthmore College.

31. Ohman, *Drawing Conclusions*, 13.

32. Jim Borgman, quoted in "Borgman Takes a Bow," *Presstime*, November, 2001, 52.

33. Ohman, *Drawing Conclusions*, 7.

34. Joel Pett, comment made in panel session at the 2003 convention of the Association of American Editorial Cartoonists, June 20, 2003.

35. Bennett, speech at Swarthmore College.

36. Mike Peters, quoted in Westin, *Getting Angry*, 97.

37. Hess and Northrop, *Drawn and Quartered*, 10.

38. Ted Rall, interview by Kent Worcester, New York City, June 17, June 24, and July 10, 1997, at www.rall.com/inter06.htm.

39. Mark Fiore, telephone interview by author, December 19, 2002.

40. Press, *The Political Cartoon*, 195.

41. James Montgomery Flagg, quoted in *Faces and Facts by and about 26 Contemporary Artists* (Freeport, NY: Books for Libraries Press, 1937), introduction.

42. Mike Peters, quoted in Sanoff, "If You," 56.

43. Ann Telnaes, telephone interview by author, February 3, 2003.

44. Mike Peters, quoted in Sanoff, "If You," 56.

45. Ohman, *Drawing Conclusions*, 13.

46. Ohman, *Drawing Conclusions*, 7.

47. Hoff, *Editorial and Political Cartooning*, introduction.

48. Signe Wilkinson, telephone interview by author, December 14, 2002.

49. Bennett, speech at Swarthmore College.

50. David Levine, *Time*, September 24, 1984.

51. Mike Peters, quoted in Westin, *Getting Angry*, 96.

52. Pat Oliphant, quoted in Westin, *Getting Angry*, 140.

53. Wayne Stroot, telephone interview by author, June 19, 2003.

54. Jeff MacNelly, quoted in Maxa, "Portrait," 4.

55. Mike Ritter, comment made in panel session at the 2003 convention of the Association of American Editorial Cartoonists, June 20, 2003.

56. Ann Telnaes, telephone interview by author, February 3, 2003.

57. Martin Rowson, interview by Lawrence Pollard of the British Broadcasting Corporation, August 18, 2002, at news.bbc.co.uk/2/hi/europe/2194967.stm.

58. Block, *Herblock's History*.

59. Jeff MacNelly, quoted in Adler, "Finer Art," 74.

60. David Low, quoted in Hess and Northrop, *Drawn and Quartered*, 21.

61. Stephen Hess and Milton Kaplan, *The Ungentlemanly Art: A History of American Political Cartoons* (New York: Macmillan, 1968), 46.

62. Wayne Stroot, telephone interview by author, June 19, 2003.

63. Ohman, *Drawing Conclusions*, 14.

64. Ann Telnaes, telephone interview by author, February 3, 2003.

65. Benjamin Franklin, quoted in "Caricature in the United States," *Harper's New Monthly Magazine*, December 1875, 27, from the website of the Cornell University library: cdl.library.cornell.edu/cgi-bin/moa/pageviewer?root=%2Fmoa%2Fharp%2Fharp0052%2F&tif=00036.TIF&cite=http%3A%2F%2Fcdl.library.cornell.edu%2Fcgi-bin%2Fmoa%2Fmoa-cgi%3Fnotisid%3DABK4014-0052-5.&coll=moa&frames=1&view=50.

66. Don Wright, quoted in Westin, *Getting Angry*, 38.

67. Block, *Herblock's History*.

68. Martin Rowson, interview by Lawrence Pollard of the British Broadcasting Corporation, August 18, 2002, at news.bbc.co.uk/2/hi/europe/2194967.stm

69. Bennett, speech at Swarthmore College.

70. Frank Swoboda, comment made in panel session at the 2003 convention of the Association of American Editorial Cartoonists, June 20, 2003.

71. Max King, comment made in panel session at the 2003 convention of the Association of American Editorial Cartoonists, June 20, 2003.

72. Rana R. Lurie, speaking at University of Southern Mississippi in 1973, at www.lib.usm.edu/%7Espcol/aaec/index.html.

73. Jim Zwick, "Political Cartoons and Cartoonists," March 18, 2005, www.boondocksnet.com/gallery/pc_intro.html.

74. Tony Auth, quoted in Adler, "Finer Art," 74.

75. Adler, "Finer Art," 74.

76. John T. McCutcheon, *New York Times*, December 3, 1975.

77. Alan Mumford, "Demons or Wimps: General Election Cartoons," at www.politicalcartoon.co.uk/html/history1.html.

78. Adler, "Finer Art," 74.

79. Press, *The Political Cartoon*, 49.

80. Lyn Nofziger, quoted in Adler, "Finer Art," 74.

81. Gerald Scarfe, quoted in Ollie Stone Lee, "Seriously Funny Work," November 5, 2001, at news.bbc.co.uk/2/hi/uk_news/politics/1618702.stm.

82. Hess and Northrop, *Drawn and Quartered*, 22.

83. Lyndon Johnson, quoted in Hoff, *Editorial and Political Cartooning*.

84. Adler, "Finer Art," 74.

85. Anthony Seldon, quoted in Ollie Stone-Lee, "Serious Funny Work," November 5, 2001, at news.bbc.co.uk/2/hi/uk_news/politics/1618702.stm.

86. Signe Wilkinson, telephone interview by author, December 14, 2002.

87. Martin Rowson, interview by Lawrence Pollard of the British Broadcasting Corporation, August 18, 2002, at news.bbc.co.uk/2/hi/europe/2194967.stm.

88. Ohman, *Drawing Conclusions*, 11.

89. Mark Fiore, telephone interview by author, December 19, 2002.

90. Herbert Block, *Straight Herblock* (New York: Simon and Schuster, 1958), 13.

91. Ohman, *Drawing Conclusions*, 14.

92. Ohman, *Drawing Conclusions*, 14.

93. Signe Wilkinson, telephone interview by author, December 14, 2002.

94. Ann Telnaes, telephone interview by author, February 3, 2003.

95. Jim Huber, telephone interview by author, May 16, 2003.

96. Bruce Plante, telephone interview by author, January 24, 2003.

97. Wayne Stroot, telephone interview by author, June 19, 2003.

98. Ann Telnaes, telephone interview by author, February 3, 2003.

99. Wayne Stroot, e-mail interview by author, August 21, 2003.

100. Bennett, speech at Swarthmore College.

101. Dan Wasserman, quoted in Hess and Northrop, *Drawn and Quartered*, 147–48.

102. Hy Rosen, comment made in panel session at the 2003 convention of the Association of American Editorial Cartoonists, June 20, 2003.

103. H. L. Mencken, quoted in Hess and Kaplan, *The Ungentlemanly Art*, 99.

104. Martin Rowson, interview by Lawrence Pollard of the British Broadcasting Corporation, August 18, 2002, at news.bbc.co.uk/2/hi/europe/2194967.stm.

105. Press, *The Political Cartoon*, 187.

106. Bennett, speech at Swarthmore College.

107. Block, *Herblock's History*.

108. Bennett, speech at Swarthmore College.

109. Signe Wilkinson, telephone interview by author, December 14, 2002.

110. Ohman, *Drawing Conclusions*, 8.

111. Signe Wilkinson, telephone interview by author, December 14, 2002.

112. Mark Fiore, telephone interview by author, December 19, 2002.

113. Mike Peters, quoted in Sanoff, "If You," 56.

114. Signe Wilkinson, quoted in Nancy Davis, "Signe Wilkinson: This 'Attack Quaker' Spares No One from Her Lampooning Pen," *Presstime*, 1995.

115. Ohman, *Drawing Conclusions*, 13.

116. Hess and Northrop, *Drawn and Quartered*, 10.

117. Press, *The Political Cartoon*, 205.

118. Press, *The Political Cartoon*, 18.

119. Sanoff, "If You," 56.

120. Pat Oliphant, quoted in Hess and Northrop, *Drawn and Quartered*, 148–49.

121. Press, *The Political Cartoon*, 21.

122. Bennett, speech at Swarthmore College.

123. Ohman, *Drawing Conclusions*, 14.

124. Ted Rall, quoted in "The Art of the Political Cartoonist," August 18, 2002, British Broadcasting Corporation broadcast, at news.bbc.co.uk/2/hi/europe/2194967.stm.

125. Block, *Herblock's History*.

126. Signe Wilkinson, telephone interview by author, December 14, 2002.

127. Herbert Block, *The Herblock Book* (Boston: Beacon, 1952), 168.

Chapter 9: Epilogue: The Future of American Editorial Cartoons

1. Jerry Adler, "The Finer Art of Politics," *Newsweek*, October 13, 1980, 74.

2. V. Cullum Rogers, telephone interview by author, January 7, 2003.

3. Stephen Hess and Sandy Northrop, *Drawn and Quartered: The History of American Political Cartoons* (Montgomery, AL: Elliott and Clark, 1996), 68.

4. V. Cullum Rogers, telephone interview by author, January 7, 2003.

5. Leonard Downie Jr., Association of American Editorial Cartoonists, Convention Update, 2002, at pc99.detnews.com/aaec/story/details.hbs?myrec=227.

6. Signe Wilkinson, telephone interview by author, December 14, 2002.

7. Associated Press, "Average Newspaper Circulation Falls," May 6, 2002, reported on Adweek.com, at www.mediaweek.com/mediaweek/headlines/article_display.jsp?vnu_content_id=1483604.

8. Jim Huber, telephone interview by author, May 16, 2003.

9. Bruce Plante, "Twenty Questions with Bruce Plante," interview by J. P. Trostle, September 2002, AAEP website, at info.detnews.com/aaec/.

10. Asa Pittman and Emma Ruby-Sachs, "Cartooning Terror," *Nation*, July 9, 2002.

11. Ted Rall, e-mail interview by author, January 5, 2004.

12. Ted Rall, e-mail interview by author, January 5, 2004.

13. Signe Wilkinson, telephone interview by author, December 14, 2002.

14. Wayne Stroot, e-mail interview by author, August 21, 2003.

15. Plante, "Twenty Questions."

16. Kevin Kallaugher, quoted in Lawrence Pollard, "Drawing to the End of an Era," at www.politicalcartoon.co.uk/html/history12.html.

17. Signe Wilkinson, interview by author, December 14, 2002.

18. Ann Telnaes, telephone interview by author, February 3, 2003.

19. Mike Peters, quoted in Alvin Sanoff, "If You Make People Mad, You Make Them Think," *U.S. News and World Report*, June 22, 1981, 56.

20. Signe Wilkinson, interview by author, December 14, 2002.

21. Ann Telnaes, telephone interview by author, February 3, 2003.

22. Jim Huber, telephone interview by author, May 16, 2003.

23. Pat Oliphant, "Animated Oliphant," PR Newswire, October 13, 2000.

24. Clay Bennett, speech at Swarthmore College, November 12, 2002.

25. Kallaugher, quoted in Pollard, "Drawing."

26. Mark Fiore, "Cartoons of the Future," December 2002, at pc99.detnews.com/aaec/story/details.hbs?myrec=270.

27. Bennett, speech at Swarthmore College.

SIDEBAR: SNAPSHOT OF A FRUSTRATED CARTOONIST

a. Ted Rall, interview by Kent Worcester, New York City, June 17, June 24, and July 10, 1997, at www.rall.com/inter06.htm. Reprinted with permission.

SIDEBAR: INTERNETTITORIAL CARTOONS

a. All Fiore quotations in this section are from Mark Fiore, telephone interview by author, December 19, 2002.

BIBLIOGRAPHY

Books and Articles

Adler, Jerry. "The Finer Art of Politics." *Newsweek*, October 13, 1980.

Ammons, David N., John C. King, and Jerry L. Yeric. "Unapproved Imagemakers: Political Cartoonists' Topic Selection, Objectives and Perceived Restrictions." *Newspaper Research Journal* 9, no. 3 (Spring 1988).

"Animated Oliphant." *PR Newswire*, October 13, 2000.

Appel, John J. "Ethnicity in Cartoon Art." In *Cartoons and Ethnicity*. Columbus: Ohio State University Libraries, 1992.

Ashbee, C. R. *Caricature*. London: Chapman and Hall, 1928.

Associated Press. "Average Newspaper Circulation Falls," May 6, 2002, at www.mediaweek.com/mediaweek/head lines/article_display.jsp?vnu_content_id =1483604.

Auerbach-Levy, William. *The Art of Caricature*. New York: Art Book Guild of America, 1947.

Barber, Phil. "A Brief History of Newspapers," December 31, 2004, at www.historicpages.com/nprhist.htm.

Becker, Stephen. *Comic Art in America.* New York: Simon and Schuster, 1959.

Bennett, Clifford T. *A Political Cartoon History of the United States*. Glenview, IL: Scott, Foresman, 1992.

Berger, Oscar. *My Victims: How to Caricature*. New York: Harper, 1952.

Blaisdell, Thomas C., Jr., and Peter Selz. *The American Presidency in Political Cartoons: 1776–1976*. Santa Barbara, CA: Peregrine Smith, 1976.

Block, Herbert. "1946 1955: The Era of Fear and Smear." *Washington Post*, December 31, 1995, at www.washingtonpost.com/wp-srv/politics/herblock/essay1.htm.

———. "1966–1975: The Agonizing Age of Nixon." *Washington Post*, December 31, 1995, at www.washingtonpost.com/wp-srv/politics/herblock/essay3.htm

———. *Straight Herblock*. New York: Simon and Schuster, 1958.

Blunt, Abbot, and Roland C. ("Doc") Bowman *The American Cartoonist*, August 1903.

Bredhoff, Stacey. *Draw! Political Cartoons from Left to Right*. Washington, DC: National Archives, 1991.

Bruckner, D. J. R., Seymour Chwast, and Steven Heller. *Art against War: 400*

Years of Protest in Art. New York: Abbeville, 1984.

Casswell, Lucy Shelton. *Seven Cartoonists: The Festival of Cartoon Art.* Columbus: Ohio State University Libraries, 1989.

Catalogue of the Salon of American Humorists: A Political and Social Pageant from the Revolution to the Present Day. New York: College Art Association, 1933.

Copeland, David A. *Colonial American Newspapers: Character and Content.* Newark: University of Delaware Press, 1997.

Couple, W. A. "Observations on a Theory of Political Caricature." *Comparative Studies in Society and History* 11 (January 1969).

Craven, Thomas, ed. *Cartoon Cavalcade.* New York: Simon and Schuster, 1943.

Cresswell, Donald H. *The American Revolution in Drawings and Pictures.* Washington, DC: Library of Congress, 1975.

Cuff, Roger Penn. "The American Editorial Cartoon—A Critical Historical Sketch." *Journal of Educational Sociology* (October 1945).

Curtis, L. Perry, Jr. *Apes and Angels: The Irishman in Victorian Caricature.* Washington, DC: Smithsonian Institution Press, 1971.

Davis, Nancy. "Signe Wilkinson: This 'Attack Quaker' Spares No One from Her Lampooning Pen." *Presstime,* 1995.

Dean, Preston Allen, Jr. *Louisiana: A Political History in Cartoon and Narrative.* Alexandria, LA: Dean Art Features, 1993.

Deur, Lynne. *Political Cartoonists.* Minneapolis: Lerner Publications, 1972.

Eisner, Will. *Graphic Storytelling.* Tamarac, FL: Poorhouse, 1995.

Emory, Michael, and Edwin Emory. *The Press and America: An Interpretive History of the Mass Media,* rev. ed. Englewood Cliffs, NJ: Prentice Hall, 1988.

Feaver, William. *Masters of Caricature.* New York: Knopf, 1981.

Fischer, Roger. *Them Damned Pictures: Explorations in American Political Cartoon Art.* North Haven, CT: Shoe String, 1996.

Franklin, Benjamin, "The Autobiography." In *Franklin: Writings.* New York: Literary Classics of the United States, 1987.

Gautier, Dick. *The Art of Caricature.* New York: Putnam, 1985.

Geipel, John. *The Cartoon: A Short History of Graphic Comedy and Satire.* New York: A. S. Barnes, 1972.

Getlein, Frank, and Dorothy Getlein. *The Bite of Print: Satire and Irony in Woodcuts, Engravings, Etchings, Lithographs, and Serigraphs.* New York: C. N. Potter, 1963.

Gilmore-Lehne, William J. "Communications History: The United States, 1585–1880; Family and School in Literacy Training and Education," at www.stockton.edu/~gilmorew/0amnhist/comuhis5.htm.

— —. "Communications History: United States, 1585–1880; Newspapers," at www.stockton.edu/~gilmorew/0amnhist/comuhis1-4.htm.

———. "Communications History: United States, 1585–1880; Visual Essays and Images for Teaching/Research in History and American Studies," at www.stockton.edu/~gilmorew/0amnhist/comuhis1-4.htm.

Gombrich, Ernest H. *Art and Illusion: A Study in the Psychology of Pictorial Representations,* rev. ed. Princeton, NJ: Princeton University Press, 1969.

Gombrich, E. H. "El arsenal de la caricatura." In *Meditaciones sobre un caballo de juguete y otros ensayos sobre la teoria del arte.* Madrid: Editorial Debate, 1988.

Heller, Steven, and Gail Anderson. *The Savage Mirror: The Art of Contemporary Caricature.* New York: Watson-Guptill, 1992.

Hess, Stephen, and Milton Kaplan. *The Ungentlemanly Art: A History of American Political Cartoons.* New York: Macmillan, 1975.

Hess, Stephen, and Sandy Northrop. *Drawn and Quartered: The History of American Political Cartoons*. Montgomery: Elliott and Clark, 1996.

Hesse, Don. "The Ungentlemanly Art." *Quill*, December 1959.

Hester, Joseph. *Cartoons for Thinking: Issues in Ethics and Values*, 2nd ed. Monroe, NY: Trillium, 1988.

Hoff, Syd. *Editorial and Political Cartooning from Earliest Times to Present*. New York: Stravon Educational, 1976.

Hynds, Ernest C. "Survey Profiles of Editorial Cartoonists." *Masthead*, Spring 1977.

Inge, Thomas. *Comics as Culture*. Jackson. University Press of Mississippi, 1990.

Johnson, David. "Britannia Roused. Political Caricature and the Fall of the Fox-North Coalition." *History Today* 51, no. 6 (June 2001): 22–28.

Johnson, Gerald, W. *The Lines Are Drawn: American Life since the First World War as Reflected in the Pulitzer Prize Cartoons*. Philadelphia: Lippincott, 1958.

Keen, Sam. *Faces of the Enemy*. New York: HarperCollins, 1991.

Ketchum, Alton. *Uncle Sam: The Man and the Legend*. New York: Hill and Wang, 1959.

Kirby, Rollin. "My Creed as a Cartoonist." *Pep*, December 1918.

Learning Network, InfoPlease, "Colonial Population Estimates," 2005, at www.infoplease.com/ipa/A0004979.html.

Leonard, Thomas C. *The Power of the Press: The Birth of American Political Reporting*. New York: Oxford University Press, 1986.

Marschall, Richard E. "The Century in Political Cartoons." *Columbia Journalism Review* 38, no. 1 (May/June 1999).

Marzio, Peter. *The Men and Machines of American Journalism*. Washington, DC: National Museum of History and Technology, Smithsonian Institution, 1973.

Maurice, Arthur Bartlett, ed. "Cartoons That Have Swayed History." *Mentor*, July 1930.

Maurice, Arthur Bartlett, and Frederic Taber Cooper. *History of the Nineteenth Century in Caricature*. New York: Dodd, Mead, 1904.

Maxa, Rudy. "Portrait of the Artist: Hottest Pen Going." *Washington Post*, December 17, 1978.

Mitchell, John Ames "Contemporary American Caricature." *Scribner's Magazine*, December 1889.

Mohn, Elsa, and Maxwell McCombs. "Who Reads Us and Why." *Masthead*, Summer 1988.

Mumford, Alan. "Demons or Wimps: General Election Cartoons," at www.politicalcartoon.co.uk/html/history1.html.

Murrell, William. *A History of American Graphic Humor*, 2 vols. New York: Cooper Square Publishers, 1967.

Nevins, Allan, and Frank Weitenkamp. *A Century of Political Cartoons: Caricature in the United States from 1800 to 1900*. New York: Charles Scribner's Sons, 1944.

Ohman, Jack. *Drawing Conclusions: A Collection of Political Cartoons*. New York: Simon and Schuster, 1987.

Payne, Harold. "Our Caricaturists and Cartoonists." *Munsey's Magazine*, February 1894.

Philippe, Robert. *Political Graphics: Art as Weapon*. New York: Abbeville, 1980.

Picon, Jacinto Octavio, *Apuntes para la historia de la caricatura*. Madrid: Establecimiento Tipografico Canos, 1877.

Pittman, Asa, and Emma Ruby-Sachs. "Cartooning Terror." *Nation*, July 9, 2002.

Pollard, Lawrence. British Broadcasting Corporation program, "The Art of the Political Cartoonist," August 8, 2002, at news.bbc.co.uk/2/hi/europe/2194967.stm.

Population Projections Program, Population Division, U.S. Census Bureau. *Projections of the Total Resident Population by 5-Year Age Groups, Race, and His*

panic Origin with Special Age Categories: Middle Series, 2050 to 2070, January 13, 2003, at www.census.gov/population/projections/nation/summary/np-t4-g.txt

Press, Charles. The Political Cartoon. East Brunswick, NJ: Associated University Presses, 1981.

Reilly, Bernard. American Political Prints, 1766–1876: A Catalog of the Collections in the Library of Congress. Boston: G. K. Hall, 1991.

Robbins, Trina. A Century of Women Cartoonists. Northampton, MA: Kitchen Sink, 1993.

Rothwell, Jennifer Truran. "Politics and Media: Teaching with Cartoons." Social Education 60 (October 1996): 326–28.

Sanoff, Alvin. "If You Make People Mad, You Make Them Think." U.S. News and World Report, June 22, 1981.

Shelton, William Henry. "The Comic Paper in America." Critic, September 1901.

Sheridan, Martin. Comics and Their Creators: Life Stories of American Cartoonists. [Boston]: Hale, Cushman and Flint, 1942.

Shikes, Ralph E. The Indignant Eye: The Artist as Social Critic in Prints and Drawings from the Fifteenth Century to Picasso. Boston: Beacon, 1969.

Shite, Frank Linstow, "Some American Caricaturists." Journalist, November 19, 1887.

Smith, Katherine Louise. "Newspaper Art and Artists." Bookman, August 1901.

Teppel, John. The Media in America. New York: Thomas Crowell, 1978.

Trumble, Alfred. "Satire, with Crayon and Pen." Epoch, June 13, 1890.

U.S. Department of Commerce. Profiles of General Demographic Characteristics: 2000 Census of U.S. Population and Housing, May 2001, at www2.census.gov/census_2000/datasets/demographic_profile/0_United_States/2kh00.pdf.

Vovelle, Michel. Prologue to La Caricature revolutionnaire/La Caricature contrerevolutionnaire, by Antoine de Baecque. Librairie du Bicentenaire de la Revolution Française series. Presses du CNRS, 1988.

Wait, Gary E. "Cartoons and Caricatures of the Civil War," Dartmouth College Library Bulletin, n.s., 37, no. 2 (April 1997), at www.dartmouth.edu/%7Elibrary/Library_Bulletin/Apr1997/Wait.html.

Weaver, John D. "Drawing Blood: Political Cartoonists." Holiday, August 1915.

Westin, Alan F., ed. Getting Angry Six Times a Week: A Portfolio of Political Cartoons. Boston: Beacon, 1979.

White, Herbert S., ed. The Copyright Dilemma. Chicago: American Library Association, 1978.

White, Richard Grant. "Caricature and Caricaturists." Harper's Monthly Magazine, April 1862.

Wilkinson, Signe. "The Rare Female Cartoonist: If Only She Wore Khaki." Originally printed in the Hartford (CT) Courant, January 25, 1999, at www.asne.org/index.cfm?id=1744.

Wood, Art. Great Cartoonists and Their Art. Gretna, LA: Pelican, 1987.

Wright, Grant. The Art of Caricature. New York: Baker Taylor, 1904.

Zwick, Jim, ed. "Political Cartoons and Cartoonists," March 18, 2005, at www.boondocksnet.com/gallery/pc_intro.html.

Websites

The following is a list of sites focusing on a specific aspect of political cartooning (historical, racial, legal, etc.) or featuring collections of cartoons.

info.detnews.com/aaec
The Association of American Editorial Cartoonists (AAEC)
Home page of the Association of American Editorial Cartoonists, featuring links to the individual pages of nearly seventy cartoonists, a history section, and a bulletin board.

www.canadiancartoonists.com
Association of Canadian Editorial Cartoonists
Links to the top cartoonists in Canada as well as a portfolio of artwork and a directory of the nation's cartoonists.

www.loc.gov/rr/print/coll/230_swan.html
Caroline and Erwin Swann Collection of Caricature and Cartoon
This is a special collection in the U.S. Library of Congress, with the work of more than five hundred artists shown in over two thousand prints, drawings, and paintings from 1780 to 1977.

library.kent.ac.uk/cartoons/
Cartoonhub—The Centre for the Study of Cartoons and Caricature
Two hundred years of British cartooning.

orpheus.ucsd.edu/speccoll/dspolitic/
Dr. Seuss Went to War: A Catalog of Political Cartoons by Dr. Seuss.
Mandeville Special Collections Library collection of Theodor Seuss Geisel's prowar, pro-America cartoons from 1941 to 1943.

www.unitedmedia.com/editoons/index.html
Editorial Cartoons
A database provided by United Media with the recent work of nearly twenty editorial cartoonists organized by date.

www.graphicwitness.org
Graphic Witness
Includes the work of left-leaning cartoonists worldwide.

www.elections.harpweek.com
HarpWeek Explore History
Cartoons from *Harper's Weekly*, *Vanity Fair*, *Frank Leslie's Illustrated Weekly*, *Puck*, and the Library of Congress Collection of American Political Prints, 1766–1876. Good source for Thomas Nast work.

www.reuben.org
The National Cartoonists Society
Includes member news, links to cartoonists' websites, and advice to aspiring cartoonists.

www.lib.ohio-state.edu/cgaweb/info.htm
Ohio State University Cartoon Research Library
One of the largest collections of political cartoons in America, featuring two hundred thousand original works and related materials organized with a very effective search system.

lcweb.loc.gov/exhibits/oliphant/oliphant.html
Oliphant's Anthem: Pat Oliphant at the Library of Congress
Exhibit of the works of the Pulitzer Prize–winning editorial cartoonist.

www.clstoons.com/paoc
Pioneering Cartoonists of Color
Features the work of political cartoonists of color from the 1920s to the present, including examples of their work and brief biographies of key cartoonists.

www.politicalcartoon.co.uk/
The Political Cartoonist Society (Britain)
Includes a history of cartooning in England, exhibitions, a gallery, and links to cartoonists in different areas of the world.

www.PoliticalCartoons.com.
Political Cartoons
Allows you to search for a political cartoon to buy or reprint.

www.StarvingArtistsLaw.com
Starving Artists Law
Focuses on legal issues related to cartooning, such as copyright and privacy regulation.

cagle.com/teacher
Teacher Guide
This section of Daryl Cagle's site is useful for developing lesson plans for elementary, middle, and high school classes that could feature political cartoons.

politicalhumor.about.com/library/bldailyfeed2.htm
Today's Political Cartoons
Offers cartoons on the latest political topics. Includes separate sections for *USA To-day*, the *New Yorker*, the *Washington Post*, CNN, and AOL.

xroads.virginia.edu/~ma96/puck/home.html
Uniting Mugwumps and the Masses: *Puck*'s Role in Gilded Age Politics
An overview and analysis of editorial cartoon history in the United States

SITES FEATURING CURRENT SYNDICATED POLITICAL CARTOONS

cartoonweb.com
Cartoonists and Writers Syndicate

creators.com
Creators—a Syndicate of Talent

www.cartoonstock.com/newscartoons/newscartoon.asp
CSL Newscartoon Service

cagle.slate.msn.com//
Daryl Cagle's Professional Cartoonists Index

www.kingfeatures.com
King Features Syndicate

unitedmedia.com
United Media

Cartoon Collections at Libraries in American Universities

The following is a list of American universities that hold extensive collections of political cartoons and manuscripts related to cartoon history. A list of major library holdings of cartoons, political and otherwise, can be found at www.lib.msu.edu/comics/otherlib.htm.

Boston University
Bowling Green State University
Brown University
California State University, Fullerton
Fairleigh Dickinson University
Kent State University
Michigan State University
Ohio State University
Princeton University
Syracuse University
University of Southern Mississippi
Western Kentucky University

CARTOON CREDITS

In preface: © 2000, The Washington Post Writers Group. Reprinted with permission. Library of Congress, Prints and Photographs Division, LC-USZ62-127451.

1.1: Library of Congress, Prints and Photographs Division, LC-USZC4-8788.

1.2: Library of Congress, Prints and Photographs Division, LC-USZ62-45406.

1.3: Library of Congress, Prints and Photographs Division, LC-USZ62-9701.

1.4: Library of Congress, Prints and Photographs Division, LC-USZ62-1531.

1.5: Library of Congress, Prints and Photographs Division, LC-USZ62-1533.

1.6: Library of Congress, Prints and Photographs Division, LC-USZ62-7984.

1.7: Cornell University Library.

1.8: Library of Congress, Prints and Photographs Division, LC-USZ62-45564.

1.9: Indiana University Libraries.

1.10: Library of Congress, Prints and Photographs Division, LC-USZ62-35522.

1.11: Library of Congress, Prints and Photographs Division, LC-USZC4-5289.

1.12: Library of Congress, Prints and Photographs Division, LC-USZ62-9487.

1.13: Library of Congress Geography and Map Division Washington, D.C. G3700 1783 .W3.

2.1: Library of Congress, Prints and Photographs Division, LC-USZ62-96402.

2.2: Library of Congress, Prints and Photographs Division, LC-USZ62-45589.

2.3: Library of Congress, Prints and Photographs Division, LC-USZ62-45591.

2.4: Library of Congress, Prints and Photographs Division, LC-USZC4-4544.

2.5: Library of Congress, Prints and Photographs Division, LC-USZ62-89742.

2.6: Library of Congress, Prints and Photographs Division, LC-USZ62-32391.

2.7: Library of Congress, Prints and Photographs Division, LC-USZ62-1575.

2.8: Library of Congress, Prints and Photographs Division, LC-USZ62-5745.

2.9: Library of Congress, Prints and Photographs Division, LC-USZC2-2386.

2.10: Library of Congress, Prints and Photographs Division, LC-USZ62-83784.

3.1: Library of Congress, Prints and Photographs Division, LC-USZ62-12963.

3.2: Library of Congress, Prints and Photographs Division, LC-USZ62-1997.

3.3: Library of Congress, Prints and Photographs Division, LC-USZ62-8840.

3.4: Library of Congress, Prints and Photographs Division, LC-USZ62-100059.

3.5: Library of Congress, Prints and Photographs Division, LC-USZ62-89748.

3.6: Library of Congress, Prints and Photographs Division, LC-USZ62-7176.

3.7: Library of Congress, Prints and Photographs Division, LC-USZ62-68148.

3.8: Library of Congress, Prints and Photographs Division, LC-USZ62-59398.

3.9: Ohio State Library Special Collections.

3.10: Library of Congress, Prints and Photographs Division, LC-USZ62-128619.

3.11: Library of Congress, Prints and Photographs Division, LC-USZ62-114830.

3.12: Library of Congress, Prints and Photographs Division, LC-USZ6-951.

3.13: Library of Congress, Prints and Photographs Division, LC-USZ62-117137.

3.14: Library of Congress, Prints and Photographs Division, LC-USZC4-6044.

3.15: Library of Congress, Prints and Photographs Division, LC-USZ62-22399.

3.16: Library of Congress, Prints and Photographs Division, LC-USZC4-4138.

3.17: Copyright 1994 by Jim Huber. Reprinted with permission.

3.18: Library of Congress, Prints and Photographs Division, LC-USZ62-28762.

3.19: Library of Congress, Prints and Photographs Division, LCPP002A-08602.

4.1: Library of Congress, Prints and Photographs Division, LC-USZ6-796.

4.2 Center for Legislative Archives U.S. National Archives & Records Administration.

4.3: Library of Congress, Prints and Photographs Division, LC-USZ62-34218.

4.4: Richard Samuel West Collection.

4.5: Richard Samuel West Collection.

4.6: Michigan State Library Special Collections Department.

4.7: Richard Samuel West Collection.

4.8: Library of Congress CAI - Jacobs, no. 66 (B size)

4.9: Library of Congress, Prints and Photographs Division, LC-DIG-ppmsca-02919.

4.10: Copyright 1920 *The Des Moines Register*.

4.11: Library of Congress, Prints and Photographs Division, LC-USZC4-4893.

4.12: Library of Congress, Prints and Photographs Division, LCPP002A-09076.

4.13: Library of Congress, Prints and Photographs Division, LC-USZC4-6574.

4.14: Library of Congress, Prints and Photographs Division, LC-USZC4-6717.

4.15: Courtesy of The Herb Block Foundation.

4.16: Courtesy of the University of California San Diego Special Collection.

4.17: Copyright 1944 by Bill Mauldin. Reprinted courtesy of the Mauldin Estate.

5.1: Courtesy of The Herb Block Foundation.

5.2: Courtesy of The Herb Block Foundation.

5.3: Copyright, [year], Tribune Media Services. Reprinted with permission.

5.4: Copyright 1948 by J. N. "Ding" Darling Foundation. Reprinted with permission.

5.5: Copyright 1948, The Providence Journal Company. Reprinted with permission.

5.6: Copyright, 1948, *Los Angeles Times*. Reprinted with permission.

5.7: Copyright 1963 by Bill Mauldin. Reprinted courtesy of the Mauldin Estate.

5.8: Copyright 1968 by Draper Hill.

5.9: TOLES ©2004 *The Washington Post*. Reprinted with permission of UNIVERSAL PRESS SYNDICATE. All rights reserved.

6.1: © 2000, 2001, The Washington Post Writers Group. Reprinted with permission.

6.2: Copyright 2003 by Wayne Stroot.

6.3: Library of Congress, Prints and Photographs Division, LC-USZ62-16780.

6.4: Library of Congress, Prints and Photographs Division, LC-USZ62-98037.

6.5: Center for Legislative Archives U.S. National Archives & Records Administration

6.6: © 2005 The Times-Picayune Publishing Co. All rights reserved. Used with permission of *The Times-Picayune*.

6.7: Courtesy of The Herb Block Foundation. Library of Congress, Prints and Photographs Division, LC-USZ62-126910.

6.8: *Boston Gazette*, March 26, 1812.

7.1: AUTH © 2000 *The Philadelphia Inquirer*. Reprinted with permission of the UNIVERSAL PRESS SYNDICATE. All rights reserved. Library of Congress, Prints and Photographs Division, LC-USZ62-127450.

7.2: Courtesy of The Herb Block Foundation.

7.3: Library of Congress, Prints and Photographs Division, LC-USZ62-45399.

7.4: Library of Congress, Prints and Photographs Division, LC-USZ62-13954.

7.5: Library of Congress, Prints and Photographs Division, LC-USZ62-1569.

7.6: Library of Congress, Prints and Photographs Division, LCPP002A-13335.

7.7: Library of Congress, Prints and Photographs Division, LC-USZ62-91465.

7.8: OLIPHANT © 1994 UNIVERSAL PRESS SYNDICATE. Reprinted with permission. All rights reserved. Library of Congress, Prints and Photographs Division, LC USZ62-120073.

7.9: Library of Congress, Prints and Photographs Division, LC-USZ62-105116.

7.10: Library of Congress, Prints and Photographs Division, LC-USZ62 120896.

7.11: Library of Congress, Prints and Photographs Division, LC-USZC4-5758.

7.12: The Ohio State University Library special collection.

7.13: Library of Congress, Prints and Photographs Division, LC-USZC4-12317.

7.14: Courtesy of the University of California San Diego Special Collections.

8.1: Library of Congress, Prints and Photographs Division, LC-USZC4-6053.

8.2: Copyright 1960 by Bill Mauldin. Reprinted courtesy of the Mauldin Estate. Library of Congress, Prints and Photographs Division, LC-USZ62-133004.

8.3: Copyright 1999 by V. Cullum Rogers. Reprinted with permission.

8.4: Copyright 1950 by Bill Mauldin. Reprinted courtesy of the Mauldin Estate. Library of Congress, Prints and Photographs Division, LC-USZ62-133015.

8.5: Permission granted on 2/18/05 by Bruce Plante, Editorial Cartoonist for the *Chattanooga Times Free Press*.

8.6: Permission granted on 2/18/05 by Bruce Plante, Editorial Cartoonist for the *Chattanooga Times Free Press*.

8.7: Library of Congress Accession no. DLC/PP-1936:0065.24

9.1: Copyright 2001 by Daryl Cagle at Cagle Cartoons, Inc.

9.2 Copyright 2002 by Mike Keefe at Cagle Cartoons, Inc.

9.3: BALL, © 2002 Ted Rall. Reprinted with permission of UNIVERSAL PRESS SYNDICATE. All rights reserved.

9.4: Library of Congress, Prints and Photographs Division, LC-USZ62-70426.

INDEX

ABOUT THE AUTHOR

EDWARD J. LORDAN, Ph.D., is assistant professor of communication studies at West Chester University in Pennsylvania. This is his second book; in 2003 he published a professional development text titled *Essentials of Public Relations Management*. Lordan has written more than five hundred columns, reviews, features, and news articles for a variety of newspapers, as well as academic articles for publications such as *Public Relations Quarterly* and the *Newspaper Research Journal*. He lives with his wife and two sons in Wallingford, Pennsylvania.